Staatliche
Kunstsammlungen
Dresden

MATHEMATISCH-PHYSIKALISCHER SALON

DKV

MATHEMATISCH-PHYSIKALISCHER SALON

STAATLICHE
KUNSTSAMMLUNGEN
DRESDEN

Zwinger
Masterpieces

DEUTSCHER KUNSTVERLAG

Index

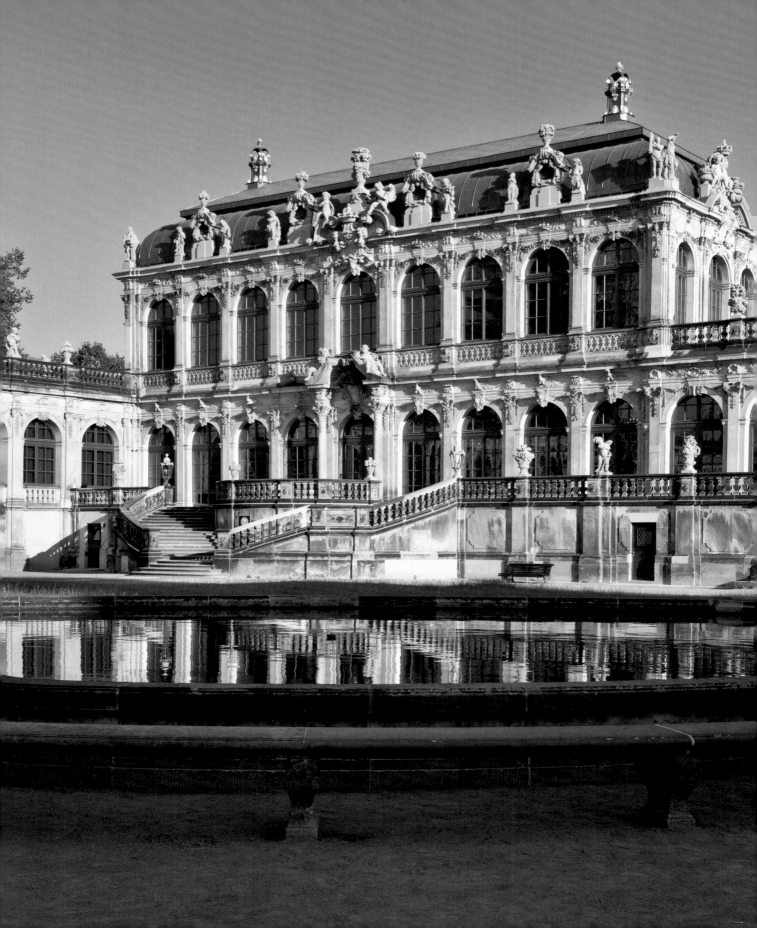

PETER PLASSMEYER

THE HISTORY OF THE MATHEMATISCH-PHYSIKALISCHER SALON

The Mathematisch-Physikalischer Salon in Dresden is one of the oldest museums in the world. Located in 1728 in a part of the Zwinger that later became known as the Glockenspiel Pavilion, it was moved to its present location in the northwest corner pavilion (Pavilion F) before 1746 (ill. 1.1). The Salon is still considered to be one of the world's leading museums of historic scientific instruments and clocks. The collection's scope ranges from timepieces and automata to microscopes and telescopes; it also encompasses surveying instruments, globes, and burning mirrors, as well as electrostatic generators from the 13th to the 19th centuries (ill. 1.2). Many of these objects were expressly produced and procured for the Saxon court in Dresden before the Salon had even been founded.

The holdings originate from a princely collection. The Saxon electors began gathering the material in the mid-16th century, initially keeping it in the Kunstkammer, located in the Residential Palace's attic. Scholars currently suggest the year 1560 as the date of the Kunstkammer's founding. The first secure source is the 1587 Kunstkammer inventory that primarily lists the estate of Elector August (1526–1586), who had died the previous year. This inventory records approximately 10,000 objects, among them over 7,000 tools and about 450 scientific instruments. Quantitively speaking, scientific instruments and tools characterize and dominate the Dresden Kunstkammer. In addition, 288 books and manuscripts are listed: Also considered *scientifica*, this means that almost 80 percent of the Dresden Kunstkammer's holdings reveal a focus on crafts or science. In the permanent exhibi-

tion, the latter exhibits are predominantly displayed in the Langgalerie (cf. p. 19–51) under the heading "The Cosmos of the Prince."

By establishing a Kunstkammer within his residence, Elector August highlighted his status among the princes of the Holy Roman Empire. After the victory at Mühlberg in 1547 Emperor Charles V (1500–1558) bestowed the electorship upon August's brother Moritz (1521–1553). The latter made Dresden the capital of the Wettin dynasty's Albertinian line and the center of his court. After Moritz's untimely death, August continued to consolidate the Albertinian rule in Saxony. Founding the Kunstkammer was one small yet crucial element within this scheme.

The collection also contains surveying tools, facilitating the production of territorial maps as well as instruments for survey work underground. The Erzgebirge mines and the natural resources quarried there – among them silver – reinforced the power and increased the wealth of the Protestant electorate. Time and again, men were commissioned to bring detected resources to the surface or discover new ones. Under August this was Giovanni Maria Nosseni (1544–1620), under Johann Georg II (1613–1680) the architect Wolf Caspar von Klengel (1630–1691), and under Friedrich August I (Augustus the Strong; 1670–1733) Ehrenfried Walther von Tschirnhaus (1651–1708).

Whereas in his early Kunstkammer Elector August stressed primarily a scholarly focus, his successors tended to expand it based on the canonical criteria known from com-

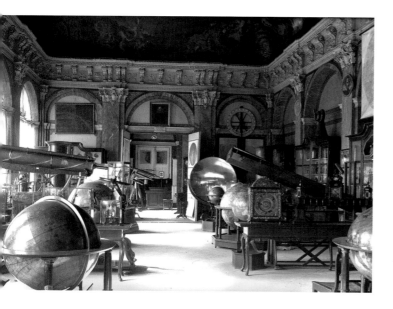

1.1 Exhibition Gallery of the Mathematisch-Physika-lischer Salon in the Dresden Zwinger (photographed before 1928)

the Regimentshaus. A permanent solution only presented itself in 1728, when the Zwinger – originally conceived as a combination of orangeries and ballrooms – was transformed into a "Palais des Sciences." It became the new home of the library, the print room, the numismatic collection, the natural history materials, and, naturally, mathematical as well as physical instruments. However, only the Mathematisch-Physikalischer Salon has remained in the Zwinger to this day. At the start, the Salon was housed on the top floor of the northwest pavilion above the Grottensaal. Destroyed during World War II it was reconstructed in a simplified version in 1952. In 1782 Karl Wilhelm Daßdorf wrote: "This is one of the most beautiful halls in the Zwinger, embellished with marble and decorated with a striking ceiling painting by the famous Mr. von Sylvestre. The gathering of all types of mathematical and physical instruments is beautiful and perfect. Owing to the recent acquisition of Count Löser's famous and beautiful objects, the collection has been considerably enhanced." (Dasdorf 1782, p. 524)

1.2 Exhibition Gallery of the Mathematisch-Physikalischer Salon, second half 19th century, drawing by U. Reinhardt for *Illustrierte Zeitung von Weber*, vol. 62, 1874.

parable collections in Ambras, Munich, and Prague. In doing so, the original collection of prototypes for developing and defending the country fell out of favor.

The spirit of the founder of the Saxon electoral Kunstkammer shone brightly once again at the end of the 17th century, when Ehrenfried Walther von Tschirnhaus's monumental burning apparatus came to the Kunstkammer. Under Augustus the Strong, Tschirnhaus was made superintendent of the princely laboratories, where – in the early 18th century – the formula for European hard-paste porcelain was developed. Tschirnhaus's burning mirrors and lenses were held in high esteem in laboratories and collections all over Europe.

Russian Tsar Peter I (1672–1725) visited Dresden's Kunstkammer in the late 17th century, expressly because of the "tools" kept there, taking them as inspiration for his own "Kunstkamera" in St. Petersburg. Augustus the Strong had the collections reorganized at the beginning of the 18th century. Until the ultimate end of the Dresden Kunstkammer in 1832 there was a slow dissolution. At first, parts of the collection were moved to the Holländisches Palais, others to

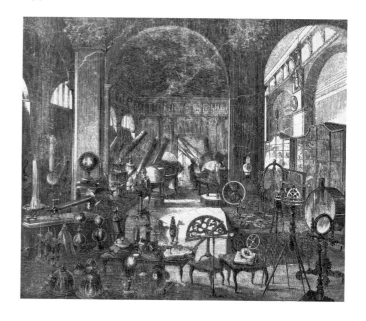

Ever since 1746, when the mathematical and physical instruments were moved to their present Zwinger location, a mutual inspiration between building and collection may be noted. The first Salon inventory was compiled between 1730 and 1732 under Inspector Johann Gottlieb Michaelis (1704–1740). At first, placing the holdings in the Zwinger was considered a type of "safekeeping." However, the claim was eventually made that the collection ought to conform to the ubiquitous "physical cabinets" established all over Europe. This meant that beyond administering a historic collection, current scientific instruments ought to be exhibited as well. The multilingual publications of Abbé Jean-Antoine Nollet (1700–1770) were a model for this approach. His writings about physics and especially electricity were popular textbooks giving teaching instructions for the natural sciences. Nollet showed all useful instruments and their application in such highly vivid language and images that after reading them, the student himself could undertake the experiments. It is therefore a natural consequence that the Salon also required equipment based on Nollet's teachings. These demands began to be made no later than the end of the Seven Years' War; the state coffers were empty, however, postponing potential shopping sprees in Paris and London into the distant future.

However, there already existed a precision mechanics workshop in Saxony capable of producing instruments of similar high quality to those found in London and Paris. Imperial Count Hans von Löser (1704–1763) operated his workshop on his property, Schloss Reinharz, with numerous craftsmen. It was mostly used to equip his personal cabinet with mechanical and optical instruments (cf. p. 63). After his death, parts of his estate were acquired for the Salon, thereby eliminating the often-decried deficiency. In 1768 the library and the instrument collection of Count Heinrich von Brühl (1700–1763) were purchased, among them a concave mirror, various telescopes, a quadrant, as well as additional measuring and artillery instruments.

In 1777 the Zwinger-based establishment received far-reaching attention following the appointment of Johann

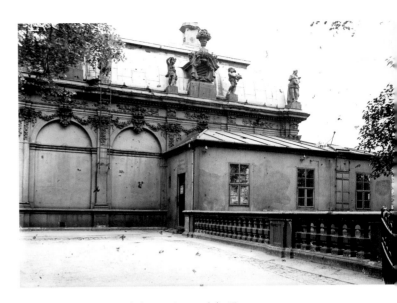

1.3 Extension for celestial observations and the Time Service. Erected under W. G. Lohrmann in 1829. The bricked-up pavilion windows are striking – they were only opened in 1928, after the extension was demolished.

Gottfried Köhler (1745–1800) and his successor Johann Heinrich Seyffert (1751–1818) as Salon inspectors. Whereas Köhler strove to establish a network with other astronomical institutions, in 1781 he set up a provisional observatory in the Zwinger collection gallery, enabling him to explore the sky. He observed comets, solar and lunar eclipses, as well as the Moon's surface, of which he produced drawings. Since exact time measurements were central to his observations, he established a Time Service in the Zwinger in 1783, whose instruments and clocks can still be seen in the Festsaal (p. 71) and in the Bogengalerie (p. 106).

Köhler and his successors were not primarily active as "scholars": Their multiple tasks at court prevented them from working with the instruments in their collections. At least they had sufficient time left to either construct or – frequently based on their own ideas and concepts and paid for out of their own pockets – to have constructed tools or clocks crucial for their work. Furthermore, they managed repeatedly to acquire high-caliber objects which define the character of this collection to the present day.

Groundbreaking developments resulted from these activities. The Salon became a public authority, an official institution, in charge of deciding all Saxon time issues. The local time was determined here – and all clocks in Dresden were set on this basis until the early 20th century. Köhler began to publicize clocks and the improvements he carried out on them – as well as his astronomical observations and measurements – in important journals. His extensive correspondence with other astronomers aided in the further dissemination of his findings. Whereas not all results were based on original research, the figures certainly sufficed as reference data to either confirm or reject data found in other places. This also holds true for his meteorological surveillances. The works of Köhler and Seyffert enabled them to consolidate the Salon's position within the established circle of European observatories. In 1798 they were both invited by the French astronomer Jérôme Lalande (1732–1807) to attend a conference on astronomy he organized in Gotha. Participants included uncounted numbers of the era's most famous astronomers.

Self-taught, Seyffert advanced to be the most innovative "Saxon" clockmaker of his time. He fabricated important clocks for the Zwinger observatory; his pocket chronometers were sought after far beyond Saxony. In preparation for his South America expedition, Alexander von Humboldt (1769–1859) undertook a special trip to Dresden in 1799 to be instructed by Köhler on the use of sextants to determine locations and barometers to determine heights. Von Humboldt bought a pocket chronometer from Seyffert that he used, along with another one by Louis Berthoud (1754–1813), during his explorations in the New World.

Most of the observational instruments initially entered the Mathematisch-Physikalischer Salon holdings during Köhler's tenure, whereas Seyffert ordered contemporary instruments from England with the aid of the Saxon envoy in London, Count Hans Moritz von Brühl (1736–1809). In this way, numerous objects became part of the Salon inventory, among them a new transit instrument by William Cary (1759–1825; p. 72, ill. 3.29) and a marine chronometer by Thomas Mudge (1760–1835; p. 73, ill. 3.32), son of the eponymous father, as well as a mirror telescope by Friedrich Wilhelm Herschel (1738–1822; p. 62, ill. 3.14).

Wilhelm Gotthelf Lohrmann (1796–1840) was named the Salon's inspector in 1827, and a year later King Anton of Saxony promoted him to be the first superintendent of the newly-founded Königlich-Technische Bildungsanstalt Sachsen (Royal Technical School). Lohrmann initiated a close cooperation between the two institutions, integrating instruments from the Salon collection into the education of his students at the Technische Bildungsanstalt. Finally, the mission – formulated in the second half of the 18th century – to extend the collection and to use it in conjunction with learning was accomplished. Until the 1850s tools and instruments were loaned to the instructors of the Bildungsanstalt – the Polytechnikum (Royal Politechnical School) and Technische Universität emerged later from this institution – for the purpose of illustration or demonstration.

Under Lohrmann, a massive extension consisting of three spaces was added at the southwest corner of the collection gallery. It replaced a wooden structure built in 1819 for observations, served as a location for sky observations, and it accommodated the Time Service (ill. 1.3) (cf. p. 71, ill. 3.28). Lohrmann was also the author of the first printed Salon catalogue, published in 1835 (ill. 1.4).

Since the mid-18th century the Mathematisch-Physikalischer Salon had always been a place for scholarship and multi-faceted educational practices. In the 1860s this era came to an end with the plan to transfer the instruments to the Polytechnikum. Preexisting organizational reasons and staff changes made the attempt to hand over responsibilities seem logical. However, the Salon's inventory no longer corresponded to the needs of the educational institution: Technically outdated, the objects had in the meantime become museum objects.

In 1832 the process to develop a representative museum began. At the time, the remaining material from the dissolved

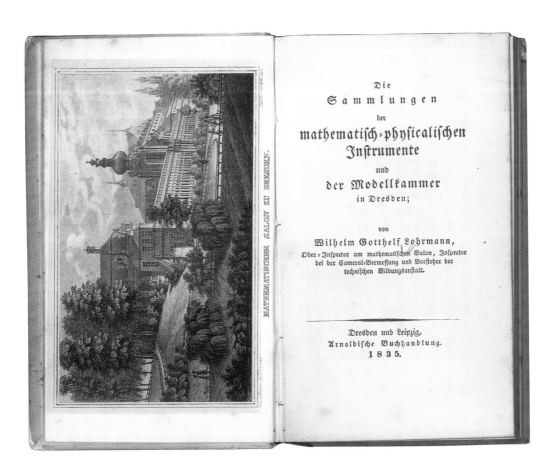

Die
Sammlungen
der
mathematisch-physicalischen
Instrumente
und
der Modellkammer
in Dresden;

von

Wilhelm Gotthelf Lohrmann,
Ober-Inspector am mathematischen Salon, Inspector
bei der Cameral-Vermessung und Vorsteher der
technischen Bildungsanstalt.

Dresden und Leipzig,
Arnoldische Buchhandlung.
1835.

1.4 Title page of the Mathe-matisch-Physikalischer Salon's first printed catalogue by W. G. Lohrmann from 1835.

Kunstkammer, also kept at the Zwinger, was distributed among the various museums. Some objects were sold. Renaissance automata (cf. p. 19) and especially numerous clocks (see p. 79) entered the Salon at this time. The few clocks that were already part of the inventory had been purchased specifically for the Time Service. Although some of the clocks with Kunstkammer provenance were given to the Historisches Museum Dresden (today: The Armory) in 1870, they were returned in 1907 in exchange for a large group of Kunstkammer tools. 1909 saw the purchase of 95 pocket watches from the collection of Dresden watchmaker Robert Pleißner, 1849–1916). This decisive expansion initiated a development over the ensuing decades, whence the Salon possessed one of the world's most important horological collections. After World War II, the globe collection underwent a similarly pur-

poseful development into an encyclopedic, comprehensive collection. It is still counted among the globally leading assemblages. Ultimately, this led to an essential change of the Mathematisch-Physikalischer Salon's character: Originally a predominantly courtly collection, it was transformed into a universal museum with fundamentally different collecting principles. Suddenly, historic objects became interesting, whereas the focus during the first centuries of its existence had been almost exclusively on contemporary objects. An arrangement according to categories is evident in the Mathematisch-Physikalischer Salon's first inventory. Compiled by Michaelis in 1730–32, it abandoned the contextualized system previously used in the Kunstkammer inventories.

The 20th century records reveal numerous alterations to building and spaces. As part of a third Zwinger renovation

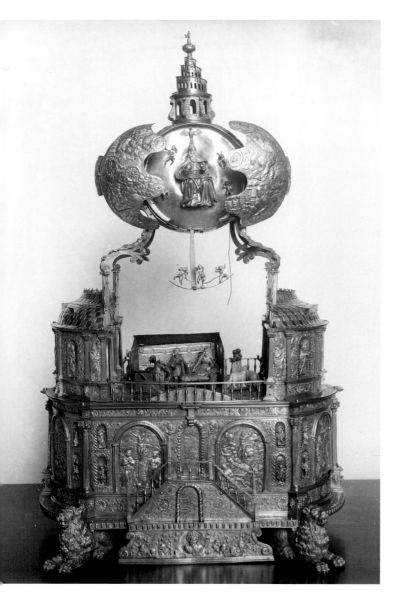

1.5 Christmas Crib Automaton, Hans Schlottheim, Augsburg, 1585 (destroyed in 1945, only fragments survive), copper, silvered brass, engraved, gilded steel, bronze, inv. no. D V 12.

The collection suffered painful losses during World War II. After the museum closed in 1939 the majority of its holdings were moved into the basement of the recently added administrative building in 1942. The large instruments were moved to the Silberkammer in the Residential Palace. In 1943 the relocation of the collection to different palaces and manors near Dresden began. In February 1945 an order was issued to move all items placed east of the Elbe to storage sites west of the river. This led to a catastrophic disaster: One of the transport vehicles had been placed near Wiener Platz during the air raid on the city center and was hit by a firebomb on February 13, 1945. As a result, a substantial portion of the 16th-and-17th-century clocks, automata, and instruments as well as valuable manuscripts of that period were either destroyed or cruelly damaged. Among these irreversible losses is also the Christmas Crib automaton of Hans Schlottheim (1545–1625) from Augsburg, one of the most significant figure-and-music automata of its time (ill. 1.5). Not only objects were lost, but the Zwinger itself was severely damaged by bombs (ill. 1.6).

Reconstruction began as early as the fall of 1945. In 1952 the Mathematisch-Physikalischer Salon reopened as the

1.6 Mathematisch-Physikalischer Salon after the destruction in February 1945

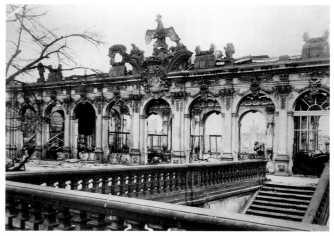

between 1927 and 1928 the ballroom windows facing the ramparts – bricked up in the 18th century – were reopened, the observation cabin was demolished, and an administrative building was erected, with a new extension for Time Service placed on its terrace.

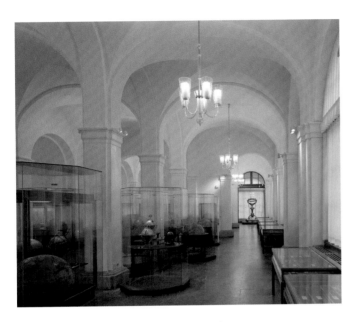

1.7 View of the Grottensaal with the globe collection and Tschirnhaus's double lens burning apparatus in the background. (photographed before 2007).

first museum in the Zwinger. Initially located in the old collection gallery of the pavilion's upper floor (Festsaal), the Mathematisch-Physikalischer Salon's exhibitions space was extended to include the former Grottensaal on the pavilion's ground floor in 1954 (ill. 1.7). The Bogengalerie, which connects the space towards the Wallpavillon, was added in 1956 (ill. 1.8).

Thus, the Salon's exhibition space was doubled. The arrangement of the exhibits followed the innovative early-20th century concept that anticipated the establishment of special collections. The original Mathematisch-Physikalischer Salon space, where for more than two centuries the entire collection had been assembled, was now exclusively reserved for the clock collection (ill. 1.9).

From 2007 until 2013 the first fundamental renovation of the edifice since its reconstruction in the late 1940s was undertaken, resulting in additional exhibition space. The latter was achieved by adding the Langgalerie, positioned between Kronentor and Pavilion. Previously used as a library

and offices, another portion of the Bogengalerie was also converted into exhibition space. Considerable changes occurred in the Grottensaal, where the 18th-century cubic volume was reconstructed. This space now serves as foyer and admission hall. To compensate for lost exhibition space, a new, windowless gallery was created. Placed adjacent to and in the ramparts wall, it presently houses the globe collection.

Since its reopening in April 2013, the extraordinary collection of the Mathematisch-Physikalischer Salon is presented in four exhibition spaces. When walking through the presentation, one encounters landmarks of humankind's civilization and the history of science. Brace yourself for an exciting expedition into the past where the thirst for knowledge and innovative power still shapes our present. This little book is your informed guide. In the following four chapters – each is dedicated to one gallery – we offer information about the objects and the general themes of the permanent exhibition.

Five key objects in the foyer (ill. 1.10–1.14) will introduce you to and prepare you for the five broad themes (observe –

1.8 View of the Bogengalerie with burning mirrors and telescopes (photographed before 2007).

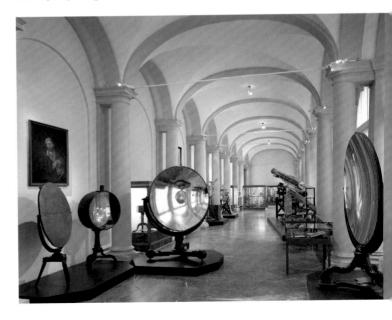

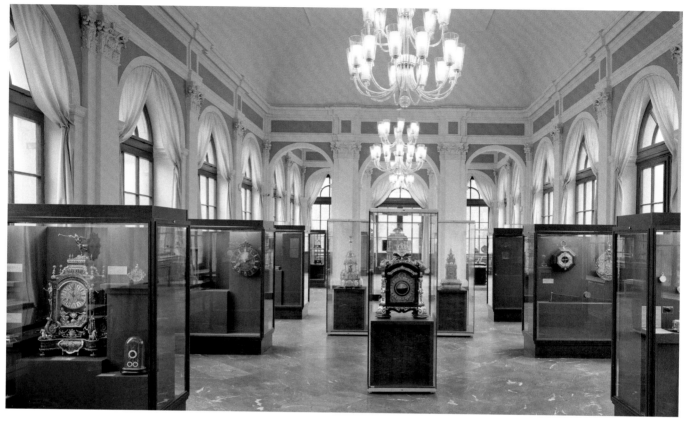

1.9 Festsaal with horological collection (photographed before 2007).

demonstrate – experiment – compare – measure) you will encounter time and again on your tour (ill. 1.15).

When this pavilion was finished in 1716, the foyer was a grotto with fountains and waterworks. A sumptuous ceiling fresco of the sea god Poseidon's wedding to Amphitrite decorated the wooden ceiling, whereas the columns and the arches were covered with colored stucco embellishments. The wall niches contained fountains as well as Balthasar Permoser's (1651–1732) sculptures of Apollo and Minerva. The grotto's end came in 1813 when the water-damaged, brittle wooden ceiling with the fresco was replaced by a groined vault that rested on multiple supports (ill. 1.7). When this space was returned in its original cubature, fragments of the old surface design were discovered

Today, five key objects occupy the wall niches, preparing visitors for their arrival at an institution – the Mathematisch-Physikalischer Salon – whose home this has been for almost 300 years. While it has formed the Zwinger's history for centuries, to this day its purpose is to examine how this world functions.

In order to know how the world functions, it is vital to *observe* meticulously; to this end, magnifying glasses, microscopes, and telescopes may be used. The Reflecting Telescope of Johann Gottlob Rudolph (active in the mid-18th century) is coated with porcelain (ill. 1.10). It was produced on the Heynitz family estate near Meissen. Regarding its artistic and technical standards, it is considered to be one of the outstanding scientific instruments of the 18th cen-

tury. The vignettes show the use of optics for surveying and astronomy.

Astronomic models such as globes, armillary spheres, and astrolabes are very useful in order to explain laws and processes. The Armillary Sphere made by Johannes Möller from Gotha (ill. 1.11) is such an instrument: It enables one to *demonstrate* and to illustrate celestial occurrences. On loan from the Herzogin Anna Amalia Bibliothek in Weimar, the object follows a geocentric conception of the world. This

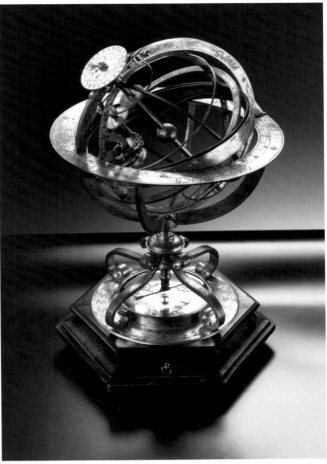

1.10 Gregorian Reflecting Telescope, Johann Gottlob Rudolph, Miltitz, circa 1750, gilded brass, porcelain, steel, maximum height: 50 cm, lens barrel length: 36 cm, inv. no. C I f 8.

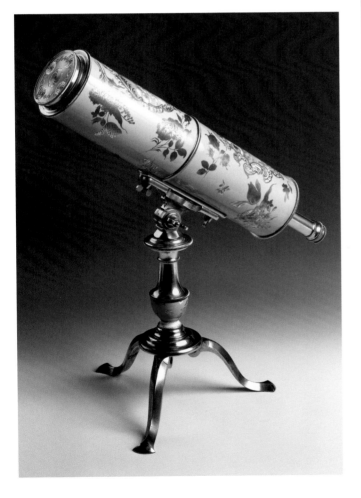

1.11 Armillary Sphere, Johannes Möller, Gotha, 1687, gilded brass, silvered, and engraved, diameter: 16.2 cm, height: 34 cm, on loan from the Herzogin Anna Amalia Bibliothek, Klassik Stiftung Weimar, inv. no. KT 800-13.

explains why the Earth is placed at the center of an armillary sphere and why the Sun – a gilded star – and the Moon – a sickle – are moveable and attached on the ecliptic.

A Vacuum Pump (ill. 1.12) by the Augsburg instrument maker Georg Friedrich Brander (1713–1783) represents instruments that permitted to *experiment* in most impressive ways. Together with electrostatic generators and burning mirrors they constitute backbone of the Physical Cabinet.

The blue Standard Weights (ill. 1.13) from the Friedrichstaler Glashütte belong to a group of instruments that were

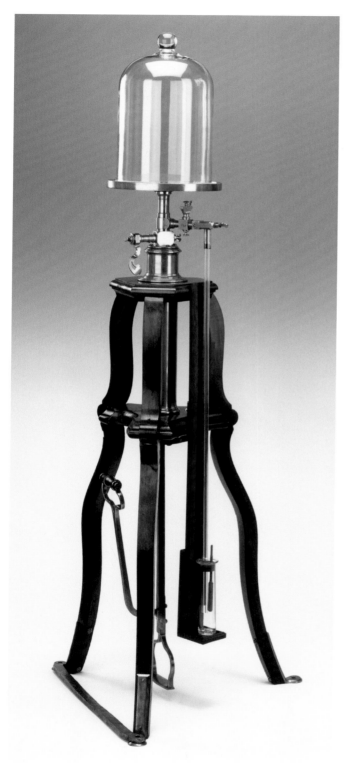

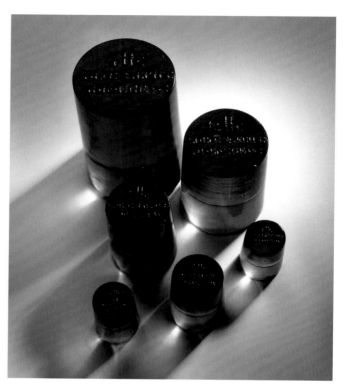

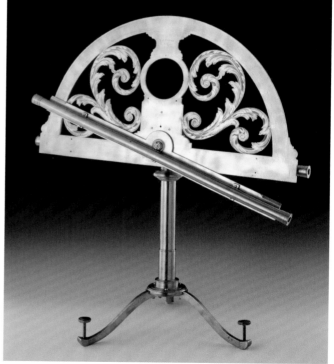

1.12 Vacuum Pump, Georg Friedrich Brander, Augsburg, circa 1760, wood, iron, brass, glass, height without glass cover: 119.6 cm, width: 61.2 cm, depth: 52 cm, inv. no. B II c 3.

1.13 Standard Weights, Friedrichstaler Glashütte, 1815, glass, diameter bottom: 4.55–9 cm, height: 3.95–7.95 cm, inv. no. B I 31.

1.14 Graphometer, Louis Chapotot, Paris, circa 1680, gilded brass, diameter: 65.5 cm, total height: 80.5 cm, inv. no. C III f 10.

used to make *compare* different aspects. Beside scales and weights, longitudinal scales, surface dimensions, and capacity measures also belong to this group. They all helped to standardize trade and were intended to prevent fraud. Index and standard scales were kept in 16th-century Kunstkammers. The former enabled the calibration of scales and weights in trade and marketplaces.

The Graphometer made by Louis Chapotot (active 1670–1700) completes the group of key objects (ill. 1.14); it served to *measure* a territory. As is the case with many instruments in this museum, the angle measurement forms the basis for further findings and tasks. Surveying and representing the Saxon territory is a central theme of the following chapter.

1.15 The new foyer in the former grotto
(photographed in 2013)

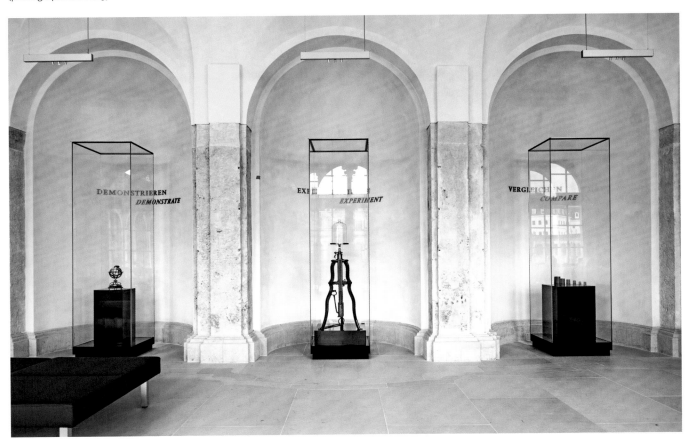

WOLFRAM DOLZ, MICHAEL KOREY, PETER PLASSMEYER

LANGGALERIE
The Cosmos of the Prince – Mechanics und Mathematics under Elector August

The Langgalerie offers abundant insights into the beginnings of scientific instruments collection at the Dresden court. In about 1560 Elector August of Saxony (1526–1586) set up a Kunstkammer in his Dresden Residential Palace, the inventory of which primarily comprised distinguished mathematical instruments, mechanical automata, and sophisticated tools. There are multiple reasons why August collected these objects. On the one hand, the various measuring gadgets mirror the ruler's desire to record, depict, and control his territory, which he surveyed with odometers attached to vehicles while traveling. On the other hand, intricate devices such as the planetary clock were representational status symbols. They were supposed to demonstrate that, thanks to such automata, the elector was capable of accounting for the highly complex movements of the stars and of explaining them. Although subsequent Saxon electors continued to collect instruments, their pursuit was less intense than Elector August's. For instance, they preferred elaborate clocks or figure automata. The instruments originating from the Kunstkammer formed the basis for the collection of the Mathematisch-Physikalischer Salon when it moved to the Zwinger in 1728.

Automata from Dresden's Kunstkammer

Towards the end of the 16th century figure automata capable of performing extraordinarily complex movements counted among the collection's great attractions. They revealed, in

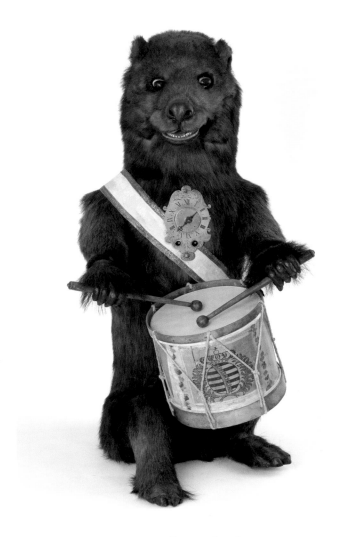

2.1 "Drumming Bear" Automaton, German, circa 1625, wood, fur, iron, brass, height: 98 cm, width: 40 cm, inv. no. D V 11

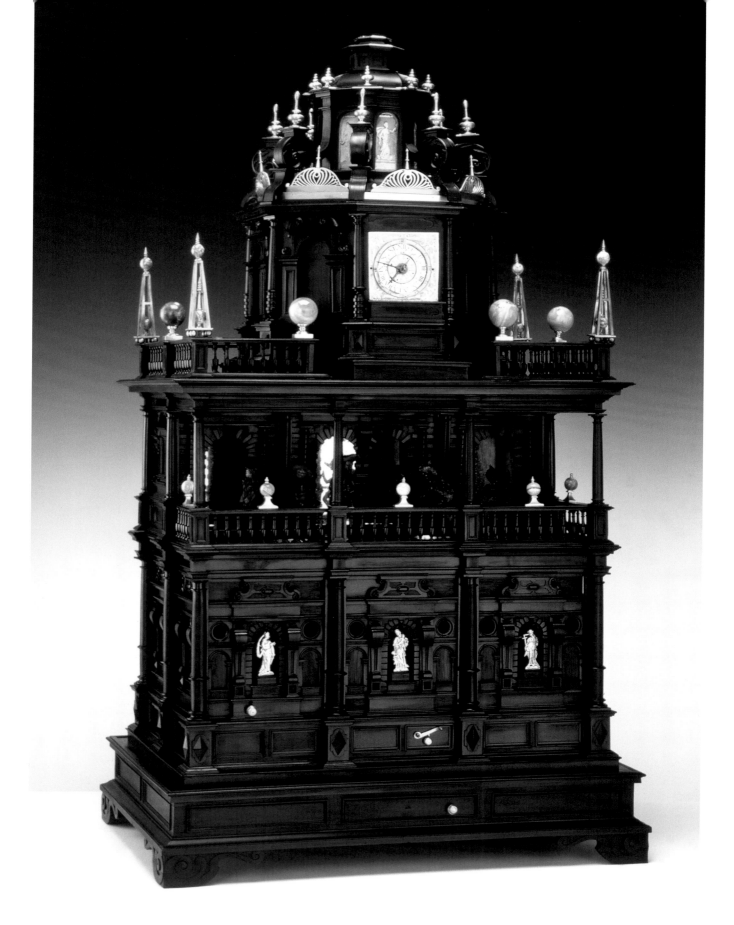

2.3 Automaton "Topsy-Turvy World", probably Hans Schlottheim, Augsburg, circa 1590, gilded brass, iron, ebony, diameter (base): 35 cm, height: 93 cm, inv. no. D V 10

the most entertaining manner, the achievements mechanics could attain.

The drumming bear with real fur comes very close to the ideal of creating an image found in nature. The invention of the mainspring not only facilitated the construction of a compact power source for clocks, but for automata as well.

2.2 Music Automaton, Matthäus Rungel, Augsburg, circa 1625, ebony, oak, agate, silver, brass, iron, leather (bellows), height: 107 cm, width: 69 cm, depth: 41.5 cm, inv. no. D V 9

A movement and a striking mechanism are hidden inside the bear. As long as the movement ticks, he rolls his eyes, which are connected with the balance via a lever system. In addition, the bear serves as an alarm clock: the clock is set by turning the silver disk in the center of the watch dial located on his chest. The bear begins to drum and moves his jaw at the scheduled time. The automaton was a gift of Duke Julius Heinrich of Saxony-Lauenburg (1586–1665) to Elector Johann Georg I (1585–1656). This is one of the last surviving automata from the time around 1600 with real fur in the world (ill. 2.1).

The music automaton in the shape of a cabinet contains two musical instruments in the lower section: an organ and an octave-spinet powered by a pin drum. During the musical presentation, two figure assemblies perform a type of dance – one of the groups is composed of European patricians, the other seemingly indigenous people from Africa. The figures move on a circular path from the terrace into the mirrored dancing hall and back. While advancing, they jump and turn alternately to the left and to the right (ill. 2.2).

In the center of this Christmas pyramid-shaped automaton, a sumptuously clad monkey sits in front of two kettledrums. At the stroke of the hour he accompanies a procession of two hunting groups with his drums. This automaton's theme is the depiction of the "topsy-turvy world": Animals become hunters who become the hunted – a topic repeatedly encountered at the Dresden court (ill. 2.3).

PP

Elector August as Surveyor and Cartographer

Elector August of Saxony actively participated in surveying his territories, making him different from most of his other contemporary rulers. Many of his own sketches and maps from his lands and his travels have survived. He also commissioned innovative mechanical odometers. As a result of his endeavor, he ultimately owned sophisticated instru-

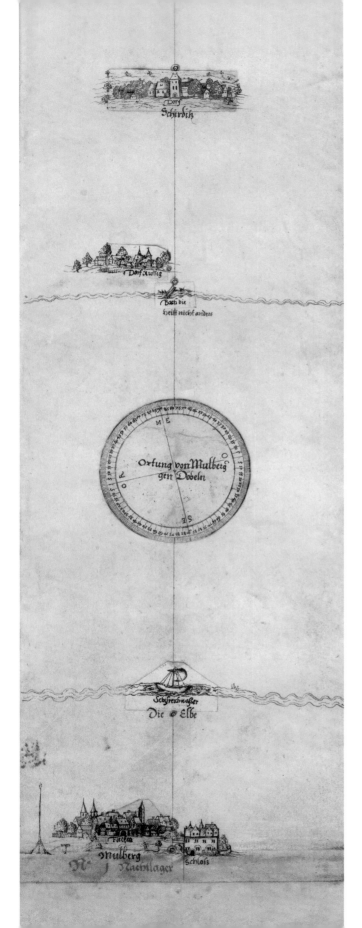

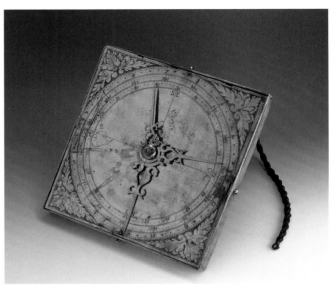

2.5 Odometer, probably Christoph Schissler, Augsburg, circa 1575, brass, steel, length: 14 cm, width: 14 cm, height: 13 cm, inv. no. C III a 1

ments capable of automatically registering distances as well as angles on a strip of paper. In the 1587 Kunstkammer inventory his surveying method is referred to as "vehicle surveying."

After extended travels, August produced so-called route rolls in collaboration with his court painter Friedrich Bercht (died in 1585). In 1575 for example, he traveled from his hunting castle Mühlberg on the Elbe to Regensburg for the imperial diet. It took him 13 days to travel the distance of approximately 54 "Meilen" (circa 365 km). The average travel speed of his carriage was 30 kilometers per day. Divided into individual travel days extending from night camp to night camp, the route roll measures 13.4 meters. The path is depicted as a straight line. All divergent directions are indicated by

2.4 Elector August of Saxony's Itinerary Scroll, Friedrich Bercht, probably Dresden, 1575, pen- and ink drawing and copperplate engravings glued to parchment, length: 1336 cm, width: 10.5 cm (Sächsische Landesbibliothek – Staats- and Universitätsbibliothek Dresden, Msc.Dresd.L.451)

compass roses. Along the way, the elector charted villages and towns, forests, rivers, and fishponds, mills and places of execution. For recurring objects such as towns, villages, or compass roses the respective map symbols were printed as copperplates, cut out, and glued to the appropriate place. Six route rolls of Elector August have survived. They are owned by the Sächsische Landesbibliothek – Staats- und Universitätsbibliothek Dresden (ill. 2.4).

It is highly likely that August used an odometer fabricated by Augsburg instrument maker Christoph Schissler (circa 1531–1608) during his journey from Mühlberg to Regensburg; the device features a maximum measuring range of 15 "Meilen" (circa 100 km; ill. 2.5).

Surviving records produced by the elector during the trip support his use of this particular odometer: In his notes pertaining to the distances covered as well as regarding the instrument, one "Meile" is the exact equivalent to 1,500 "Ruten." Unlike the "Rute" (4.295 meters), the "Meile" had not yet been standardized: Whereas this instrument takes 1,500 "Ruten" for one "Meile," according to the odometer which Christoph Trechsler t. E. (circa 1546–1624) produced at a later point, it is 2,000 "Ruten." This odometer's switching mechanism is mounted orthogonally to dial and gearing, enabling

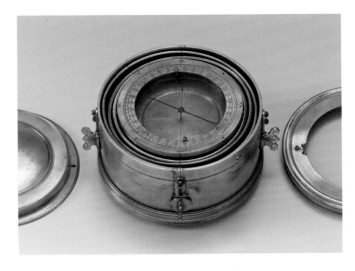

2.7 Marine Compass, probably Denmark, circa 1560, gilded and silvered brass, diameter: 12 cm, height: 9.8 cm, inv. no. C VI 2

a convenient reading of the distances on the horizontally mounted face in the carriage (ill. 2.6).

The conformity between the compass roses on Elector August's route rolls and the wind rose – divided into four quadrants (A, B, C, and D) representing 90 degrees each – with the marine compass exhibited here suggests that this instrument was used during the recording of the above-mentioned route in 1575. The compass already sports a cardan suspension. It is characterized by three mutually moveable rings; they ensure that the compass bowl affixed to them will always be horizontally aligned, enabling measurements even with the carriage in a tilted position. A plummet on the bottom of the compass ascertains a quick stabilization. This is one of the oldest compasses constructed in this way (ill. 2.7).

The last and at the same time the most sumptuous of an original set of twelve odometers owned by the elector was made in 1584 by Christoph Trechsler in Dresden. Here, one of August's dreams came true: He desired a complex instrument that would be capable of registering directions as well as long distances. Unfortunately, the elements necessary for automatic recordings have been missing since World War II.

2.6 Carriage with Odometer (in: Paul Pfinzing, Methodus Geometrica, Nuremberg, 1598)

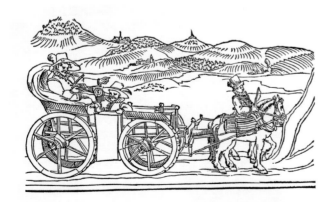

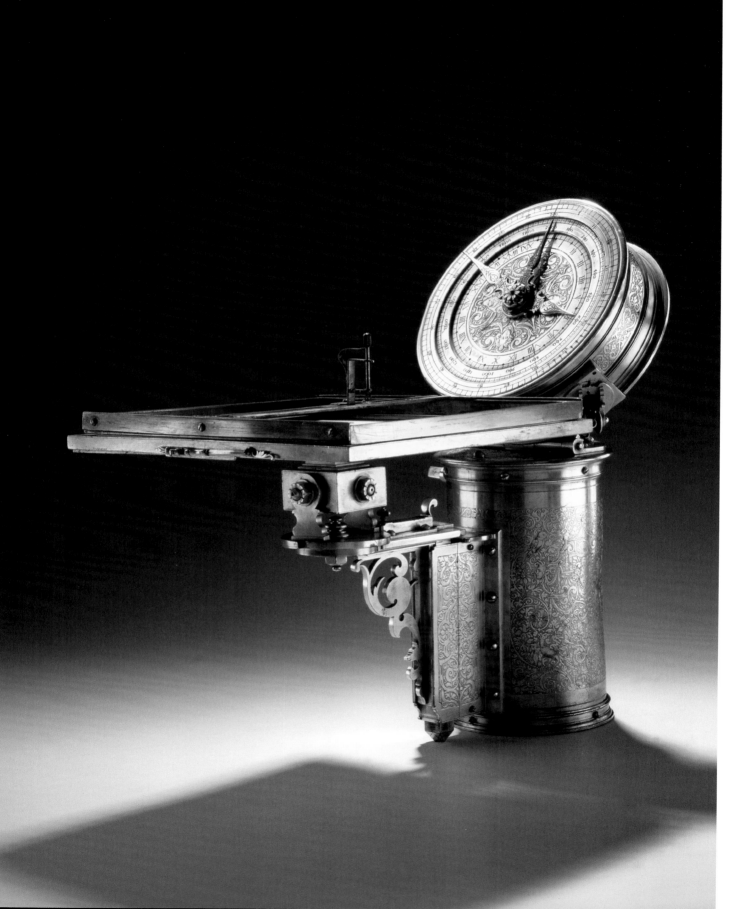

In 1569 the Augsburg instrument maker Christoph Schissler produced an unusual measuring square for Elector August. Schissler referred to it as "Quadratum Geometricum." The reliefs on the side illustrate its application. It compares similar triangles, making it possible to determine the height of a tower or the width of a river without directly measuring the object. The central panels of both sides of this refined instrument permitted the princely user to read off the result directly without having to do the calculation first. The instrument was severely damaged during World War II; as a result, the alhidade is missing. The tripod with the figure of a Turk mounted on its top was destroyed (ill. 2.9a, b, c, 2.10).

2.9a Geometric Square (Quadratum Geometricum), front, Christoph Schissler, Augsburg, 1569 (damaged in 1945), brass, originally gilded, length: 37.5 cm, width: 37.5 cm, inv. no. C I 1

The operating mode for the two odometers exhibited here consists of counting the wheel revolution with the aid of a switch mechanism. The number of revolutions of the wheel multiplied by the wheel circumference equal the distance traveled. A gear unit enables the direct reading of the "Ruten" and "Meilen" traveled. The maximum measuring range of Trechsler's odometer is 20 "Meilen" (circa 180 km). A pair of compasses and a reduction scale also belong to this object. With the aid of the latter the recorded distance could be transferred to the paper using the correct scale (ill. 2.8).

2.8 Odometer, Christoph Trechsler t. E., Dresden, 1584, gilded brass, engraved, punched, iron, height: 42 cm, diameter (clock face) 17 cm, inv. no. C III a 4

2.9b Geometric Square (Quadratum Geometricum), back, inv. no. C I 1

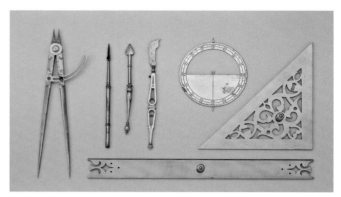

2.11 Drafting Instruments, Germany, circa 1575, gilded brass, steel, inv. no. A I 4, A I 22, A I 20, A I 27, A I 29, A I 36, A I 67 (left to right)

2.12 Drafting Compass, probably Dresden, circa 1580, gilded brass, diameter: 15 cm, length (ruler): 16.5 cm, inv. no. C III c 17

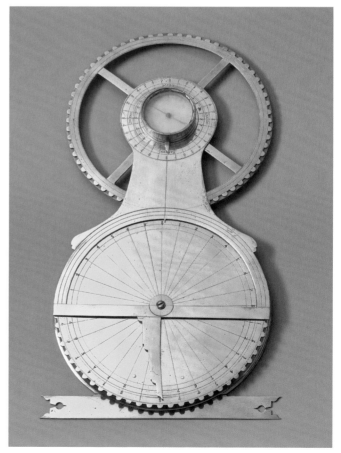

2.9c Geometric square (Quadratum Geometricum), Christoph Schissler, Augsburg, 1569 (damaged in 1945), inv. no. C I 1 (photographed before 1945)

2.10 Drawing from the manual for Quadratum Geometricum by Christoph Schissler (destroyed in 1945)

2.13 Drafting Compass, Erasmus Habermel, Prague, circa 1600, gilded brass, diameter: 21 cm, inv. no. C III d 1 (acquired in 1911)

After measuring the covered distance and recording the angles in the terrain, numerous tools were required to draw a map that was based on the measurements. To this end, the elector utilized a variety of precisely manufactured drawing instruments. Since ancient times, a ruler and a pair of compasses are considered critical drawing devices. The first Dresden Kunstkammer inventory of 1587 lists more than 400 drawing instruments, among them 218 pairs of compasses, 37 rulers, 19 T-squares, 50 scales, 18 triangles, 37 set squares, 11 protractors, and 17 folding rulers. Originally kept in the specially furnished "Reißgemach" in the Dresden Residential Palace's Kunstkammer, the elector himself used them. Of this compendium approximately three dozen pieces have survived (ill. 2.11).

In order to transfer the angle onto a sheet, a special instrument was developed – the so-called Auftragsbussole. "Bussola" is the Italian term for compass; the literal translation is "socket." In this case, "auftragen" signifies "to draw on paper." An Auftragsbussole is thus a compass showing the angles; additionally it serves to draw the already measured angles. The Auftragsbussole shown here consists of a compass and a rotatable ruler. The angle recorded when measuring in terrain is adjusted on the upper scale ring. When turning the pointer over the scale, the upper gearwheel turns simultaneously. This, in turn, drives the lower gearwheel, moving the ruler connected to it. Finally, the ruler draws the line indicating the direction (ill. 2.12).

Likely produced by Erasmus Habermehl (approx. 1538–1606) around 1600, the Mathematisch-Physikalischer Salon only purchased the Auftragsbussole in 1911: It did not belong to the inventory of the princely Kunstkammer. This is certainly one of the masterpieces of Early Modern tool making. The compass plate bears the coat-of-arms of the Italian medical doctor Franciscus de Paduanis (around 1600, the emperor's personal physician in Prague). The letters "EH" – the maker's initials – are inscribed into the rose hill of the coat-of-arms. The compass rose is subdivided into 32 cardinal points. A hare hunt is depicted on the ruler (ill. 2.13).

WD

Early Modern Surveying Methods

To survey a territory means measuring distances and angles. In the simplest case, distances are paced off. More precise results are achieved when using a measuring chain or an odometer. Changes in direction – as they inevitably occur in bends or border lines – were measured with a compass (bussole). The fixed direction "magnetic north" served as orientation point, from whence the angle to the target point was determined. The technical term for this principle is compass traverse (ill. 2.14).

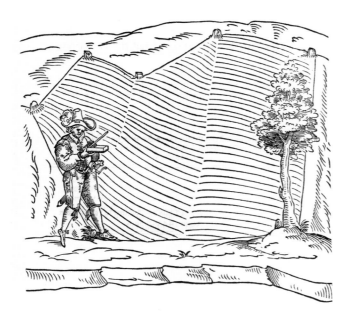

2.14 Surveyor (in: Paul Pfinzing, Methodus Geometrica, Nuremberg 1598)

In 1631 Mattheus Heintz from Zwickau fabricated a compass with diopter capable of particularly precise angle measurements. To this end, Heintz constructed a mechanical fine tuning device consisting of a micrometer screw with micrometer drum that is subdivided into 60 sections. This construction facilitates the reading of up to 1/60 degree, i.e. precise to within one angle minute. The engravings on the 360°-division – placed on the ground plate and arranged in one-degree increments as well as inlaid in ivory on the compass rose –are fascinatingly meticulous. (ill. 2.15).

In 1533 Gemma Frisius, active in the Flemish town of Louvain, delivered the first scientific description of a new surveying method entitled triangulation. Intended for extensive areas, it divides the entire region into a network of triangles. If one measures all the angles in the triangles, it is possible to calculate the length of all distances in the network by virtue of simply measuring the distance between two points in a triangle. Developed later, the theodolite was really the most suitable aid for measuring angles. This universal angle measuring tool permits the determination of horizontal (orientation) angles plus vertical (elevation) angles from one single standpoint. For this, a vertical circle was mounted on top of a horizontal one.

However, the theodolite Victor Starck built in Dresden in 1633 was not intended to be used in open terrain: It served representational purposes. Functions of the device not required for angle measuring support this suggestion, among them, a vertical and a horizontal sundial with calendar data that is only an accessory. Furthermore, Starck equipped the instrument's horizontal and vertical circles with an exact angular division with transversal subdivisions, making possible a reading precision of up to 1/10 degree. Another special feature Starck added was a so-called needle level (with encapsulated needle gauges) instead of a regular pendulum (ill. 2.16).

WD

2.15 Compass with diopter, Mattheus Heintz, Zwickau, 1631, gilded brass, ivory, length: 13.4 cm, width: 10.7 cm, height: 6.8 cm, diameter (compass): 10.7 cm, inv. no. C III d 8

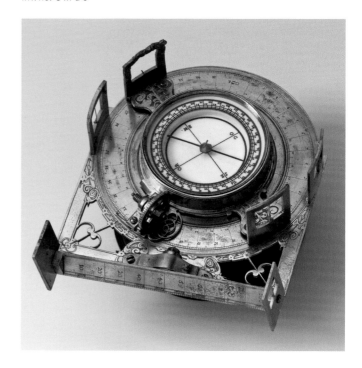

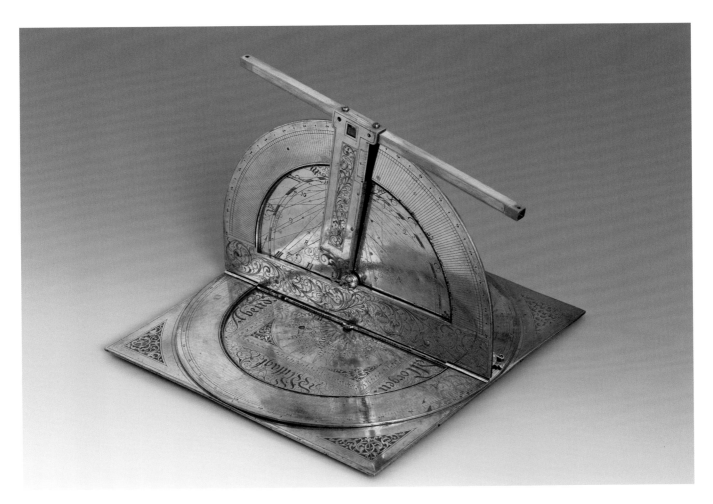

2.16 Theodolite, Victor Starck, Dresden, 1633, gilded brass, engraved, length: 21.7 cm, width: 21.7 cm, height: 15.7 cm, inv. no. C III f 7

Surveying Instruments for Mining

The discovery of vast quantities of silver deposits in the Erzgebirge mountains in 1168 and 1470 established the wealth of the duchy of Saxony. A precondition for bringing the treasure to the surface was a highly developed mining industry as well as surveying techniques. Beginning in the 16th century the surveyors below ground were referred to as "Markscheider" or "Schiner." The word originates from two German terms: "border" and "separate." Originally,

the "Markscheider" was responsible for surveying the border between adjacent mines. Their typical instruments for angle measurements were the compass and the so-called "Schinzeug," the miner's compass. The latter was developed specifically for poor visibility underground; here, a cord replaced the visual line of sight. This surveying method is called "Ziehmarkscheidekunst": implying that cords were put up between point of origin and target point in the pit.

The miner's compass served to determine the course of the mining tunnels. A hand with a hook was placed on the

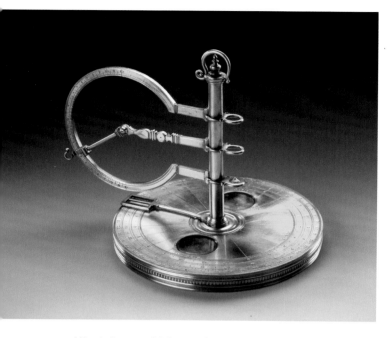

2.17 Miner's Compass ("Schinzeug"), probably Augsburg, circa 1585, gilded brass, diameter: 15 cm, height: 15 cm, inv. no. C III c 6a

2.18 Mining Compass, German, 1561, gilded brass, silvered, diameter: 17.6 cm, height: 3.5 cm, inv. no. C IV 2

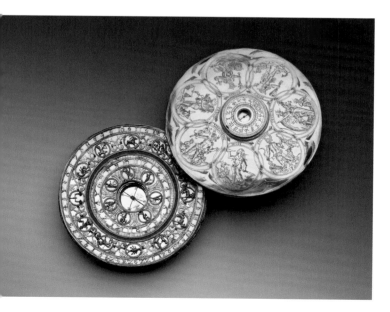

gadget's vertical circle. A chord was mounted to the hook and was connected to a second gadget with a hook. Depending on the course the cord took, it was possible to determine the angle by reading the hands of the vertical or the horizontal circle. Unlike our present custom of 360 angular degrees, the circles were divided into 24 hours. The late-16th-century miner's compass exhibited in the Salon has two compasses on its base plate (ill. 2.17).

The silvered and gilded mining compass with electoral Saxon coat-of-arms on the inside of the lid belongs to the representational mining instruments in Elector August's collection. It reveals the typically Saxon angle division into 24 hours. The depiction of the planets and the zodiac signs mirror the teachings of alchemy. According to alchemy, metals developed from the four elements through impact emanating from planetary rays. Each planet is assigned a metal as well as the astrological house with its respective symbol, for example sun = gold (GOLT) = lion (Ω) (ill. 2.18).

WD

Sundials

Sundials are among the oldest scientific instruments. They have been known since antiquity. One only needs to stick a simple rod into the ground for it to cast a shadow on a sunny day. The shadow's direction changes synchronously with the Sun's apparent movement around the Earth as in the northern hemisphere it wanders from east to west. The length of the shadow also changes corresponding to the seasons and therefore depends on whether the Sun's position is high or low. Thus, the shadow of a sundial can provide information about the current calendar date and especially the time of day. Displaying the time became one of the central functions of sundials. Initially installed on house facades and in gardens, they began entering Kunstkammers as virtuosic showpieces during the 16th century.

The system of lines on sundials from around 1600 reveal something astonishing: Time was not always counted begin-

ning at midnight (1 × 24 or 2 × 12 hours); instead, there were regional differences. We even come upon variants where the counting of 24 hours begins with sunrise ("Babylonian hours") or with sunset ("Italian" or "Bohemian hours") – to cite only the most frequently encountered types.

Made in early-16th-century Nuremberg, this astronomic compendium (a.k.a. universal compendium) is one of the oldest exhibits in the Dresden Kunstkammer. The square instrument combines a quadrant with diverse other functions. A nocturnal, located on the outside of the lid, enables one to determine the time, while a vertical sundial is placed inside. The upper portion of the opened box contains a compass – which enables the user to orient the sundial toward the north – and a horizontal sundial. The underside shows a sun quadrant (ill. 2.19).

We know from antiquity that clocks were used to display the solar run; to this end, a hollow sphere was used, intended as a recreation of the celestial sphere. Such sundials are referred to as scaphe (ill. 2.20). The inside of the semi-sphere of this particularly impressive gilded example shows five systems lines. They make it possible to read the Sun's position within the zodiac (horizontal lines), civic hours (vertical lines and designations 4–12 and 1–8), the Babylonian hours (diagonally ascending line and line numbered 1–16), and the Italian hours beginning with the sunset (diagonally descending line and line numbered 8–14). The fifth set of lines is irregular and unnumbered. These lines represent the temporal hours, i.e. the twelve equal segments into which day and night are subdivided. During the course of the year, the length of day and night hours varies: In the summer half-year, the twelve day hours are longer than the twelve night hours; in the winter half-year, it is the other way around. They are only equally long at equinox, at the beginning of spring and fall.

Originally, this scaphe was orientated to the north with a now-lost compass, and the shadow of a ball located in the center of a concavity indicated the time. The line system is calculated for a geographic latitude of 51° (north), thereby corresponding with Dresden's position.

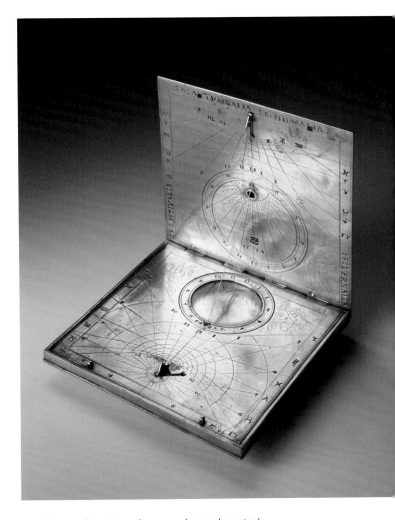

2.19 Compendium, Nuremberg, 1514, brass, glass, steel, height opened: 10.3 cm, height closed: 0.8 cm, width: 9.3 cm, depth: 9.3 cm, inv. no. D I 65

Christoph Schissler from Augsburg was likely the most famous instrument maker of his time. Elector August repeatedly procured objects from him. At the time, it was essential for any courtly collection to own Schissler's palm-sized astronomical compendium. Each item was unique, differing from each other in only minute details. Schissler inscribed his signature and the year 1558 on the rim of the exhibited box. Lid and base plate can be opened, and every plane that becomes visible reveals more information. Whereas, on the

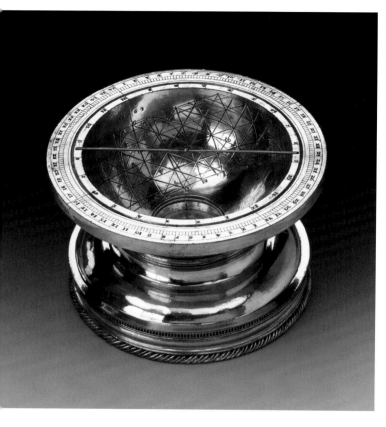

2.20 Hemispherical Sundial (Scaphe), German, 1561,
gilded brass, diameter: 14.6 cm, height: 9.7 cm,
inv. no. D I 12

Schissler's divider is also an instrument with multiple applications. It only takes a few movements to turn it into a sundial, a scale for diverse linear measures (e.g. the so-called Augsburg Werkschuh, Gallic and Roman foot) or, if suspended from the hook at the end of its handles, it can be made into a leveling tool, capable of measuring differences in altitude (ill. 2.22).

Schissler kept producing new and altered versions of his instruments. Today, especially his hexagonal and octagonal astronomical compendia can be encountered in many collections. Another exquisite example of his inventiveness is the horizontal sundial with the striking figure of a Turk. In its hands, the figure holds the gnomon (in the form of a cord) whose shadow provides information displayed in the numerous line systems. The lines intersecting in the nadir represent the civic hours. The parallel lines show the different duration of temporal hours and may also be called

2.21 Compendium, Christoph Schissler, Augsburg, 1558,
gilded brass, diameter: 8.5 cm, height: 1.5 cm,
inv. no. D I 13

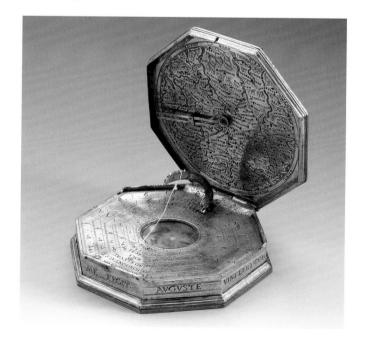

top of the lid, we see a map of the Earth with the North Pole at center, the underside sports a map of Germany. On the top of the box, a horizontal sundial is mounted, indicating the polar altitudes 42°, 45°, 48°, 51°, and 54°; and a concentric compass is set there as well. The underside lists the geographical latitude for 49 towns. The inside of the bottom contains a lunar clock with the aspects of the Moon as well as indications for sunrise, sunset, and length of day and night. The underside of the bottom is a nocturnal.

What is particularly striking today is the high copper content of the box's surface. This is due to the extremely high temperatures this instrument was exposed to during the bombardments of Dresden in February 1945 (ill. 2.21).

2.22 Multipurpose Dividers, Christoph Schissler, Augsburg, 1566, gilded and engraved brass, length (side): 15.4 cm, inv. no. D I 58

missioned the gunsmith to construct scientific instruments, thereby laying the foundation for Saxony's independence from the Nuremberg and Augsburg workshops. Trechsler also made an attempt at sundials. The special feature in his horizontal sundial is that a heavy plumb line is kept under the clock face. Thanks to a type of cardan suspension in the base, the plumb line is aligned vertically, thus assuring that the clock face is always horizontal. The clock face displays the hours in Roman numerals (IIII to XII and I to VIII), leaving out the nighttime hours. A little compass is mounted in their place. A silvered shadow caster can be set to the respective geometric breadth. This sundial is clearly a Kunstkammer object rather than a tool, evidenced by the fact that it was hardly intended to be transported. It was impossible to use the object as a clock in the Kunstkammer, simply because the Sun was absent there – unless the sundial could have been moved near a window (ill. 2.24).

planetary hours. These hours divide day and night – the latter separated from one another – into twelve equal sections. This explains why on the northern hemisphere a daytime hour is longer in summer than a nighttime hour and why it is the exact opposite in winter. Further lines on the horizontal plane offer information pertaining to the length of day and night, sunrise, sunset, the Sun's position within the zodiac, and the date. There is a disc on either side of the figure, one of which shows which planet rules at which hour of the day; the other may be attuned to the phase of the Moon. Thanks to the gnomon's shadow, cast by the Moon, the clock can actually be used as a clock during the night at full Moon. (ill. 2.23).

The most famous Dresden instrument maker in the late 16th century was Christoph Trechsler t. E. Elector August com-

2.23 Horizontal Sundial, Christoph Schissler, Augsburg, 1562, brass, width: 21.5 cm, depth: 19 cm, figure height: 11.5 cm, inv. no. D I 37

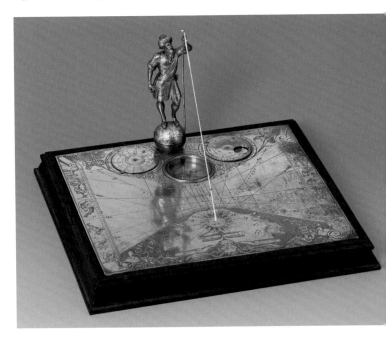

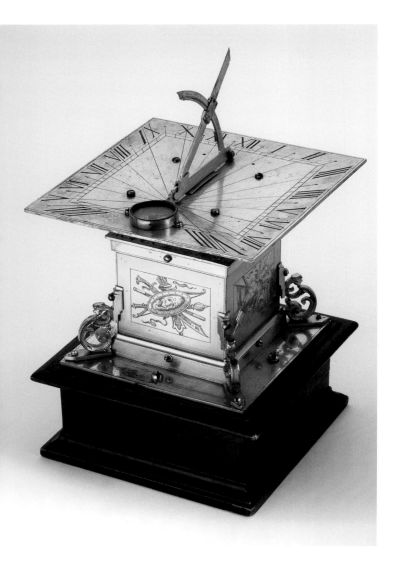

2.24 Horizontal Sundial, Christoph Trechsler t. E.,
Dresden, 1611, brass, wood, length: 11.3 cm, width: 11.3 cm,
height: 18.5 cm, inv. no. D I 52

Astronomers discovered early on that the time could be determined through the aid of the nocturnal starry sky. One of the most popular constellations, the Great Bear, a.k.a. Big Dipper, needs close to 24 hours to revolve once around the North Star. In order to take advantage of this regular movement for the determination of the time, special nocturnals were developed. An illustration of Peter Apian (1495–1552;

ill. 2.25) shows how they work: Equipped with a handle and a clock face, the North Star is revealed through a hole in the central disk. A kind of hand is turned until it touches the two rear stars of the Big Dipper. In doing so, the two stars form a line that continues all the way to the North Star. At the point where they intersect with the clock face, special (tactile) knobs make it possible to feel the time – given that there is sufficient light, the time may of course also be read. Embellished with virtuosic engravings, Erasmus Habermehl's silvered disk is a wonderful example of a nocturnal (ill. 2.26).

PP

2.25 Illustration of a Nocturnal (in: Peter Apian, Cosmographia, Landshut 1524)

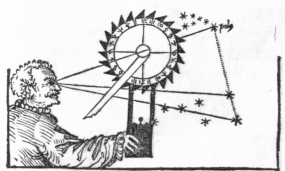

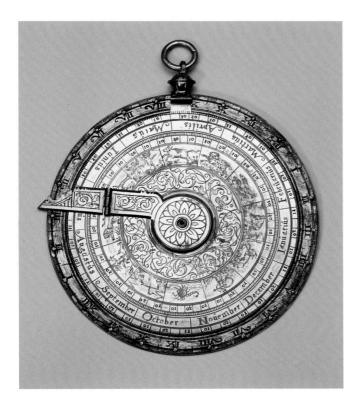

2.26 Nocturnal, Erasmus Habermehl, Prague, circa 1600,
silvered and gilded brass, diameter: 11.1 cm, inv. no. D I 1

Innovative Mathematical Instruments around 1600

During the 15th and 16th centuries mathematical practice began to extend into new areas. Perspectival drawing, fortification design, and production of cannons were added to traditional disciplines like astronomy, surveying, and constructing sundials. Instruments intended for all these applications were incorporated into the Dresden Kunstkammer, as were novel encryption devices and calculating devices. A selection of them will be introduced and described in the following text.

Invented around 1600, the proportional divider (ill. 2.27) remained one of the most-frequently used and most-flexible mathematical instruments for two centuries. It facilitated numerical calculation as well as the determination of exchange rates, planning of fortifications, specifications for the correct length of organ pipes, and much more. The sector could be put to such a wide range of different uses that

2.27 Sector, probably Dresden, circa 1640, gilded brass,
side length: 33.9 cm, side width: 8.0 cm, height: 0.9 cm,
inv. no. A I 44

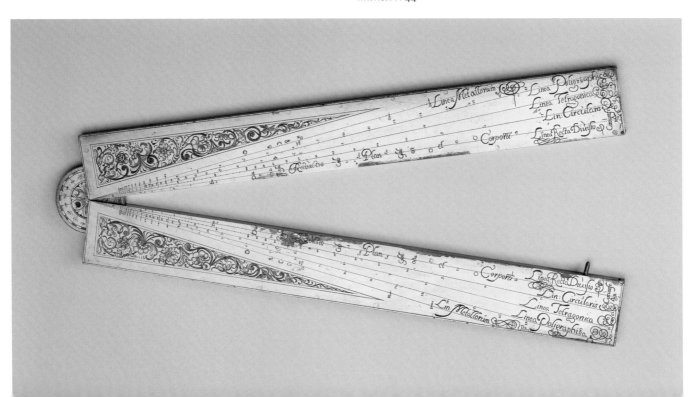

the Italian scholar Galileo Galilei (1564–1642) praised it as the "royal road" to math – sought after since antiquity. He went on to state that it enabled one to learn in just a few days what otherwise would have required long and arduous studies.

The principle of how this instrument works is based on the side ratio of similar triangles in order to solve diverse arithmetic tasks. A simple divider is always used as well, in order to identify the sector's spreading and to read the result on its scales.

In the middle of the 16th century the German territories were not considered especially sophisticated when it came to encoding messages or deciphering the news of others. The Vatican's encoding secretary even suggested that the Germans and their neighbors understood so little about codes that they preferred to burn or tear up their encoded mail rather than to attempt to decipher it. In retrospect, this evaluation appears somewhat inaccurate, especially considering the following two objects from the electoral Saxon Kunstkammer.

The first exhibit, an unusual looking compass, is presumably unique. Its right handle is firmly mounted, whereas the left can be moved laterally thanks to a slit. When the nut fixed to the middle of the silver disk is turned, the disk turns (the image shows it at the top adjusted to "F"), and the distance between tips changes. Each letter in the alphabet corresponds to a specific distance. Hence it would be possible to create a message using this cryptological divider: letter by letter as a series of bars with the respective corresponding lengths. Even more refined would be a sequence of unobtrusive, appropriately placed sights. An identical compass is required in order for the recipient to decipher the message (ill. 2.28).

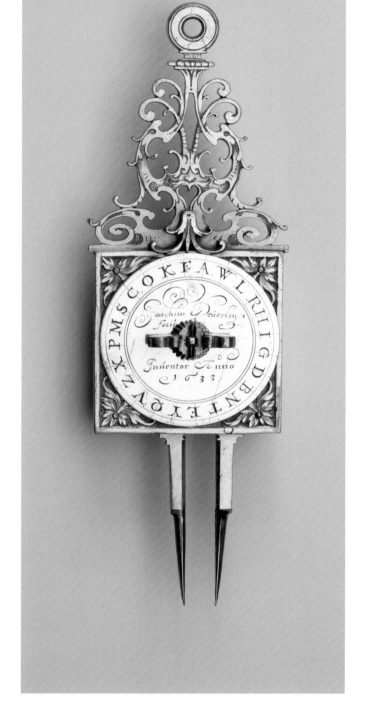

2.28 Cryptological Divider, Joachim Deuerlin, Dresden, 1633, gilded brass, silver, steel, length: 14.5 cm, width: 4.4 cm, inv. no. A I 10

2.29 Encryption Device, probably Dresden, before 1587,
brass, original gilded, diameter: 27.8 cm, inv. no. A I 159

This is, however, not a safe procedure since each letter corresponds exactly to bar lengths or the distance of holes, enabling one to match the marks. Accordingly, it would be relatively easy for a third party to hack the code.

The second device is one of the oldest surviving examples of a subtler system. With the help of its original 24 rings the letters in a message can be moved within the alphabet – for example the first letter by one position, the second by two etc. Using the coded succession of letters turns the word SALON into TCOSS. This turns two different letters from the original text – O and N – into the same letter S. Repeated, identical letters of the urtext are cited as different letters in the encoded form. An encoded message using this system is ultimately very challenging to decipher. Recorded in 19th-century collection inventories as a permutation machine, this object was severely damaged in 1945 during the Dresden bombardment (ill. 2.29).

MK

About Notch and Bead Sight – Gunner's Levels

If you want to hit a target with a cannon, certain requirements must be met: First, the gun must be aimed at the target. This happens by sighting the barrel (side leveling) at the goal. The simplest devices for aiming are marks on the highest points

of breech and muzzle, colloquially termed notch and bead sight. Secondly, the barrel must be at the appropriate height (height leveling), because we know from experience that the shooting range depends on the inclination angle of the gun barrel. In the 16th century, however, this interdependency was not yet completely clear. Special attachments were developed for both of the alignment procedures cited above. These instruments underscore the enormous inventiveness as well as the immense knowledge of artillery that the Saxon instrument makers had. Most of the cannon attachments in Dresden's Kunstkammer were primarily prototypes and presumably never used on the field. Instead, they were representational. We know for a fact that Elector August gave some of these instruments as presents to the emperor and to other princes he befriended. It can be assumed that he intended them to signal his military strength, as these items enabled him to demonstrate that he owned the newest and best military instruments available at the time.

2.30 Diagram of Shot Trajectories, Paul Puchner, Dresden, 1577, colored drawing, pen, brush, height: 30 cm, width: 40 cm, inv. no. G I 73

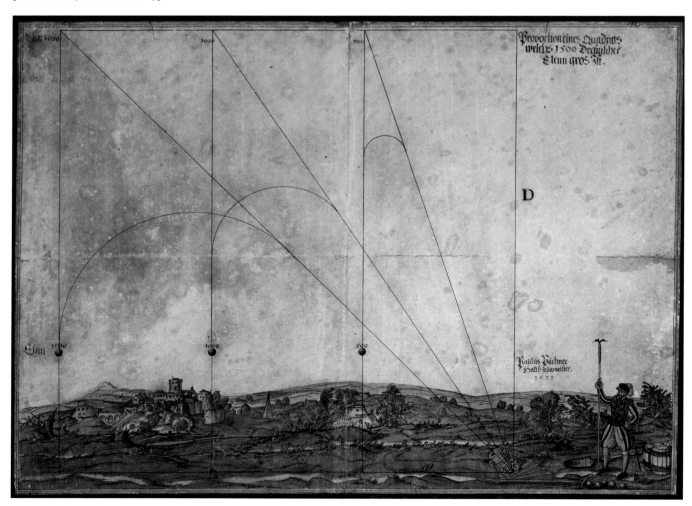

The Italian mathematician Niccolò Tartaglia's (1499–1557) theory formed the basis for electoral Saxon Oberstland- and Hauszeugmeister (master armorer) Paul Puchner's (1531–1607) drawing from 1577: within the orbit of a mortar ball, Puchner drew three right-angled triangles inside a square. The largest triangle's hypotenuse is the same length as the diagonal of the square. For a maximum shooting range of 1,500 ells Puchner presupposed a barrel inclina-tion of 45°. In order to depict shorter ranges such as 500 or 1,000 ells, he divided the square into rectangles of corre-sponding breadth and recommended a line of fire along the hypotenuse of the respective rectangle. The drawing's lower right corner appears to be the oldest depiction of a Saxon artillerist in uniform – equipped with linstock and sword (ill. 2.30).

Puchner's drawing can also be seen as an instruction for the gunner's quadrant that Christoph Trechsler t. E. pro-duced. What is special about it is that it fulfills two functions: The front – with the instruction "ZUM GEOMETRISCHEN ABMESSEN" (for geometric measure) – serves to determine the distance. For this, the goal is initially targeted using the diopter on the upper rim of the instrument; thereafter, the amplitude of the plumb bob over the ratio scale – revealing a maximum value of 2,000 – is noted. The back contains the leveling scale "EIN MORSER GEOMETRISCHER WEISE ZU RICHTEN" (a mortar for geometric leveling). This scale cor-responds exactly to the distances quoted in the drawing in ells of 500, 1,000, and 1,500. Once mounted on top of the muzzle, the mortar is tilted until the range (in relation to the maximum distance) is displayed on the pendulum. At the same time, the scale figures must, for instance, be multiplied by the factor 100. The spandrel bears the electoral Saxon coat-of-arms. The engraved initials "HA" (Herzog August) and "KM" (Kurfürst, Markgraf) stand for Elector August, simultaneously elector of Saxony and margrave of Meissen (ill. 2.31).

Whereas the big gunner's quadrant was mounted on the muzzle of a mortar (high-angle gun), the small gunner's

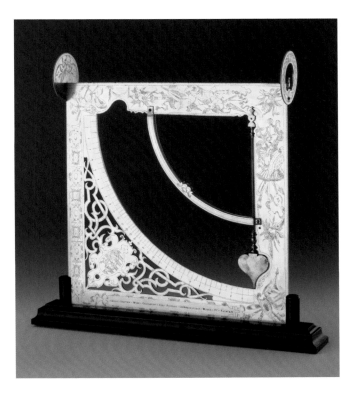

2.31 Gunner's Quadrant, Christoph Trechsler t. E., Dresden, 1572, gilded brass, punched, iron, height: 36 cm, width: 31.7 cm, inv. no. C V 9

sextants – made by Christoph Trechsler and his son of the same name – were inserted into the gun barrel of a can-non (flat-fire gun). Paul Puchner also recorded this in his 1577 drawing with the depiction of the barrel with gunner's level and bullet (ill. 2.32).

Christoph Trechsler t. E. produced a gunner's level in 1614 that offered the possibility of adjusting it to different calibers. To this end, interchangeable disks were fastened to the mounting bolt. To aim, an additional gunner's gauge with a square cross section could be inserted vertically into the gun attachment to align with the direction of fire. A tuning hand on the upper tip of the miner's level made a mark in a wax groove that had an angle scale engraved below, thereby recording the shot's elevation angle. This permitted succes-sive shots at the target without needing to take a note of

2.32 Illustration of a Cannon Muzzle with Gunner's
Level and Cannon Ball, Paul Puchner, Dresden 1577,
colored drawing, brush, height: 47.8 cm, width: 138.4 cm,
inv. no. G I 74

the angles for every new shot. A cross spindle was used to calibrate the lateral direction. Attached on the outside, the volute, along with numerous engravings and artillery motifs, reveals that this gunner's level served representational purposes (ill. 2.33).

Christoph Trechsler t. Y. improved his father's instrument in 1623: He combined two jaws – a spindle assured free movement – with the gunner's quadrant, making it possible to use the device for any caliber. The cumbersome switching of prefabricated disks could be omitted. Two caliber scales for iron bullets were applied to the transversally placed spindle frame, making it possible to decipher the caliber on the instrument's barrel (ill. 2.34).

Gunner's levels with sights belong to the simplest type of gunner's levels. They were employed for use with flat-fire guns. To do so, a moveable sight was placed into a guiding frame with an inch scale. This served to adjust the gun bar-

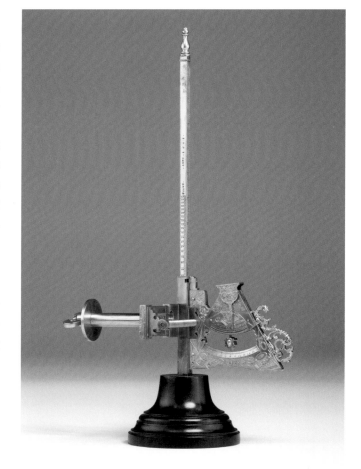

2.33 Gunner's Level, Christoph Trechsler t. E., Dresden,
1614, gilded and engraved brass, punched, width: 9.6 cm,
height: 22.8 cm, inv. no. C V 45

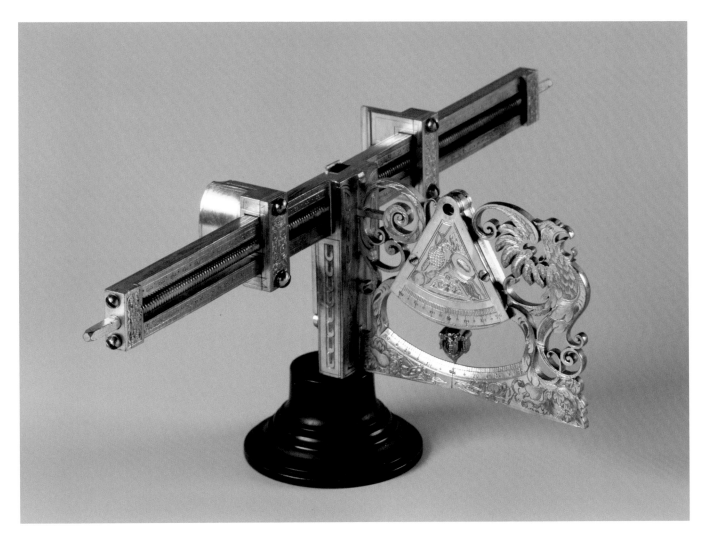

2.34 Gunner's Level, Christoph Trechsler t. Y., Dresden,
1623, gilded and engraved brass, punched, length:
33.4 cm, width: 12.5 cm, height: 8.5 cm, inv. no. C V 40

rel's inclination. Initially, an empirical scale figure for the re-spective shooting range was derived from a shooting chart. The scales were customarily quoted in Nuremberg inches. Then, the sight was adjusted to the value derived from the chart in the guiding frame. When adjusting the gun, the bar-rel needed to be raised until the visor line moved through the hole of the aperture sight over the muzzle's highest point to the target (ill. 2.35).

Combination- or universal leveling devices combine gun-ner's levels with sight, and gunner's quadrant in one instru-ment. Usually the quadrant is laterally attached at the sight's frame. This is also the case in Christoph Schissler's gunner's level, dated 1567. Here, the sight is moved up and down with the aid of a vertical spindle. A convex ground plate makes it easier to mount the device on top of the cannon (ill. 2.36).

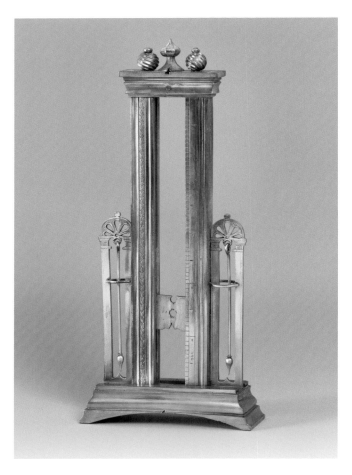

2.35 Gunner's Level and Sight, German, circa 1560, gilded and engraved brass, punched, height: 17.8 cm, width: 7.9 cm, inv. no. C V 34

In Victor Starck's elaborately designed gunner's level the central element – the frame with the moveable sight – is dominated by numerous functional parts and thus almost invisible: At the bottom, it is covered by a gunner's quadrant, on the top by an elevation indicator with sighting tube. Instead of a pendulum, Starck used a needle level. The latter is made up of two small glass tubes with two encapsulated needle levels. A compass appears on the top, whereas a window to read distance or inclination was placed at the bottom. As in the gunner's quadrant of Christoph Trechsler t. E. (cf. p. 39, ill. 2.31) here, too, distances can

be read. In contrast to the latter, the angle scale from 0 to 45 (degrees) is positioned directly above the distance scale from 0 to 1,500 (ells). With the aid of a spindle, the entire gunner's level can be positioned perpendicular to the target (ill. 2.37).

The oldest gunner's level with sight and quadrant was made around 1490; its original owner was Duke Albrecht III

2.36 Gunner's Level and Sight, Christoph Schissler, Augsburg, 1567, gilded and engraved brass, punched, height: 26 cm, width: 10 cm, inv. no. C V 35

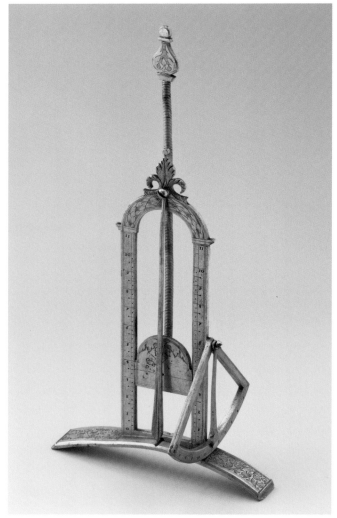

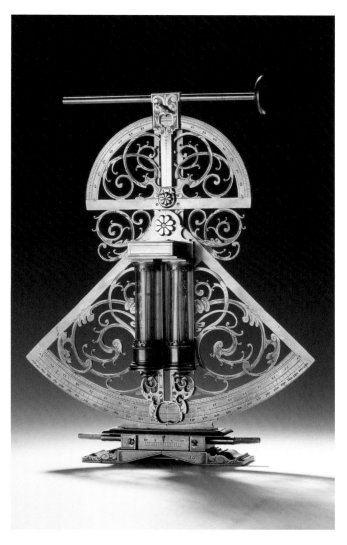

2.37 Gunner's Level and Sight, Victor Starck, Dresden, 1635, gilded and engraved brass, punched, height: 25 cm, width: 19.3 cm, depth: 4.5 cm, inv. no. C V 12

culverin hints at the fact that this is an early example of a demonstration instrument (ill. 2.38).

Most gunner's levels from around 1600 were more precise than the cannons aligned with them. They serve to document discourse around artillery rather than their actual

2.38 Gunner's Level, German, circa 1490, iron, length 22.5 cm, height: 30 cm, inv. no. C V 38

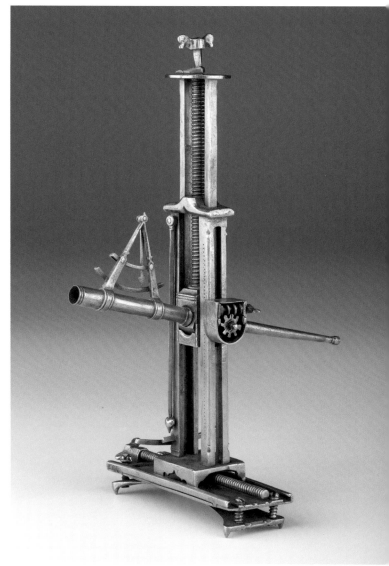

(Animosus) of Saxony (1443–1500). Instead of a simple sight, a visor pipe in the shape of a culverin was screwed onto this instrument, making its height continuously adjustable within the guiding frame by using a spindle. The vertically attached fine spindle is remarkable insofar as it represents one of the earliest screw micrometers in the realm of precision mechanics. The tiny pendulum attachment above the

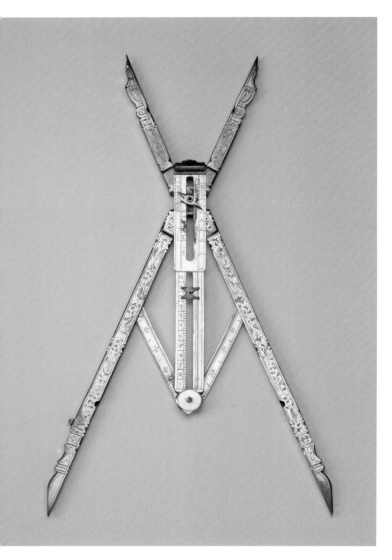

2.39 Gunner's Sector, German, late 16th century, gilded and engraved brass, silver, steel, length (side): 33.5 cm, width: 2.0 cm, inv. no. A I 11

duced in a ratio of 1:2. In order to fulfill the other function, the maker has constructed a deltoid. Here, the broad silver bar with scales for the caliber of iron-, stone-, and lead bullets, as well as an extra elevation scale for the device's inclination corresponds with the deltoid's symmetry axis (ill. 2.39).

WD

Balances and Weights

Balances were the first precise measuring instruments people used in their daily lives. Because only accurate scales ensure fair trade, they have been considered the absolute symbol of justice since antiquity. Rulers who wanted to be considered fair liked to use this symbol as a dec-

2.40 Standard Weight, German, 1579, brass, length: 4.3 cm, height: 1.4 cm, inv. no. B I 25

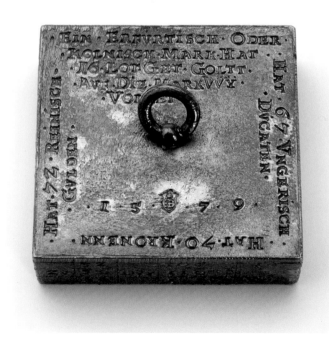

use as tools on the battlefield. The gunner's level turned into an effective object for strategic propaganda and was therefore constructed in increasingly sumptuous and complex ways. One of those showpieces is a gilded pair of compasses that may be equally used as reduction compasses, gunner's gauge, gunner's level, and gunner's quadrant. When applied as reduction compasses, distances can be enlarged or re-

orative device. It is therefore not surprising that precious balances are among the early holdings of the electoral Saxon Kunstkammer. In the introduction of his handwritten inventory Johann Gottlieb Michaelis, first inspector of the Mathematisch-Physikalischer Salon, wrote in 1732: "The most noble static instruments are scales; thanks to them the weight of bodies can be determined with the aid of weights whose heaviness is already known." (Michaelis 1732, fol. 2v.)

2.41 Steelyard, Nuremberg, circa 1590, brass, steel, copper, length: 121.8 cm, inv. no. B I 22

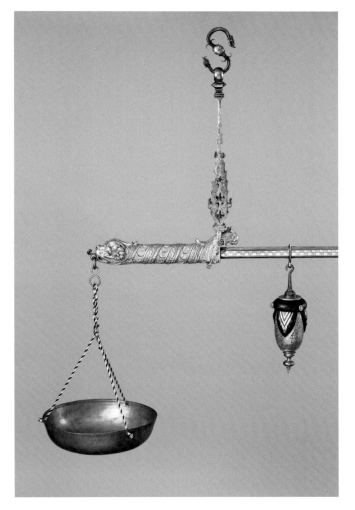

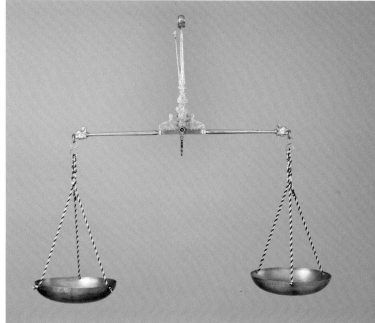

2.42 Balance, Nuremberg, circa 1590, brass, steel, length: 59.5 cm, height: 41.5 cm, inv. no. B I 32

In the 16th century the mark served as a German reference weight. One mark silver was the equivalent of a half-pound or 16 lot silver, i.e. circa 230 grams (ill. 2.40). The currency denomination Mark is also derived from the weight unit Mark.

The load arm of this late-16th-century steelyard is worked like a sword hilt with a gilded ram's head as the pommel. To weigh, one simply moves the weight on the balance arm until equilibrium is reached; then, the result is read in mark and lot (ill. 2.41).

This balance is embellished with two nymphs on its arms and two engraved heads on the side of its central rod. In both cases one of the depicted figures is male, the other female: perhaps it testifies to the harmony between the sexes. (ill. 2.42).

A set of weights by Konrad Most from 1588 consists of brass weights inserted into one another. The smallest weighs half a lot (circa 8 grams), the larger (the vessel itself)

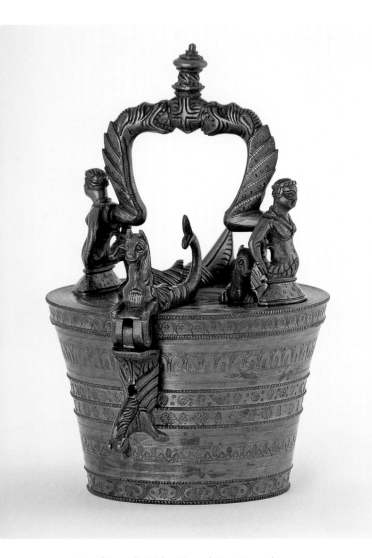

2.43 Set of Nested Weights, Konrad Most, Nuremberg,
1588, brass, bronze, height: 18.5 cm, inv. no. B I 24

400-times as much, i.e. 25 mark (circa 5 kg). Europe-wide, the
Nuremberg red smiths produced most of such weight sets;
they were always gauged according to local measurement
units. This set was delivered along with the beam balance
described above (cf. ill. 2.42; 2.43).

MK

Carry Heaven on Earth. Princely Celestial Machines

To comprehend the celestial laws of the stars and planets
is among the oldest dreams of humankind. Based on this,
astronomers have surveyed the sky, outlining mathematical
theories in order to understand the movements of the stars
in the most exact possible manner and attempt to predict
it. In order to realistically envision the celestial processes
without being compelled to undertake complex calcula-
tions, the Saxon electors acquired numerous exquisitely
worked celestial machines: Elector August the astronomical
clock, his son Christian (1560–1591) the mechanical celestial
globe. For the princes, these extremely rare machines car-
ried heaven on earth. Moreover, they symbolized something
central vis-à-vis their legitimacy as rulers: their proximity
to god.

Elector August's astronomical clock counts among the
outstanding mechanical creations of the early modern era.
He commissioned the artwork from his brother-in-law, Wil-
helm IV of Hesse-Cassel (1532–1592), himself a recognized
astronomer. On its four sides, the astronomical clock indi-
cates where the classical "planets" – Mercury, Venus, Mars,
Jupiter, Saturn, as well as Sun and Moon – are located as
seen from the Earth. Ancient Greek astronomers referred
to these celestial bodies as *planetes* ("tramp stars") because
they change their position slowly against the background
of the fixed stars: They appear to wander. Recording the
planets' proper motion has always been a central goal of
astronomers. The authoritative model for these movements
until the 16th century was the late-antique mathematician
Claudius Ptolemy (circa 100–circa 160 CE). Based on obser-
vations and calculations undertaken by Greek astronomers

2.44 Astronomical Clock, Eberhard Baldewein, Hans
Bucher, Hermann Diepel, et al., Marburg/Kassel, 1563–
1568, gilded brass, silver, iron, steel, enamel, height:
118 cm, width: 62.5 cm, depth: 62.5 cm, inv. no. D IV d 4

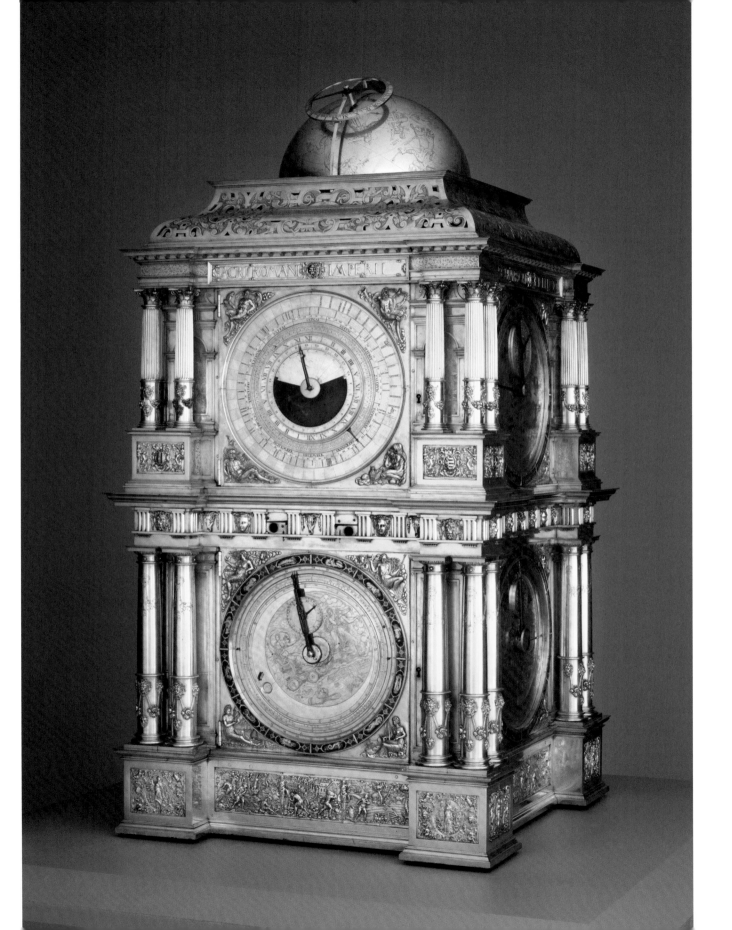

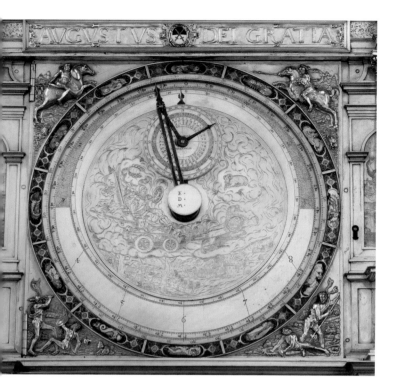

2.45 Astronomical Clock, Eberhard Baldewein, Hans Bucher, Hermann Diepel et al., detail (depiction of the course of Mars)

and Babylonian calendar makers, generations of Islamic astronomers refined the latter model during the Middle Ages. The clock shows the celestial position of the planets from our terrestrial viewpoint.

A celestial silver globe crowns this clock. Made of two semi-spheres, it spins on its own axis once a day. A golden sun disk travels in a groove, passing through the twelve zodiac signs during the course of one year. The orbits of the other six classical "planets" (including the Moon) are shown on different indicator disks attached to the clock.

The genius Eberhard Baldewein (1525–1593) from Marburg constructed the highly complex movement inside in collaboration with the clockmaker Hans Bucher (active approx. 1560–1580). The clockwork drives the celestial globe and the planet hands. Two further movements assure the striking of full- and quarter hours (ill. 2.44).

Even before the clock was finished, there were rumors abroad that it was "more beautiful, larger, and more elaborate" than its famous model in Cassel, which Wilhelm had constructed for himself. The gossip was certainly well founded. Neither the outbreak of the plague nor repeated technical difficulties or cost increases diminished August's desire to own this world machine. When it was finally presented in Dresden – after five arduous years of waiting – an eyewitness reported that, because of its multiple displays of celestial movements, the elector was "not unamused and enthralled." (Korey 2007, p. 52)

The upper disk on the clock's front reveals the course of planet Mars; the lower disk is an astrolabe driven by a clockwork. Between both disks a small minute clock face indicates the days of the week.

Upon closely inspecting the disk that depicts the course of Mars (ill. 2.45), it becomes evident that the particular position of the long hand results from a combination of two movements: Firstly the turning of the "deferent circle," an engraved, flat circle near the disk's center; secondly the rotation of the "epicycle," a small, elevated circle near the edge. The result of this circle-in-circle movement on each planet disk results in the fact that as the clock runs, the tip of each planet hand performs one slow forward and one slow backward movement within the outer enameled ring of the zodiac signs, in the very same way we observe planetary movements in the sky with our naked eye.

However, seen from the terrestrial perspective, a planet's velocity in its respective orbit is not constant: The phases of its backward movement in the sky occur in irregular temporal distances and are of unequal duration. The inclusion of different geometrical refinements in the circle-in-circle model enabled Ptolemy to account for the vast majority of irregularities noticed during observation. Baldewein, Bucher, and the other craftsmen needed plenty of inventiveness and manual dexterity to recreate Ptolemy's theory in a mechanical astronomical clock. Ultimately, one single, powerful spring mechanism drives multiple transmission gears as

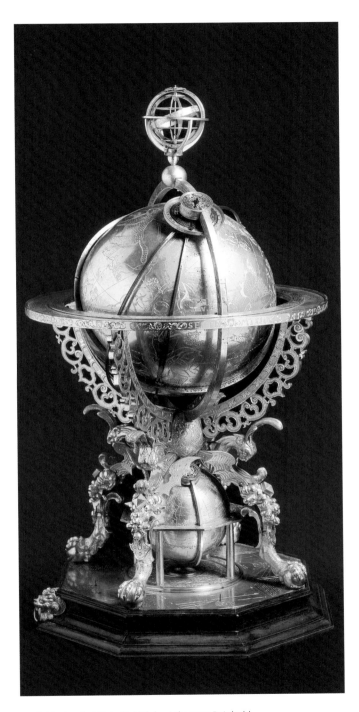

2.46 Mechanical Celestial Globe, Johannes Reinhold, Georg Roll, Augsburg, 1586, gilded and silvered brass and copper, engraved, punched, rosewood, height: 56.5 cm, diameter (celestial globe) 20.5 cm, inv. no. E II 2

well as all of the clock's hands. Thanks to this clockwork, the relatively "fast" rotations of the globe (in one day) and the Moon (in one month) are not the only phenomena indicated. Other, much slower celestial movements are also recorded. The planet hand on the Saturn disk even requires more than 29 years for one rotation – thus, thanks to moving only circa 1° per month, it is approximately 10,000 times slower than the revolving celestial globe.

When Christian I succeeded his father August in 1586 he purchased a mechanical celestial globe made by Johannes Reinhold (circa 1550–1596) and Georg Roll (1546–1592) in Augsburg. A total of six such globes are known and have been preserved to this day. One of them was even produced for Emperor Rudolf II (1552–1612).

A complex movement is located inside this gilded celestial globe (ill. 2.46). When wound up, the globe revolves around its own axis once a day. The stars depicted on it rise and set, just like we observe it in the sky. Additionally, the clockwork moves two iron meridian rings with the aid of a little Sun disk and a Moon ball along the twelve signs of the zodiac. The Sun only revolves around the celestial ball once a year, the Moon once a month. The phases of the Moon are indicated thanks to a ratchet, whereby the Moon orbit's 5-degree-deviation from the ecliptic was ignored.

Placed under the celestial globe is a globe of the Earth. The armillary sphere at the very top serves as an analogue instrument for replicating and computing what we see in the sky. A mechanically driven ring with the Julian and the Gregorian calendars for the years 1586 until 1627 is mounted on the horizon ring – the large, horizontal ring that is hovering around the celestial globe. Four sundials on the base plate complete the incredibly complex construction. Even the hand-written instructions for the globe have survived. They describe not only the various functions but also the symbolic meaning the globe has for its owner.

WD, MK

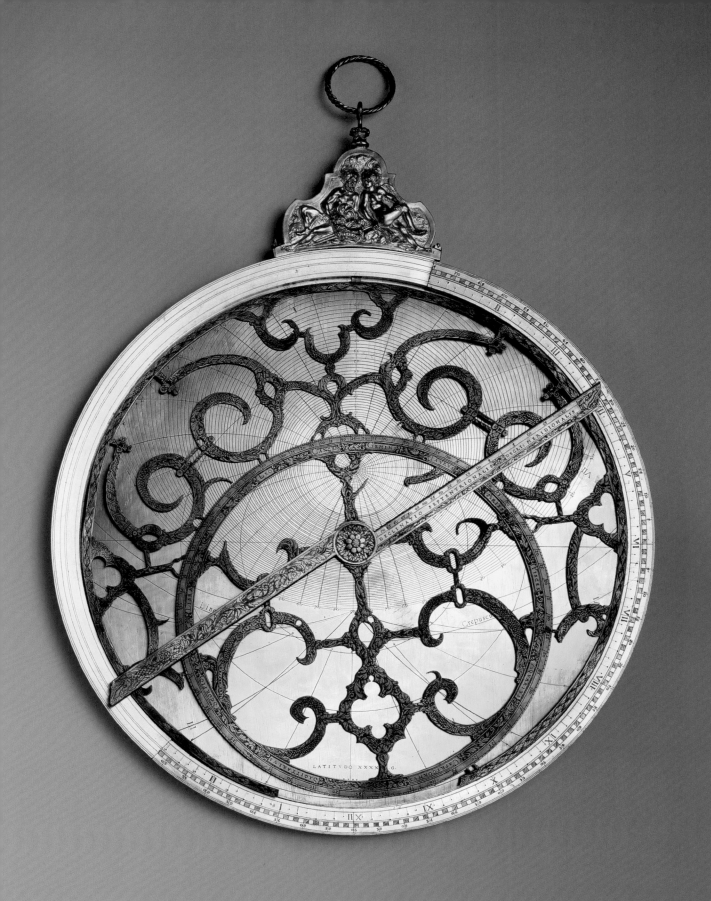

Astrolabes

An astrolabe (ill. 2.47) reproduces the starry sky not in a three-dimensional fashion, as does a celestial globe. Instead – because of a simpler operation – it reproduces the starlit sky on a two-dimensional disk. An astrolabe enables us to adjust the view of the sky at any time – something only a computer program might be able to accomplish today. Yet, the astrolabe is capable of much more: The alhidade on its rear enables the user to measure the height of a star over the horizon in order to determine the local time. It is hardly a surprise that in medieval and early modern times astrolabes were among the most frequently used instruments.

Elector August acquired this astrolabe in 1568 together with a pair of globes (cf. p. 117, ill. 5.2). All three instruments were made by Johannes Prätorius (1537–1616), professor for mathematics and instrument maker. For the Salon's permanent exhibition, the astrolabe was disassembled; the presentation of its individual components serves the purpose of illustration.

Assembled, astrolabes look like this remarkably beautiful example by Thomas Pregel: Its delicate embellishments are particularly captivating (ill. 2.48).

MK

2.48 Astrolabe, Thomas Pregel, Zwickau, 1629, gilded brass, diameter: 28.5 cm, height: 37.6 cm, inv. no. C II 14 (acquired in 1999)

2.47 Astrolabe, Johannes Prätorius, Nuremberg 1568 (damaged in 1945), brass, original gilded, diameter: 39.5 cm, height: 53.5 cm, inv. no. C II 3

MICHAEL KOREY

FESTSAAL
Instruments of Enlightenment

When the Mathematisch-Physikalischer Salon was founded in 1728 its collection comprised the older mathematical instruments from the princely Kunstkammer as well as outstanding examples of innovative experimental devices, among them the monumental burning apparatus of Ehrenfried Walther von Tschirnhaus (1651–1708) and an impressive vacuum pump by Jacob Leupold (1674–1727).

Large telescopes refer to the observatory, instituted in the Festsaal in 1777 and in existence until 1928. From this location, the inspectors of the Salon determined Dresden's official time for 150 years and compiled the first systematic weather records for the region.

The Salon thus stood for three aspects from the Age of Enlightenment until well into the 19th century: physical cabinet, observatory, and administrative office. A specific museum phase began at the end of the 19th century: The exhibits were less frequently used practically. Instead, they increasingly became the focus of historians as significant testimonies of the history of science.

For two centuries, until 1945, the Mathematisch-Physikalischer Salon presented itself exclusively in the Festsaal: It was the only space to store the collection and at the same time to operate select instruments. Used for the clock collection after World War II, the Festsaal's appearance is once more dominated by burning apparatus, telescopes, and large physical devices, just as it was in the 18th century.

Ehrenfried Walther von Tschirnhaus's Burning Apparatus

Even in ancient times it was known that light – when focused on one spot using concave mirrors and convex lenses – produces heat. The famous story of ancient mathematician Archimedes relates that he saved his hometown of Syracuse during the second Punic War by setting the entire Roman fleet on fire with the help of a burning lens.

In about 1650 efficient burning mirrors were heavy and unwieldy because they were made of cast metal, and the best lenses were still relatively small. In the last two decades of the 17th century, the Saxon scholar Ehrenfried Walther von Tschirnhaus produced major improvements in these instruments. Born in Kieslingswalde (today Sławnikowice, Poland) in Upper Lusatia, he was instructed in mathematics and natural sciences at an early age and then went to study at the famous Dutch University of Leiden. After his studies, he met famous scholars on his travels throughout Europe. He befriended the philosopher Baruch de Spinoza (1632–1677) and he collaborated with Gottfried Wilhelm Leibniz (1646–1716). When he visited France in 1676/1677 he first witnessed a powerful burning mirror, the mirror of which was cast from a metal alloy by François Villette (1621–1698). Three years later, after returning to Kieslingswalde from his extended study trip, he began to construct burning apparatus of unexpected quality and size with the mechanic Johann Hoffmann: He fabricated mirrors from chased copper and lenses from glass

3.1 Portrait of Ehrenfried Walther von Tschirnhaus, engraving by J. M. Bernigeroth, circa 1708, inv. no. G I 78

blocks beginning in 1690. His mathematical research –the focal lines of concave curves was among the topics – received much attention. Although he tended to generalize his findings prematurely, he was the first German to be admitted to the Académie Royale des Sciences in Paris (ill. 3.1).

Many contemporary accounts reflect the fascination stemming from von Tschirnhaus's instruments. They were matters of conversation in Paris and Saint Petersburg, in London and Florence. Many scholars ordered devices from him, using them for their own experiments. They were also useful in Saxony in conjunction with early efforts to produce the luxury item of porcelain: Used in melting experiments with different materials, Tschirnhaus's products made direct observations and reactions possible.

Distinguished by its meticulous workmanship, this burning mirror (ill. 3.2) from 1686 demonstrates that Tschirnhaus produced an exquisite instrument. While the curvature of the chased copper surface corresponds exactly to the segment of a wooden sphere, modern measurements reveal that the precise shape has been preserved to this day: The mirror's curvature deviates by only about 0.1 % from a perfect spherical shape. Yet, the copper surface was chased to a thickness of barely 2 mm. The mirror can be moved in two directions in its mount: The horizontal axis makes it possible to tilt it, the fork in the stand below enables it to be turned vertically. Hence, an axial alignment of the mirror towards the Sun is possible. The copper mirror is placed on top of a concave wooden base reinforced by iron bands.

The combustion area is located roughly two arm lengths away from the mirror's center and has approximately the size of a coin. To apply contemporary terminology: Under perfect conditions temperatures of up to circa 1,500° C can be achieved. Therefore, using sunlight alone, this mirror can burn a hole into a copper plate. Other metals and even asbestos, at the time considered absolutely incombustible, could be melted with it as well.

The mirror was presented to Elector Johann Georg III of Saxony (1647–1691) on July 17, 1690. Its surface reveals damage, presumably from dripping firing samples.

When directing Tschirnhaus's double lens burning apparatus (ill. 3.3) towards the Sun, the sunlight collected by the

3.2 Burning Mirror, Ehrenfried Walther von Tschirnhaus, Kieslingswalde (today Sławnikowice, Poland), 1686, copper, embossed, basswood, fir and pear wood veneer, iron, diameter: 158.5 cm, maximum height: 230 cm, focal distance: approx. 99.5 cm, inv. no. B V 10

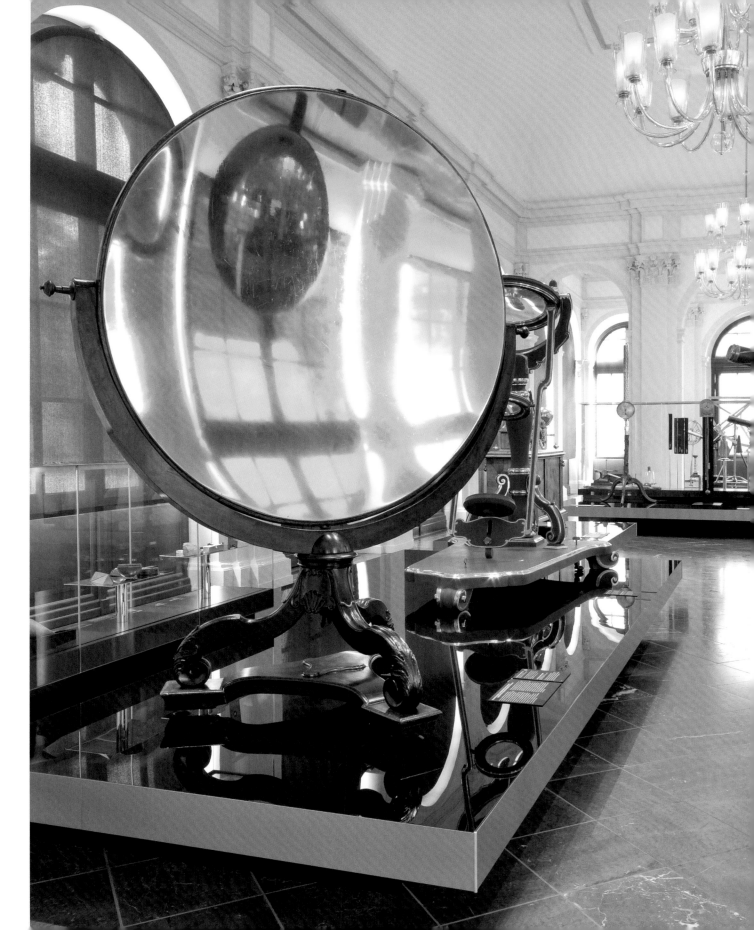

large lens falls onto the second lens ("collecting glass"). The latter focusses it onto a coin-shaped spot. In comparison to burning mirrors, burning lenses can be more easily operated in melting experiments, because light source and melting sample are found on different sides of the lens. They are, however more challenging to produce than burning mirrors. The lenses are the truly unique aspect of this instrument. Sanding and polishing immense lenses was an arduous undertaking that also required sufficiently large and pure blocks of glass. Their production, in turn, was particularly time-consuming: Simply for the glass to slowly and evenly cool after melting and casting required three weeks.

3.4 Melting Samples (produced with a laser), based on von Tschirnhaus's material samples: kaolin, tin and brick (from left to right)

3.3 Double-Lens Burning Apparatus, Ehrenfried Walther von Tschirnhaus, Kieslingswalde (today Sławnikowice, Poland), circa 1690, glass, wood, mounted, iron, diameter main lens: 49.5 cm, diameter (additional lens): 26.0 cm; stand: maximum length: 213 cm, maximum width: 140 cm, maximum height: 260 cm, inv. no. B V 6

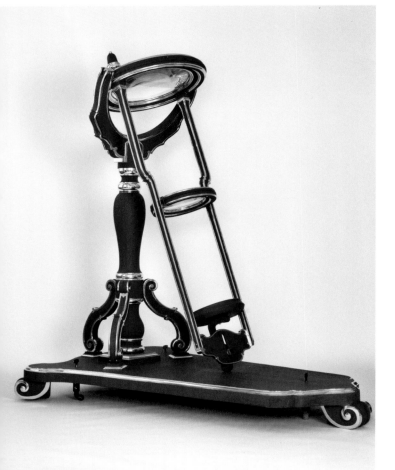

According to the respective entry in the earliest inventory of the Mathematisch-Physikalischer Salon (1730–1732), the instrument initially looked different: Both lenses were connected with three turned wooden rods. The present shape and coloring – the latter was restored in 1985 after examining the color composition – are the result of later alterations. It appears that the piece received its present representational appearance around 1750, possibly as homage to its use in conjunction with Tschirnhaus's porcelain investigations. Its current form prohibits use of the instrument because the collective glass and plate are rigid today, thereby making it impossible to focus the apparatus precisely.

Tschirnhaus described the results of numerous burning experiments – for example in letters to scholars such as Leibniz or the head of the Glashütte Pretzsch near Wittenberg, with whom he collaborated, as well as in contributions in the journal *Acta Eruditorum*. Regarding the behavior of bricks under the burning glass he noted: "Bricks may be as big as they want: they do begin glowing and then vitrify very much." (quoted after Reinhardt 1912, p. 114). None of his samples have survived. The materials presented in the collection – bricks plus four other substances Tschirnhaus

described: copper, pyrite, pewter, kaolin – clarify the effects of concentrated radiation and were produced using a laser (ill. 3.4).

According to its inscription, this microscope with ivory handle was made in 1692 by Cosmus Conrad Cuno (1652–1745), the most important optician working in Augsburg at the end of the 17th century. It is the only microscope in the world to bear his signature.

Microscopes like this one, with only one lens, are also referred to as "simple" microscopes. The lens is built in to the upper ocular made of ivory. One can see eight different preparations in succession when looking through the lens.

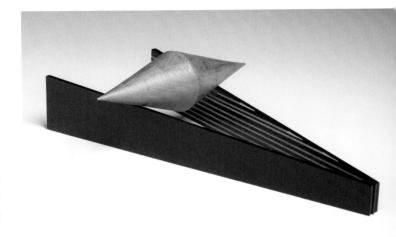

3.6 Upward-Rolling Double Cone (with new tracks), circa 1700, wood, diameter: 8.56 cm, length: 27 cm, inv. no. B V 52

3.5 Microscope with four Flee Glasses, Cosmus Conrad Cuno, Augsburg, 1692, wood, ivory, glass, cardboard, marble paper, leather, microscope: diameter: 4.9 cm, length: 11.3 cm, case: height: 4.7 cm, width: 13.0 cm, depth: 8.2 cm, inv. no. B V 180 (acquired 1996)

A hair or the wing of a fly, for instance, is inserted into a grooved, rotatable disk. A small screw – regulating the distance between ocular lens and the preparation – permits focusing. Additional oculars are found in the little companion box, as well as four "flee glasses" (magnifying glasses in wooden tubes), and a tiny ivory box, where extra mica platelets that can be used as slides are kept. The ivory box lid is embellished with the golden initials of von Tschirnhaus: "E W v T." This microscope was conceivably once gifted to him. (ill. 3.5).

The Mathematisch-Physikalischer Salon also preserves a few objects from Tschirnhaus's estate. Among them is a double cone that can achieve mesmerizing things: When placing it close to its tip onto the slightly tilted tracks, it rolls upwards! Apparently contradicting the laws of nature, the paradoxical toy was first recorded in 1694 in England. In the context of mechanical presentations, it remained popular until the late 18th century. The answer to this riddle is the fact that the double cone's center of gravity shifts lower as it rolls upward on the diverging tracks (ill. 3.6).

Succeeding Archimedes. Inventiveness in Optics

Burning mirrors and related devices are not merely more or less complex tools. Since the time when Archimedes supposedly used a burning mirror to save his hometown Syracuse, it has been surrounded by a very special aura – and its inventor is considered a role model and undisputed authority. This was particularly apparent at Dresden's court in conjunction with Ehrenfried Walther von Tschirnhaus's succession. Three men from Saxony received the epithet "second Archimedes" as this time, due to their inventiveness as exemplified in the optical products exhibited here: The court mechanic Andreas Gärtner (1654–1727; ill. 3.7), the Salon's

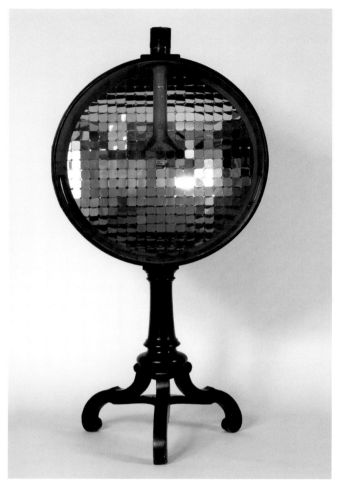

3.8 Illuminating Mirror, Andreas Gärtner, Dresden, circa 1710, glass, mirrored on rear, steel, wood, iron, diameter: 71 cm, maximum height: 172 cm, inv. no. B V 9

3.7 Portrait of Andreas Gärtner, unknown master, oil on canvas

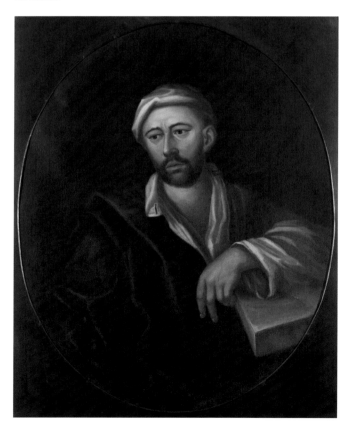

first inspector, Johann Gottlieb Michaelis (1704–1740), and court carpenter Peter Höse (1686–1761).

The surface of Andreas Gärtner's illuminating mirror consists of 342 small, square plane mirrors that are attached to a curved wooden surface (ill. 3.8). An oil lamp in the focus served as light source – certain lighthouses function in a similar way. According to eyewitness accounts, such mirrors were employed to great effect in the so-called Zeithainer Lustlager of 1730, a military camp near Meissen. The Prussian King Frederick William I (the "soldier king," 1688–1740)

and his son, Crown Prince Frederick (later "Frederick the Great," 1712–1786), were present during this maneuver. It was intended to demonstrate the reinvigorated Saxon army.

Gärtner constructed multiple types of burning mirrors using various materials – for example, as seen here, from a collapsible tabletop, covered with gold leaf on an appropriate plaster priming (ill. 3.9). Due to the slight curvature, the mirror focuses the sunlight in such a way that it only slightly increased warmth. Yet, it apparently sufficed as an effective treatment for rheumatism. Gärtner himself called his mirrors with this function "cure or medicinal mirrors."

3.9 Portable Burning Mirror, Andreas Gärtner, Dresden, circa 1710, gilded wood, plaster, brass, iron, diameter: 109 cm, height: 166 cm, inv. no. B V 8

3.10 Burning Mirror, rear, Peter Höse, Dresden, circa 1740, brass, iron, stand: wood, diameter: 142 cm, height: 205 cm, focal distance: 51 cm, inv. no. B V 47

For the brass burning mirror by Peter Höse, we have documentation of melting attempts with more than 100 minerals originating from Saxony. The mirror mount reveals holes at top and bottom, referring to the former attachment of a bracket to hold burning samples. The museum purchased the mirror in 1768 from the estate of the Saxon prime minister, Count Heinrich Graf von Brühl (1700–1763). It came without its frame, which was lost in the Seven Years' War (1756–1763) during the siege of Dresden. It is not clear whether the present frame, in which the mirror is still mounted today, was retrieved after its acquisition or whether a new frame was made. The back of the plane mirror's wooden support is decorated with an undated depiction of the Sun. (ill. 3.10).

Much Ado about Nothing: Early Experiments with Vacuums

Beside other 17th-century inventions such as telescope and microscope, the vacuum pump was *the* flagship of the new experimental sciences. Public demonstrations with this instrument were among the main attractions of the new scientific academies, for instance the London Royal Society. Magdeburg's mayor, Otto von Guericke (1602–1686), invent-ed the "air pump" – this is the historic term for the vacuum pump. He demonstrated its impact in several sensational performances during the 1650s. In doing so, he produced – by pumping out the air between two hemispheres placed on top of each other – such a great vacuum that even a number of horses were unable to pull the hemispheres apart.

Augustus the Strong bought this particularly sumptu-ous vacuum pump after a demonstration at the Leipzig Fair (ill. 3.11). It served to imitate Guericke's experiment in a

3.11 Vacuum Pump, Jacob Leupold, Leipzig, 1709, gilded brass, steel, iron, wood, veneer, length: 176 cm, width: 49 cm, height: 146 cm, inv. no. B II c 1

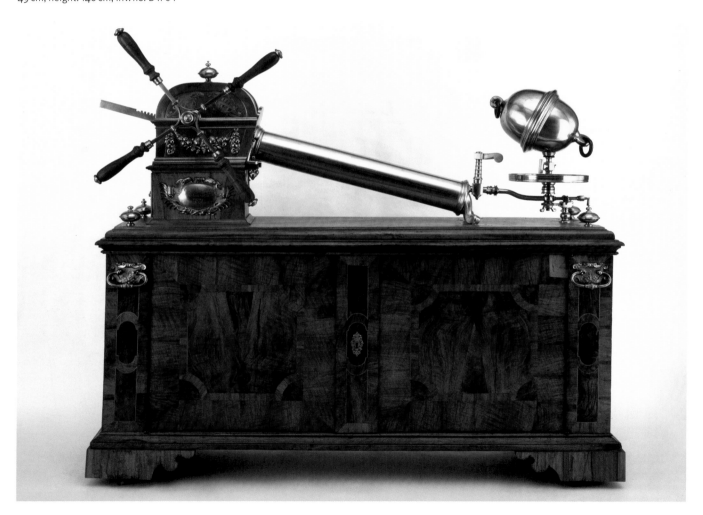

slightly smaller version and by employing weights instead of horses. When turning the pump's large cross, one pulls up a piston that is inserted into the tilted brass cylinder. In doing so, some of the air from inside the sphere – seen in the image on the right – is sucked into the cylinder. When the spigot at the bottom of the cylinder base is closed and the wheel turned back, the air in the cylinder escapes through the spigot valve. By repeating the procedure – first suction, then draining – more air is evacuated until a space with heavily thinned-out air is created inside the sphere – effectively a vacuum. Now, the sphere is mounted on gallows and is weighed down with weights. The weight is continuously increased until the point is reached were the spheres – compressed by air pressure – separate.

When the hemispheres are replaced with a glass cover, a burning candle or a bird is placed underneath, and the air is evacuated once more, the effects of the vacuum are observed directly: The candle is extinguished or the bird suffocates – unless the demonstrator admits air again in a timely manner. Historic illustrations document such procedures. The inventories list glass covers as well as other utensils that were once kept in the base cabinet.

Apart from the electoral Saxon coat-of-arms, there is also a Latin inscription on the pump. In a free translation it states: "The experiment gives birth to the truth." The elaborately worked wood veneer and the artful design of the brass engravings prove that air pumps were not merely devices for experiments but representational objects as well.

For better understanding, an accurate reproduction of this vacuum pump was made and its missing accessories were reconstructed. The reconstruction is regularly presented at public demonstrations. During the presentations of the apparatus in the Zwinger – an authentic 18th-century place – Salon visitors can experience something that was of central significance during the Age of Enlightenment: joint pursuit of an experiment and then joint struggle for explanations of the observed phenomena.

See Further through Mirrors. English Reflector Telescopes

Telescopes have only been in existence for about 400 years. The first authenticated reports about "a certain instrument with whose aid one could see very far" date to 1608. Surprisingly fast – within only two years – Galileo Galilei and others made spectacular discoveries in the sky with the still imper-

3.12 Galilean Telescope, 1613 (destroyed in 1945), leather, sheet metal, length: 69 cm, inv. no. C I f 1

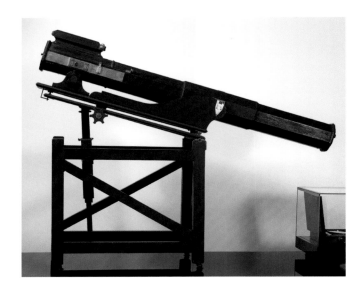

3.13 Newtonian Reflecting Telescope, George Hearne, London, circa 1730, wood, painted black, brass, mirror film, glass, height: 106 cm, width: 122 cm, depth: 62 cm, lens barrel length: 248 cm, inv. no. C I f 16

fect instrument: Among them, for example, that there are moons belonging to Jupiter and that the Milky Way consists of a multitude of stars. Inventory entries verify that the first telescopes entered the Kunstkammer of the Saxon electors in early 1613. Until it was destroyed on February 13, 1945, one of them was considered the world's oldest firmly dated telescope. (ill. 3.12).

The imaging elements of these early instruments initially consisted of glass lenses. Although they quickly spread all over Europe, these refracting telescopes had many serious deficiencies. For example, the glass lenses refract a white light beam into the spectral colors whose focus points are different – this causes blurred images. To avoid such mistakes, Isaac Newton (1643–1727) suggested the use of mirrors instead of lenses. In a reflector telescope based on Newton's design, a concave mirror at the end of the lens barrel reflects the light (hence, it is not segmented), gathers it and directs it to the side via a small plane mirror located at the opposite end of the lens barrel. There, the observer can look at the image, enlarged by the ocular (i.e. a lens or a system of lenses).

Newton's own reflector telescope from 1667 was only 15 cm long. It was not until two generations later that opticians in London, among them George Hearne (active approx. 1705–1740), produced mirrors for significantly larger instruments like this telescope presented in the Salon. They could display faint stars sufficiently brightly (ill. 3.13).

Originally from Hanover, Friedrich Wilhelm Herschel (1738–1822), like many of his compatriots, emigrated to England during the personal union between the duchy of Hanover-Brunswick and the English royal house. Originally a military musician like his father, he developed an early amateur passion for astronomy before it became his profession. The form and finish of the telescope mirrors he created were of such outstanding quality that he was able to observe more celestial objects with sharp clarity than any of his contemporaries. His 1781 discovery of Uranus brought him great fame. He achieved the latter with the help of a "7-foot" reflector telescope (identical construction as the piece in the Salon), thereby extending, for the first time since antiquity,

3.14 Newtonian Reflecting Telescope, Friedrich Wilhelm Herschel, London, circa 1785, mahogany, mirror film, glass, brass, height: 151 cm, width: 83 cm, depth: 47 cm, lens barrel length: 215 cm, inv. no. C I f 7

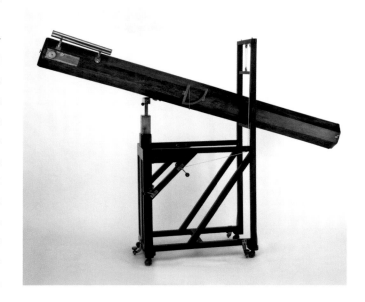

The "Mechanical Laboratory" of Imperial Count Hans von Löser

Far from the Saxon residence in Dresden, at Schloss Reinharz in the Dübener Heide, property of Imperial Count Hans von Löser (1704–1763), a workshop for the creation of scientific instruments came into being in the second third of the 18th century. The optical, mathematical, and physical instruments and the clocks fabricated there were definitely on par with the best contemporary products from metropolises like London and Paris.

Löser was of old noble Saxon descent. After studies in Wittenberg and a Grand Tour, his fast-rising career began at the court of Saxon Elector Friedrich August II (1696–1763). His activities brought him numerous high titles: He was conference minister, general tax collector, hereditary marshal, and later imperial count. Löser founded a workshop around the year 1740 – initially to produce instruments for his own needs. It can be assumed that he undertook astronomical observations from the castle tower. By the middle of the 18th century, the experts working for him included the mechanics Johann Gottfried Zimmer and Johann Siegmund Mercklein, clockmaker Lehmann, as well as Johann Gottlob Rudolph, trained in optics, on a temporary basis. As time went by, the Löser workshop also dealt with a few commissions. Such small and distinguished workshops in the countryside were actually something of a German specialty. In 18th-century England and France, instrument making was concentrated in the capitals, where there were enormous sales opportunities. There, instrument makers adapted to the needs and tastes of wealthy aristocratic collectors and research scientists – at the time many of them were both. In Reinharz, many excellent examples of new instruments were made – among them telescopes and microscopes, thermometers and barometers, vacuum pumps and electrostatic generators, as well as pendulum clocks – all characteristic of the "scientific revolution" in the Age of Enlightenment. Famous natural scientists, also from abroad, detoured to Reinharz to inspect Löser's instru-

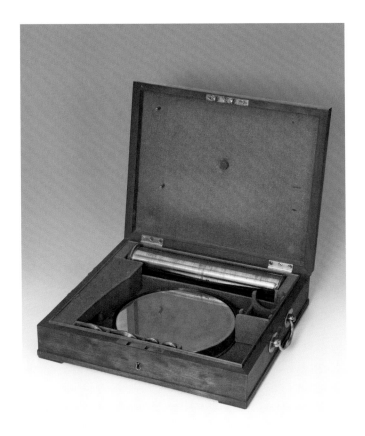

3.15 Main Mirror of a Reflecting Telescope, Friedrich Wilhelm Herschel, London, circa 1783, mahogany, mirror film, brass, diameter (mirror): circa 22 cm, inv. no. C I f 14

the number of known planets. Herschel invented a special, gallows-like mount for the instrument, making it easier to use, because – independent of the telescope's incline – the lateral eyepiece always remains on a comfortable eyelevel. (ill. 3.14).

The Salon once owned an even larger "10-foot" reflector telescope of Herschel's manufacture that was almost 3 m long. The English King George III (1738–1820) presented it to Count Hans Moritz Brühl (1736–1809) who passed it on to Elector Friedrich August of Saxony in 1803 for his Salon. Only a few of its parts have survived World War II, among them the main mirror, kept separately in a case (ill. 3.15).

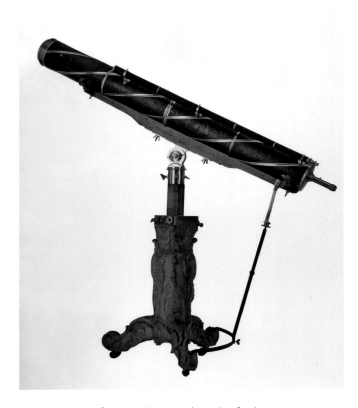

3.16 Gregorian Reflecting Telescope, Johann Gottfried
Zimmer, Johann Siegmund Mercklein, Reinharz, 1742,
oak, brass, iron, copper, height: 350 cm, lens barrel
length: 255 cm, inv. no. C I f 9

ments. The workshop was dissolved after his death. A large
portion of the instruments came to Dresden, where they
significantly expanded the Mathematisch-Physikalischer
Salon's collection.

One of the earliest reflector telescopes produced in
Germany is this impressive Rococo showpiece with Löser
provenance. Covered in Morocco leather, the tube rests
on a carved oak stand with the carved Löser coat-of-arms
at the top: positioned in a mirror image are two entwined
letters L (for Löser) with a crown above. This telescope's
renown is based on its rich and diligent design but also
on the prominence of its aristocratic commissioner. It was
originally equipped with an exact screw micrometer to mea-
sure the position of stars. Accordingly, the translator of the

most popular textbook on optics at the time, Robert Smith's
A Compleat System of Opticks (Cambridge 1738), prefaced his
1755 edition of the English text with a detailed description
and illustration of exactly this telescope. He stated that it
was particularly honorable that such an instrument was
made in Germany, not in England, "the fortunate island,
where learned men are rich and great people are learned,"
and that "thanks were owed not an ordinary artist but a
noble statesman" (ill. 3.16).

Covered with fish skin, the reflector telescopes functions
according to the same optical system as the big leather-cov-
ered telescope: A concave mirror at the bottom of the tube
gathers ambient light, which is then reflected by a second,
smaller concave mirror at the top end. A hole in the lower
mirror makes it possible to view the resulting image through
the eyepiece. Numerous changeable eyepieces for different
magnifications as well as a truncated eyepiece with a ground
glass for viewing solar or lunar eclipses are among the acces-
sories (ill. 3.17).

The special feature of this refraction telescope is its ro-
tatable revolver head. It contains three lenses with different
focal points. Corresponding to the selected lens, the length
of the lens barrel (minimum 67 cm, maximum 100 cm) must
be adjusted with the aid of extensions (ill. 3.18).

Fitted into a sphere, a projection lens – the so-called "sci-
optic ball" – is an optical instrument that gets screwed into
window shutters. When orienting the convex lens toward the
Sun, it is capable of gathering the sunlight and directing it
into dimmed spaces. The gathered light is suitable for prism
experiments on light breakdown or – by adding a further
lens – to enlarge the projection of microscopic slides (ill. 3.19).

Together with its counterpart, a thermometer of the
same size in the London Science Museum, and a signifi-
cantly larger device with a carved stand, also kept in the

3.17 Gregorian Reflecting Telescope, Löser-workshop,
Reinharz, circa 1750, brass, iron, fish skin, maximum dia-
meter: 15.0 cm, maximum length: 59.9 cm, inv. no. C I f 18

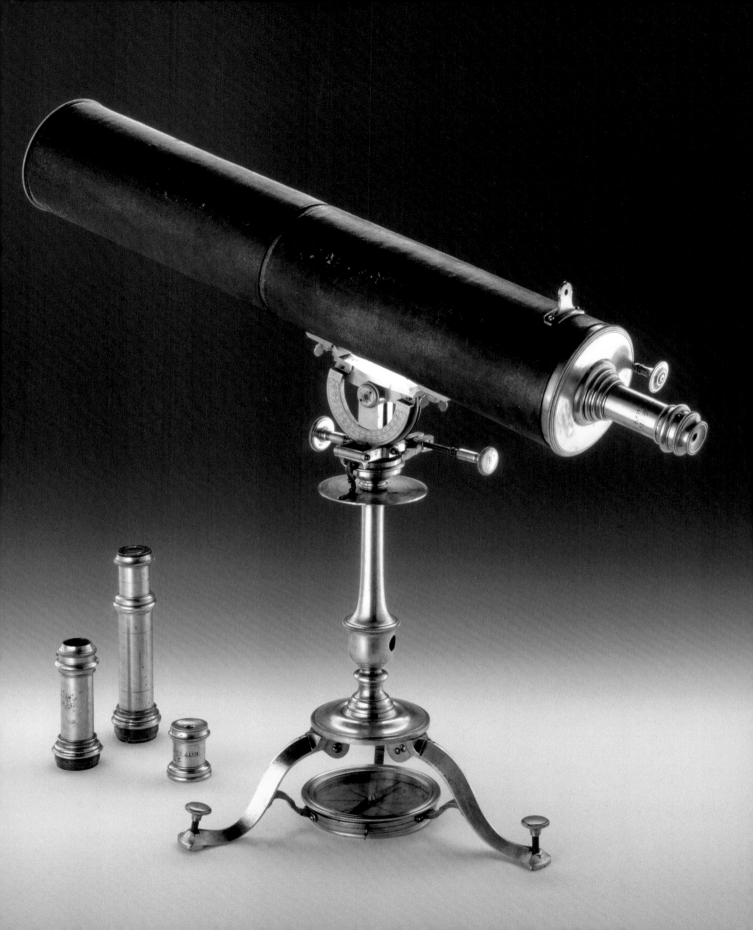

3.18 Draw-Tube Telescope, Johann Siegmund Mercklein, Reinharz, 1761, copper barrel covered in red Morocco leather, brass, iron, stand: oak, height: circa 350 cm, length: 255 cm, inv. no. C I f 23

Mathematisch-Physikalischer Salon, the metal thermometer by Zimmer is one of the world's oldest instruments for measuring the temperature by virtue of expanding of a solid metal (ill. 3.20). Four lead rods inside the cylinder are so skillfully connected through levers that even a minimal expansion of the metal suffices – when heated from 0° C to 100° C, a 1,000 mm long lead rod only extends to the length of 1,003 mm – to move the blue-colored hand behind the glass pane. The gilded hand, mounted in front of the glass plate, can be moved manually to adjust the reference values, making it easier to detect small deviations.

The temperature is measured in Delisle degrees (°De), a now-forgotten 18th-century-scale that goes back to the French astronomer Joseph-Nicolas Delisle (1688–1768). His scale is organized in the opposite way from the Celsius scale: 150° corresponds to the freezing point of water; 0° is the boiling point. The scale of the exhibited thermometer proceeds from 80° to 200° (this corresponds to the Celsius range of 46,7° C to -33,3° C). Standard values (among them the regular body temperature) and record values (for instance the highest temperatures ever recorded in Paris or Saxony) are engraved into the brass plate behind the clock face.

Mass-produced glass thermometers are affordable today. This was not the case in the middle of the 18th century, when hand-blown glass tubes were still in use. The inevitable

3.19 "Scioptic Ball," Löser-workshop, Reinharz, 1741, brass, glass, wood covered with red leather, steel, cork, height: 12 cm, width: 26 cm, depth: 18.5 cm, inv. no. B V 76

fluctuations in their circumference made calibration more difficult, as evidenced when comparing scales of various examples produced in the Löser workshop (ill. 3.21).

A thin, perforated metal pipe is located in the center of the delicate ivory spiral of this hygrometer, an instrument to measure humidity. A gut string, stretched vertically in the pipe's center, expands or contracts, depending on the relative humidity, whose value is indicated with a hand on the upper pane (ill. 3.22).

A hydrometer serves to measure the density of fluids. Pursuant to the Archimedean principle, the weighted, spherical buoyancy body is only immersed into the fluid until the weight of the fluid displaced equals its own weight (ill. 3.23).

Equipped with striking mechanism and repeater, and sometimes with an alarm, carriage clocks look like oversized pocket watches. The piece illustrated here has a full plate movement with barrel, fusee, chain, verge escapement, and balance wheel (ill. 3.24). The quarter-hour repeater, the repetition of the number of quarter-hour strikes, is released by a drawstring; the bell is placed at the bottom of the case. Since the mid-17th-century such carriage clocks were primarily made in Augsburg and neighboring Friedberg. While the clockmakers from southern Germany placed their carriage clocks in masterfully worked silver cases, Johann Andreas Lehmann opted for a decorative enameled case. Framed by a flower garland, the exterior of the case depicts a landscape with a ruin. Only very few of Lehmann's watches are known.

On the clock face of this odometer more than 10,000 double steps can be read off. With the aid of two hooks on the reverse of the instrument, it can be tied to a belt. Pulling at the connection cord placed between triggering switch and heel will release the switchgear. A wooden, leather-covered case protects the instrument (ill. 3.25).

3.20 Metallic Thermometer, Johann Gottfried Zimmer, Reinharz, circa 1748, brass, partly gilded and silvered, glass, lead, iron, height: 45.5 cm, diameter (clock face): 17.5 cm, inv. no. B III 16

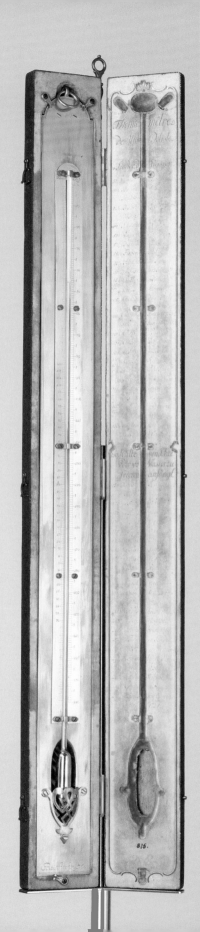

3.22 Hygrometer, Löser workshop, Reinharz, circa 1750, wood, turned ivory, engraved brass, mounted, glass, gut string, blued steel, diameter: 17.4 cm, height: 37.8 cm, inv. no. C VII 1

3.21 Portable Thermometer, Johann Siegmund Merck-lein, Reinharz, 1760, gilded, silvered, and engraved brass, blued steel, glass, mercury, wooden case covered with fish skin, height: 58.2 cm, width: 4.2 cm, case: height: 60.8 cm, width: 6.2 cm, depth: 2.8 cm, inv. no. B III 6

3.23 Hydrometer, Löser workshop, Reinharz, circa 1750, gilded brass, glass, length: 16.5 cm, diameter (ball): 5.2 cm, inv. no. B II b 3

3.25 Pedometer, Johann Gottfried Zimmer, Reinharz, 1741, engraved and gilded brass and silver, case: wood, leather, diameter: 6.7 cm, height: 1.5 cm, inv. no. C III a 5

The sundial (ill. 3.26) must be placed in a horizontal position and directed to the south, before it can be used. Additionally, its silver clock face must be tilted according to the local latitude so that it runs parallel with the equator. Then,

3.24 Carriage Clock with enameled case, Johann Andreas Lehmann, Reinharz, 1755, diameter: 9.2 cm, diameter (case): 10.9 cm, depth: 6.4 cm, inv. no. D IV c 12

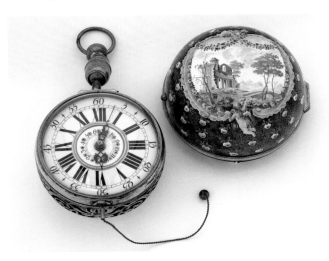

the small minute clock face gets turned until a sunbeam falls through the top slit. Comparable to a mechanical clock, it is now possible to read the hours on the large and the minutes on the small clock face.

When Count Hans von Löser died in 1763 a number of large cases containing surgical instruments were found among his possessions. Originating from his workshop, they served to treat then widespread maladies, among them kidney stones. Only very few of these instruments are still preserved today.

A few years ago, a pendulum clock with the inscription "anno. J. G. Zimmer A Reinhartz:1744" appeared on the art market. One of the earliest German pendulum clocks made for astronomical observations, it was very likely used together with the mirror telescope of Zimmer and Mercklein (cf. p. 64, ill. 3.16) on the tower of Schloss Reinharz, which had been heightened the same year. The clock is equipped with a minute pendulum and an inverse construction of the movement – with a so-called Huygens's endless winding mechanism, an invention of the Dutch mathematician Christiaan

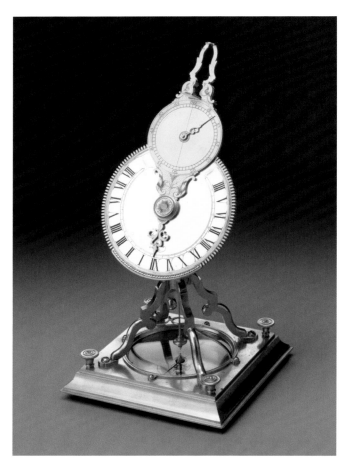

3.26 Equinoctial Sundial, Johann Gottfried Zimmer, Reinharz, circa 1760, gilded and silvered brass, glass, blued steel, maximum height: 22.7 cm, width: 11.2 cm, depth: 1.2 cm, inv. no. D I 9

Huygens (1629–1695) – as well as a pioneering clock face. Within the dominant minute ring a window is situated. Behind it, the second-disk turns; its scale is made up of four times the sequence of the numbers 1 to 60. Below the minute ring, through one further window, the hours are shown in Roman numerals. This clock was constructed to read the smallest time units (ill. 3.27).

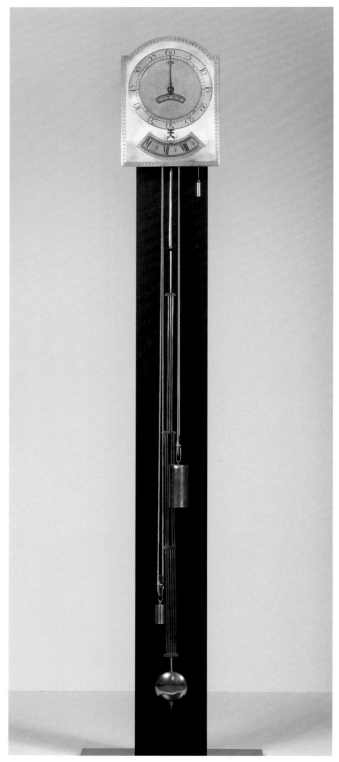

3.27 Pendulum Clock, Johann Gottfried Zimmer, Reinharz, 1744, gilded and silvered brass, lead, steel, width: 20.7 cm, height face: 28.2 cm, pendulum length: 123.3 cm, inv. no. D III 24 (acquired in 2016)

The Zwinger's Time Service. The Salon as Government Agency

For about 150 years, the Mathematisch-Physikalischer Salon was the place for Dresden's time.

The Salon took on this function after 1777, when the enthusiastic astronomer Johann Gottfried Köhler (1745–1800) was made its first inspector. Köhler immediately began to make celestial observations. This required a precise determination of the time. Therefore, he proceeded to compare the Sun's zenith at noon – using a meridian running through the Mathematisch-Physikalischer Salon – with the passage of a precision pendulum clock to determine the local time for Dresden: He looked at the pendulum clock at 12 o'clock, the very moment the Sun reached its zenith. Under Wilhelm Gotthelf Lohrmann (1796–1840), inspector since 1827, a brick extension was added to the Zwinger terraces in 1829. Intended for astronomical research and for the Time Service, it replaced a wooden structure from 1819 and remained until 1928 (ill. 3.28).

The time determined here became Dresden's official reference time. Köhler's activities and multiple publications of the celestial occurrences observed from the Zwinger assured the salon a firm place within the network of European observatories.

The transit instrument is placed exactly over a meridian, a longitudinal circle running through South- and North Poles. It was originally mounted between deeply anchored, massive sandstone columns to prevent vibrations. Its telescope can only be tilted vertically and cannot be moved horizontally. Thus, it always remains over the meridian and points to the south. Thanks to a crosshair in the ocular of the telescope it is possible to determine the exact moment when a celestial body passes a line – i.e. when the latter reaches its zenith. For the Sun it means that it is then 12 o'clock "true local time" (ill. 3.29).

The first clock in the Salon's Time Service office, Köhler's precision pendulum clock worked there for more than 100 years and was among the first precision clocks manufactured in Saxony. Its approximately one-meter-long pendulum swings once a second. Minutes are recorded on the large clock face, whereas the small clock faces at top and bottom show seconds and hours (ill. 3.30). Köhler was self-educated as a clockmaker.

This pendulum clock, a so-called seconds counter with small power reserve, ticks in second intervals. The bell tolls every minute, allowing the observation of the passage of the Sun or a star through the transit instrument, while at the same time counting the seconds that have passed since last looking at the precision pendulum clock and controlling

3.28 Extension (Meridian House) from south (photographed in 1927)

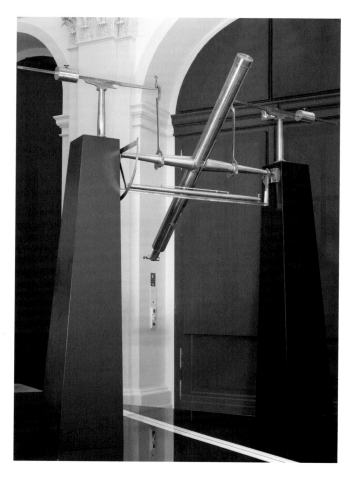

3.29 Transit Instrument, William Cary, London, circa 1800, brass, steel, glass, height: 138.5 cm, maximum width: 208 cm, inv. no. C II 8

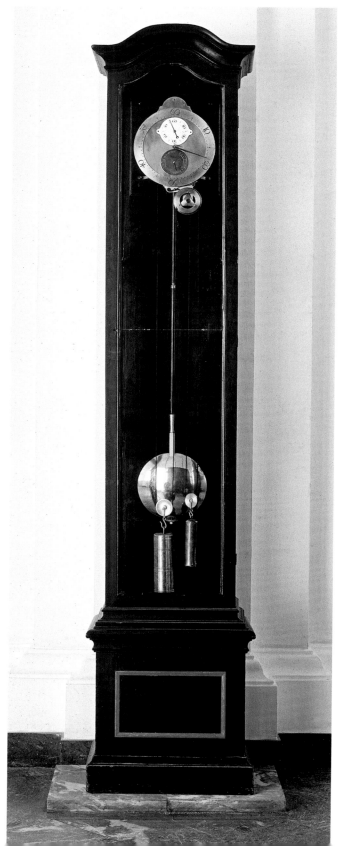

its passage. This "eye-ear" method was especially popular in places like Dresden, where only one person was responsible for making the observations (ill. 3.31).

Around the year 1800, Thomas Mudge jun. (1760–1843), son of the famous clockmaker with the same name, produced marine chronometers that were considered to be

3.30 Precision Pendulum Clock, Johann Gottfried Köhler, Dresden, before 1777, deal, brass, iron, glass, case: pear wood, height: 199 cm, width: 42.5 cm, depth: 25.5 cm, inv. no. D III 12

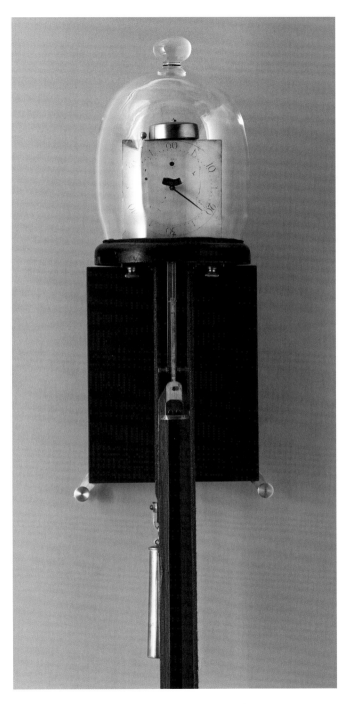

3.31 Seconds Counter, Johann Gottfried Köhler, Dresden, circa 1790, brass, partly silvered, pendulum rod spruce wood, movement: height: 22.8 cm, width: 8.5 cm, depth: 5.5 cm, pendulum rod: length: 86 cm, pendulum bob: diameter: 22.1 cm, inv. no. D III 23

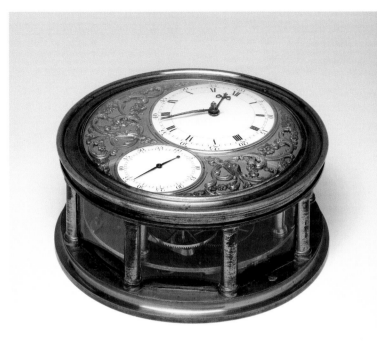

3.32 Marine Chronometer "COPIE No. 18," Thomas Mudge jun., Robert Pennington, Richard Pendleton, et al., London, 1796, gilded brass, enamel, glass, silver, diameter: 12.5 cm, height: 6.7 cm, inv. no. D IV b 12

among the most precise at the time. This clock entered the Salon in 1803 as a gift of Count Brühl and was used to determine the time. Since this chronometer could be easily transported and was effectively protected against impact, it was easy to set it to the time of Köhler's precision pendulum clock which was placed in the safe inside. This made it possible to control it on the outdoor observation spot with the help of the chronometer (ill. 3.32).

What enables an observer to find the northsouth direction? This specially mounted telescope makes the search easier. First, the observer targets a star in the southeastern hemisphere, then the lens barrel is screwed onto the semicircle and the targeted direction is marked along the lower ruler. After that, the telescope is turned and the observer waits until the same star appears in his telescope at the

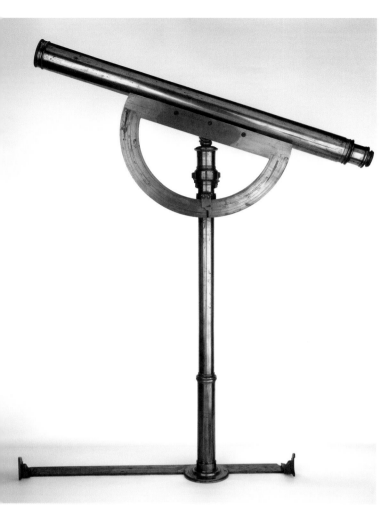

3.33 Equal-Altitude Instrument for finding the local meridian, probably Dresden, circa 1780, brass, lacquered, glass, tube: length (minimal): 68.5 cm, diameter: 5.6 cm, stand: height: 81.5 cm, depth: 13.3 cm, length (sight) 57.5 cm, inv. no. C II 11

the disposal of the elector, a man keenly interested in the natural sciences.

Precision Instruments to Determine the Position of Stars

Although telescopes had already entered the Kunstkammer in 1613, we only have scarce information pertaining to their use in observing celestial phenomena for the ensuing 150 years, especially comets and solar- or lunar eclipses. The use of telescopes for regular celestial observations and systematic surveys can only be proven at the Dresden court in the last third of the 18th century. At that time, there was a strong interest in astronomy, actively shared by Elector Friedrich August III (1750–1827), the Salon's inspectors, and Count Hans Moritz von Brühl. The latter, envoy to the English Court, was an especially passionate astronomer; in his London environment he initiated numerous improvements of scientific instruments. From his own collection, he gave the circle illustrated here to Leipzig's Universitätssternwarte in 1803. He also presented the above-mentioned chronometer by Mudge jun. (cf. p. 73, ill. 3.32) to the Saxon elector for the Zwinger observatory.

Thanks to the precise division of its scales and the magnifying glasses attached above them, the circle was capable of reading the position of stars within up to 10 arc seconds, i.e. the 360th part of one degree. Once referred to as the "most beautiful and most accomplished instrument" (Möbius 1823, p. 14) in the Leipzig observatory on the Pleißenburg, it has been in Dresden since 1905 (ill. 3.34).

Quadrants, the most important astronomical instruments before telescopes were invented, served to identify the position of stars. Johann Gottlieb Köhler commissioned the quadrant in order to broaden the Salon's holdings of

same height in the southwestern sky and notes this direction on the ruler as well. At that point, south is the center of the two targeted directions (ill. 3.33).

This instrument can be dismantled and can thus easily be moved. Therefore, it was possibly used to determine local meridians and may have been used in other places as well. We know that during the summer months Köhler had to travel regularly from Dresden to Pillnitz, where he was at

3.34 Astronomical Circle, Edward Troughton, London, 1793, brass, glass, steel, mahogany, height: 175.5 cm, width: 105 cm, depth: 90 cm, inv. no. C III c 33

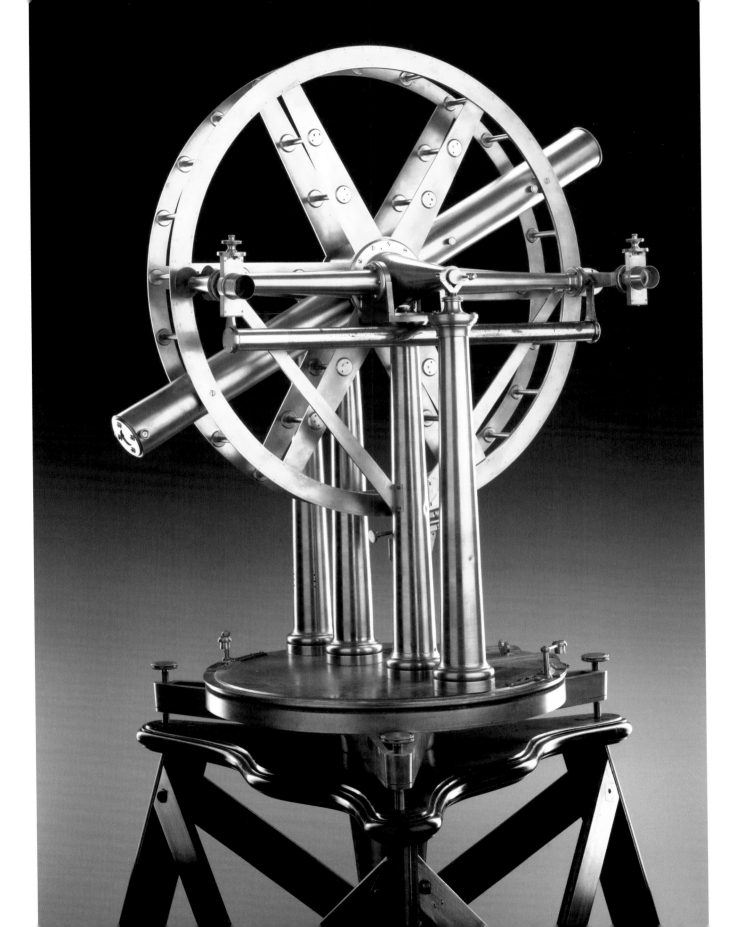

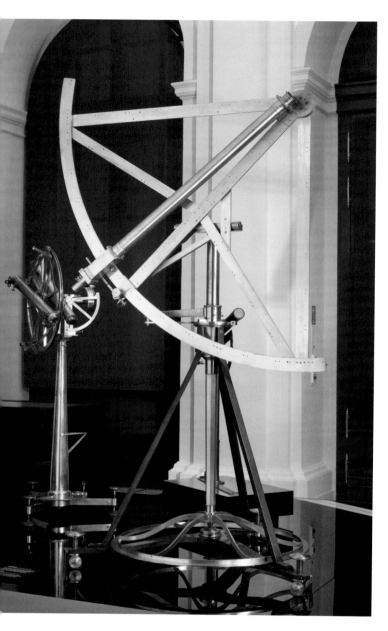

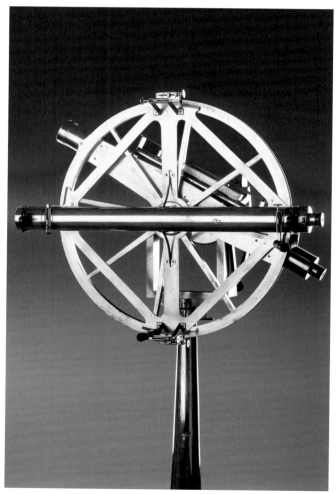

(i.e. the angle between the meridian and the vertical plane). However, this device remained unfinished (ill. 3.35). It was customary for Köhler to pay for such orders out of his own pocket. He died deep in debt.

Equipped with two telescopes, the special construction of this repeating circle makes repeated targeting and hence measuring of angles easier. This instrument, used at the Leipzig observatory, can be applied to precision-measure angles in land surveying as well as in astronomy (ill. 3.36).

3.36 Borda Repeating Circle, Étienne Lenoir, Paris, circa 1790, brass, iron, glass, wood, ivory, height: 143.5 cm, width: 67.7 cm, depth: 50.5 cm, inv. no. C III c 35

3.35 Quadrant, Johann Jacob Schöberlein, Dresden, brass, iron, stand: partly lacquered black, height: 202 cm, inv. no. C III c 32

astronomical measuring instruments. This device made it possible to identify the height of a star above the horizon; in addition, it was also capable of determining the azimuth

A famous relative of this device in France was used, beginning in 1792, to measure the length of a northsouth line between Dunkirk and Barcelona. The resulting circumference of the Earth served to derive the length unit "meter" from it (as one 10,000,000th part of the quadrant between equator and North Pole).

Meteorological Observations in the Zwinger

Beside regular astronomical observations to determine the time, the inspectors of the Mathematisch-Physikalischer Salon began their systematic weather recordings in 1828: Six times per day, temperature and air pressure – plus wind force, precipitation and the Elbe's water level – were measured and noted in the Zwinger. Ministries and farmers used the data for plans and to make decisions – and once even a court was among the users in conjunction with a murder trial. The measuring instruments no longer exist. However, a large-sized tome has survived with the handwritten readings of the first 25 years (1828–1852; ill. 3.37). These entries have been digitized; the vast quantity of data can be accessed interactively on a screen in the permanent exhibition.

3.37 Cover of the manuscript with weather data in Dresden for the years 1828 until 1852

PETER PLASSMEYER

BOGENGALERIE
The Course of Time

In Europe, the history of mechanical clocks begins in the Middle Ages with huge, weight-driven clocks in church towers or town halls. Their strike of the hour structured the life of the community and was a call for prayer. Often complex apparatus, they not only indicated the time, but illustrated divine creation as a whole, including the celestial course and the creatures of Earth, for example, a cock crowing the hour.

When the mainspring was invented in the 16th century, it became possible to build smaller clocks. They began entering the private realm in the shape of table clocks and later became wearable as pendant- or pocket watches. Precious cases protected the clockwork from dust and dirt. According to our present standards, early clocks were not particularly precise. It was not until the middle of the 17th century, with the introduction of the pendulum, that they became precision instruments.

Initially, clocks entered the Mathematisch-Physikalischer Salon as necessary auxiliary devices for the observatory, instituted in 1777 (cf. chapter 3, p. 71). With the final dissolution of the Kunstkammer in 1832, Renaissance clocks and automata with courtly provenance began to be added. A systematic development of the clock collection did not begin until 1909, when the Salon's Inspector Max Engelmann (1874–1928) acquired a substantial part of Dresden watchmaker Robert Pleißner's (1849–1916) collection for the museum. At one go, 95 clocks – ranging from 16th-century pendant watches to late-19th-century pocket chronometers – entered the collection.

Exquisite examples from the collection document the history of the clock from its outset to the beginning of clockmaking in Glashütte in the Erzgebirge region, where watches began to be manufactured in the mid-19th century, when Ferdinand Adolph Lange started to train young watchmakers there. Successful to this day, Glashütte products count among the best in the world.

The so-called Gothic wall clock marks the beginning of the clock's history. Mounted on a chair-like console, this weight-driven wall clock is one of the oldest surviving domestic clocks. Similar objects already appear in paintings of such Florentine masters as Fra Angelico (1387–1455) and Sandro Botticelli (1445–1510); they were used from the 15th until the late 17th centuries. This clock demonstrates that some were in use for several centuries. Likely produced in the first half of the 16th century, this clock was originally equipped with a balance, which was replaced with a pendulum after 1657 – the year the first pendulum was fitted into a clock. The modification "for pendulum" is an important hint to support the notion that early clocks could be kept in operation for long periods of time.

The simple construction without a case is striking: this clock offers easy access to examine the movement and striking mechanism. The only decorative element, now lost, was the painted clock face which was subsequently replaced by one made from Plexiglas. The polished stainless steel parts and the two bells are later additions to this clock, which entered the collection as a fragment (ill. 4.1).

16th- and Early-17th Century Clocks

With the introduction of the mainspring in the 16th century, it became possible to produce smaller clocks and movements. Table clocks in the shape of turrets or monstrances as well as ones with horizontal clock faces were particularly popular. The challenge was to come up with increasingly small clockworks while at the same time increasing the technical complexity in order to combine the maximum number of displays and automaton functions in one encasement. The most important watchmaking centers were the free imperial cities: Augsburg, Nuremberg, and Strasbourg.

Table clocks in the shape of gilded turrets resembling miniature versions of medieval clocktowers were typical for the time around 1600. A particularly appealing example is this turret clock by Paulus Schuster (master by 1587–1624), a clockmaker from Nuremberg. Made in 1587, this was his masterpiece. It came into the possession of the Saxon electors when Electress Sophia (1568–1622) purchased it as a Christmas present for her husband, Elector Christian I (1560–1591). The captivating elements of the turret include its filigree design and the fantastic basse taille enamel. Big and small clock faces offer a multitude of astronomical, astrological, and mechanical information (ill. 4.2a, b).

Mounted on the front, the main clock face shows an astrolabe (cf. chapter 2, p. 51) and a Sun hand to indicate the hours (twice the numerical sequence I–XII), plus two additional silver Moon and dragon hands. If the dragon hand is congruent with Moon and Sun hands, a solar or lunar eclipse will come to pass. A small clock face on the lower left indicates quarter hours and minutes; a clock face on the lower right side shows "half time" (with the Roman numerals I–XII); beside it the alarm can be set.

4.1 Gothic Wall Clock, probably south Germany, mid-16th century, later converted to accommodate a pendulum, iron (new additions include bells, weights, and hammer), height without weights: 49 cm, width: 15 cm, depth: 16 cm, inv. no. D IV b 183

The annual calendar and a hand for the "big clock" (with the Arabic numerals 1–24) are mounted on the back. In its center, various moveable segment disks offer information pertaining to the number of bright day- and dark night hours. Weekdays and planetary gods are shown on the lower left, and on the lower right side, the striking mechanism can be set. The four Neptune figures on the corners of the pedestal alternate moving their heads every minute for 15 seconds, whereas the cock crows near the tower top at full hour, while two men ring the bells. The bronze relief on the base depicts the deeds of Hercules. A total of eight mechanisms move clock faces, striking mechanisms, and the automata.

Beside turret clocks, table clocks in the shape of monstrances, mirrors, or tabernacles were also widespread. The special feature of Caspar III Buschmann's (1563–1629) clock (ill. 4.3a) is its ebony case. Ebony was a very rare material in Europe. Thanks to the Fugger trading company, it came to the West and to Augsburg from the Indian town of Goa, where the Fuggers had a branch. Ebony objects were stamped with hallmarks as was the custom regarding silver works. The producers thereby guaranteed that they were not merely using fruitwood dyed black.

The backplate is equally sumptuous: The hammers of the striking mechanism are dolphin-shaped – in those days, dolphins were thought to look like this. (ill. 4.3b).

Of the uncounted preserved clocks with a horizontal clock face, this table clock with mounted alarm (ill. 4.4) bears a particularly early signature. An inscription on the top of the clockwork's barrel states that Jakob Zech (died 1540) from Prague built it in 1527. The alarm was added approximately 100 years later. It is placed on the clock face in such a way that the hook under the alarm determines the wake-up time. When the hour hand moves the hook sideways, the alarm is released and begins to ring.

Clockwork-driven automata were especially popular toward the end of the 16th century, specifically when technically complex and opulently designed. Outstanding Salon specimens of this type are discussed in chapter 2 (cf. p. 19).

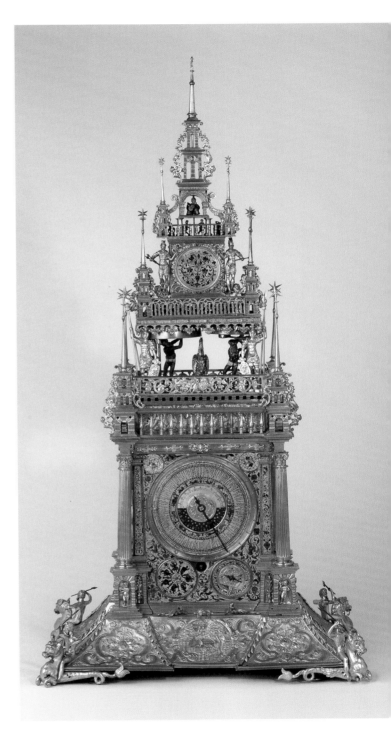

4.2 Table Clock, Paulus Schuster, Nuremberg, 1587, bronze, brass, silver, glass, wood, height: 78 cm, width: 36 cm, depth: 30 cm, inv. no. D V 8

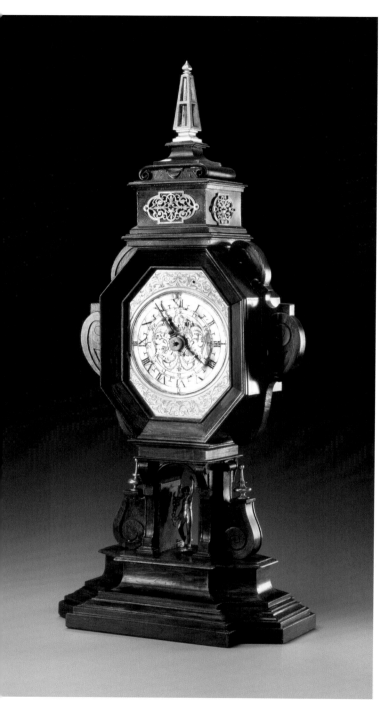

Later, large quantities of simpler automata were manufactured with eyes that moved according to the balance wheel's pace – connected with the latter via rods, they move as long as the clock is wound: These automata are also referred to as "eye changers."

Quite a few automata in the Salon collection depict animals, among them an eagle, a dog, and a lion. The "Turkish rider" is an eminently handsome example. In his case, a bell in the pedestal strikes the hour, upon which he bows his head and lifts the sword. (ill. 4.5).

What is noteworthy about these automata is how small their clock faces are and that one must really search for them. They are merely a hint at the driving mechanism: the

4.3b Monstrance Clock, Caspar III Buschmann, detail: back plate, inv. no. D IV b 17

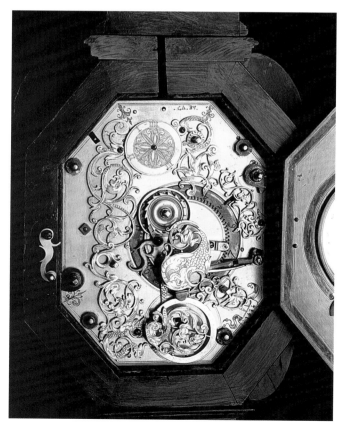

4.3a Monstrance Clock, Caspar III Buschmann, Augsburg, circa 1625, case: ebony, veneer, movement: gilded brass, height: 55 cm, width: 23.5 cm, depth: 16.5 cm, inv. no. D IV b 17

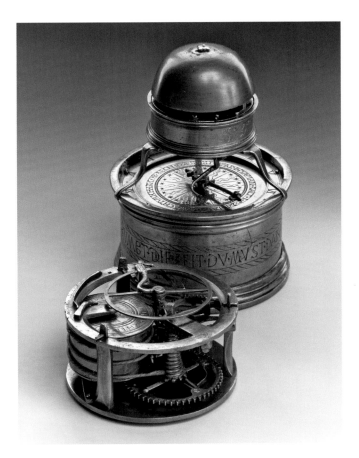

4.4 Table Clock with Alarm, Jakob Zech, Prague, 1527, brass, iron, diameter: 10 cm, height with alarm: 15 cm, inv. no. D IV b 153

in English. These watches were highly sensitive; the mainspring frequently broke if the watch was dropped and could no longer be used. Also the hands – in the beginning there was only an hour hand – needed to be protected to prevent the imminent danger of catching them in the wearer's garments. This is why the hands were protected either with a glass or a metal cover. The latter was executed in fine openwork, not only for aesthetic reasons. This offered

4.5 Automaton "Mounted Turk," probably Augsburg, late 16th century, gilded brass, iron, ebony, length: 33.5 cm, width: 22.5 cm, height: 42 cm, inv. no. D V 1

clock function is incidental. Once part of a pair – one moved forward, the other backward – this crayfish automaton, a reproduction of a crayfish (ill. 4.6a). The backward-crawling piece was lost during World War II. The automaton can move its pincers, legs, and tail. Two gearwheels that protrude from the chest as well as one additional support wheel move it forward – the legs move freely in the air (ill. 4.6b).

In addition to the big clocks already presented, small clocks make up the second group of mechanical clocks. Before moving to pockets and wrists, they used to be worn on a chain around the neck and are called "pendant watches"

4.6a "Crayfish" Automaton, top, Augsburg, 1589, copper, brass, steel, length: 20.5 cm, width: 13 cm, height: 3 cm, inv. no. D VII 3

4.6b "Crayfish" Automaton, bottom, inv. no. D VII 3

easy visual access to the numerals and hands, thereby making it possible to read the time with the cover closed. (ill. 4.7).

This oval-shaped pendant watch is among the perfectly worked pieces required to be presented in addition to a table clock to pass the master exam in Augsburg between 1577 and roughly 1732. The clock face displays hour (1–12), date (1–31),

weekday, as well as the phase of the Moon (full Moon – decrescent Moon – new Moon – waxing Moon), and age of the Moon, i.e. a subdivision into 29 ½ days, the length of a cycle duration (1–29 ½). A striking mechanism may occasionally be found housed in a small case (ill. 4.8).

Wearable clocks came in multiple forms and shapes, be it in the guise of crosses, tulips, or skulls. The search for un-

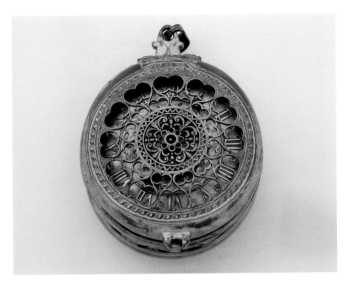

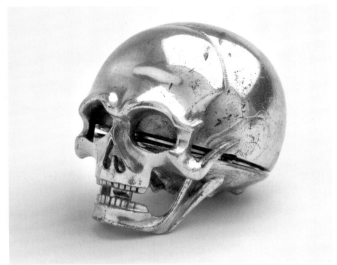

4.7 Pendant Watch, Jean Baptiste Deboule, Geneva, circa 1630, brass, steel, diameter: 3.9 cm, height: 7.3 cm, width: 5.3 cm, inv. no. D IV a 133

4.8 Pendant Watch, probably Martin Zoller, Augsburg, circa 1630, silver, brass, steel, diameter: 2.9 cm, height: 4.78 cm, width: 3.66 cm, inv. no. D IV a 425

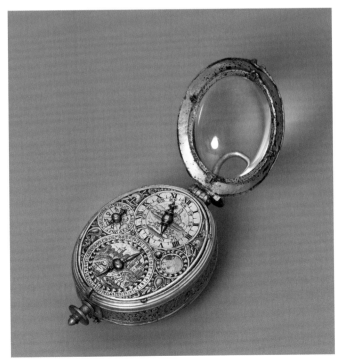

4.9a, b Skull-Shaped Pendant Watch, Jaques Joly, Geneva, circa 1630, silver, brass, steel, height: 3.7 cm, width: 3.4 cm, depth: 4.4 cm, inv. no. D IV a 255

usual motifs frequently resulted in the creation of virtuoso cabinet pieces. In this example, the movement is placed in the calvarium. Opening the lower jaw reveals the clock (ill. 4.9a, b).

Early Paths of Precision

The precision of 16th-and 17th-century clocks often left much to be desired. Even elaborate and expensive clocks were repeatedly a quarter hour fast or slow. At first, this was a construction flaw. Unlike weight mechanisms, a clock drive with a mainspring results in irregular force delivery. As the spring unwinds, the force it releases diminishes. Experiments to solve this problem were undertaken time and again, for instance with the assistance of rolling-ball clocks: Its movement is regulated by the run of a ball over an inclined plane.

In the early 17th century Galileo Galilei discovered that a ball covering an identical distance always rolls down an inclined plane with the same velocity. When building his clock, Matthäus Halleicher (1643/44–1704) made use of this principle (ill. 4.10): Located on a bridge that rests on two baluster-shaped feet – flanked by turrets on both sides – is a rolling ball. A central structure with the clock face rises in the middle. Within the bridge, behind a glass pane, a ball runs on two stretched wires – at first from left to right and then back again to the left end of the bridge. Located below the left turret and connected via hidden means, the weight of the ball releases the driving mechanism and the hands in the central structure. At the same time, the ball is raised to the upper track again with the aid of a type of lift ("Schöpfer") and the next cycle begins. A cycle of the ball on the stretched and tilted steel wires in the so-called running box

4.10 Rolling-Ball Clock, Matthäus Halleicher, Augsburg, 1674, pear wood, pine, brass, steel, glass, silver, height: 89.5 cm, width: 141 cm, depth: 27 cm, inv. no. D IV b 30

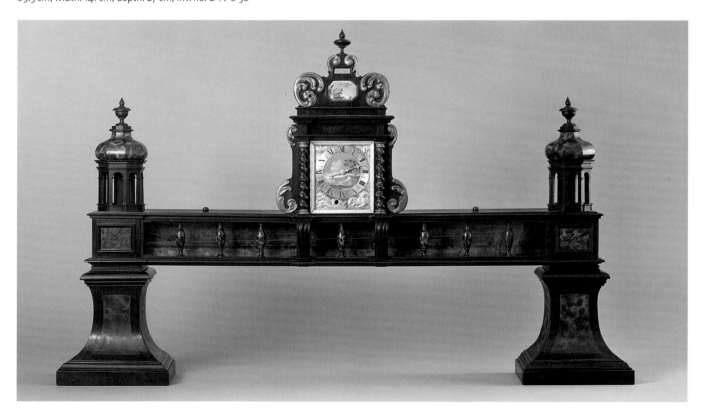

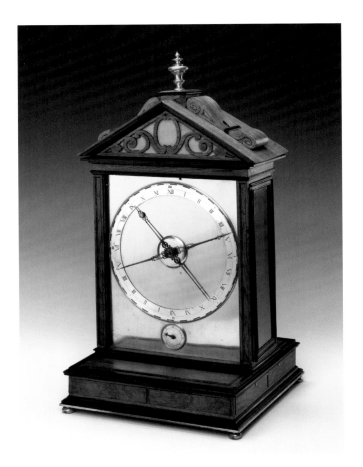

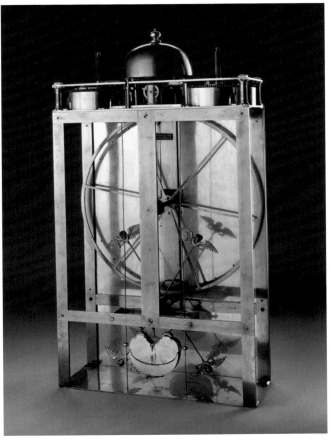

4.11a Table Clock with Cross-Beat Pendulum, front, attributed to Jost Bürgi, Prague, circa 1625, wood, silver, brass, steel, glass, height: 50.5 cm, tympanum width: 27.5 cm, base depth: 26.5 cm, inv. no. D IV b 24

4.11b Table Clock with Cross-Beat Pendulum, movement from the back, inv. no. D IV b 24

takes 12 seconds – thus the hand's step time is also exactly 12 seconds. This means that the hour hand is moved forward five times per minute. In this case, a movement with verge escapement is indispensable. However, it only operates the lift that carries the ball back to its initial position.

Although convincing, this principle failed, mainly because the ball could easily get derailed even after a brief run. Practical experiences thus overruled the advantages of theoretical precision.

This table clock ascribed to Jost Bürgi (1552–1632) of Switzerland uses a different mechanism (ill. 4.11a). It is equipped with a so-called cross beat escapement and a remontoire. The clock face has a minute-track and is capable of counting the hours from I to XII twice. Unusually thin hour and minute hands turn over the clock face. The small clock face below the chapter ring serves as gear adjustment. Thanks to lateral glazing, the big escape wheel with cross beat escapement and driving weight can be seen. Numerous sophisticated details were built in here, enabling the improvement of synchronism in table clocks. They usually do not have driving weights because they lack the necessary drop height – the weight would have to be lifted all the

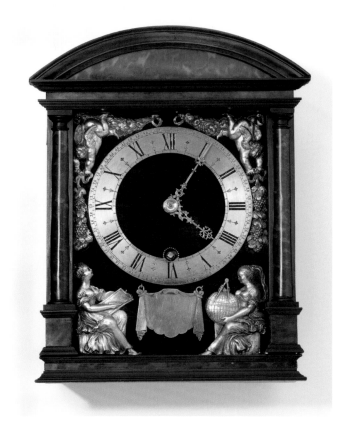

4.12 Haagse Clock, Johannes Steffens, The Hague, before 1674, silver, ebony, tortoiseshell, brass, steel, textile, height: 32.5 cm, width: 24.6 cm, depth: 12.5 cm, inv. no. D IV b 21

The speed difference of table clocks with cross beat pendulum is supposed to be less than a minute per day, making them the most precise clock before the introduction of the pendulum. Hans von Bertele (1903–1984) ascribed this clock to Jost Bürgi in the 1970s. However, a mid-17th-century drawing by Hans Buschmann (1600–1662) in the Herzog August Bibliothek in Wolfenbüttel shows an almost identical clock, making this suggestion doubtful.

The introduction of the pendulum marked a turning point in clockmaking. In 1657 the scholar Christiaan Huygens (1629–1695) ordered The Hague clockmaker Salomon Coster (1622–1659) to furnish a typical Dutch wall clock with a short pendulum: This was the birth of the pendulum clock. Fixed to the extended spindle, the pendulum moved on the back of the clockwork. The difference in accuracy of Coster's clocks was only 10 seconds per day – it took another 100 years to beat this figure.

Saxon Elector Johann Georg (1647–1691) gave this wall clock by Johannes Steffens from The Hague to his father, Saxon Elector Johann Georg II (1613–1680) in 1674. Due to its shape, it belongs to the very early pendulum clocks. Its noble case was made of tortoise shell, ebony, and silver applications (ill. 4.12).

The Clock as Furniture

During the Baroque and Rococo eras, clocks became integral furnishings and were thus part of the representational room design. The pendules, i.e. pendulum clocks produced in the milieu of the French court in Paris or Versailles, set the style throughout Europe. Distinguished by their elaborate cases, they were embellished with intarsia in the so-called Boulle-technique (named after the cabinet maker André-Charles

time. That is exactly what the spring mechanism achieves: It lifts the weight hourly. This model combines the compact construction of spring mechanisms with the high precision of weight drives. The clock received its name because of the cross beat escapement, Jost Bürgi made the first specimen in Cassel in 1595. The lateral glass panes make it easy to see the cross beat escapement. Thanks to two pallets – mounted on two separate shafts and alternately engaging the teeth of the escape wheel – the sequence of the movement is suppressed; the movement is only gradually released according to the pace of the two foliots swinging back and forth with the two shafts of the verge escapement (ill. 4.11b).

4.13 Wall Clock with Boulle Casing, signature: BALTHA-ZAR A PARIS, Paris, circa 1720, movement probably mid-19th century, bronze, oak, enamel, glass, brass, tortoiseshell, steel, height: 100 cm, width: 55 cm, depth: 26 cm, inv. no. D IV b 131

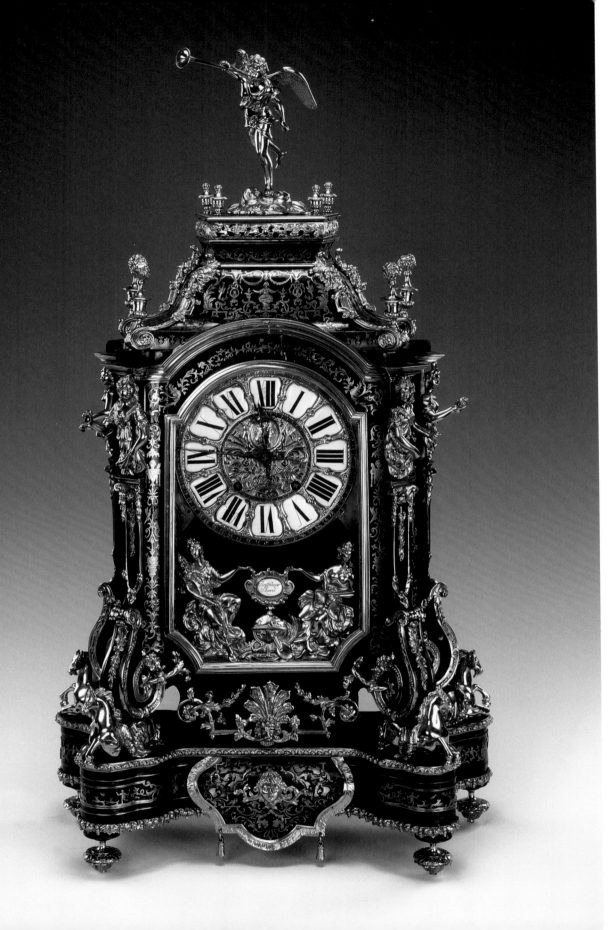

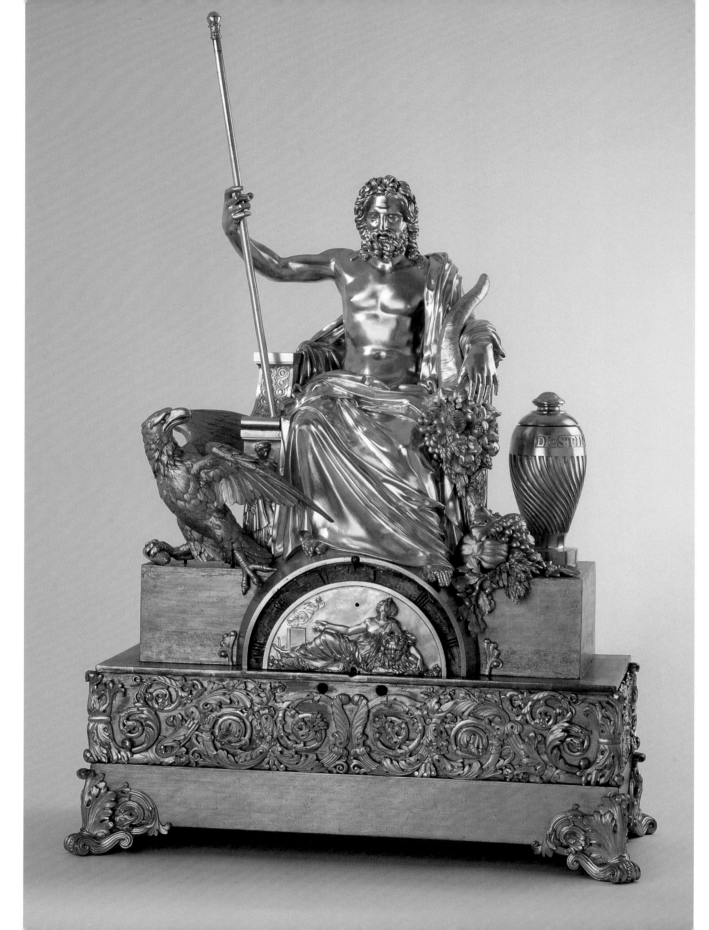

Boulle, 1642–1732), using tortoise shell and brass marquetry, as well as applied bronze castings (ill. 4.13).

With regards to clock faces, it ought to be pointed out that during the course of the 18th century, initially only the cartouches with the hour digits were enameled; this was later extended to comprise the entire clock face.

The design of French pendules changed all the time. Whereas in the beginning, the lateral portion below the clock face was constricted, towards the end of the 18th century the entire case began to develop into sculpture or a sculptural group. "Zeus enthroned" is an admirable example: Here, the Greek god is seated on a throne, holding a staff in his right and a cornucopia in his left hand; an eagle and an urn flank the throne. The rotating clock face is visible in a circle under the figures; an arrow indicates the time. Numerous versions of this pendule were produced. The wooden pedestal is a later addition; it appears that the base was originally made of stone (ill. 4.14).

Wearable Clocks

Pocket watches were representational pieces of jewelry, sometimes outfitted with sumptuous cases. At the end of the 17th century, when pocket watches from England and Switzerland began to replace those from southern Germany and France, some clockmakers – especially in Augsburg and Paris – began to specialize in constructing pocket sundials: They soon gained vast popularity: A well-liked travel-aid, the compass helped to determine directions and the gnomon aided in determining how much time remained until nightfall.

The golden case of this splendid pocket watch is enameled on all sides. The reverse reveals motifs from Greek

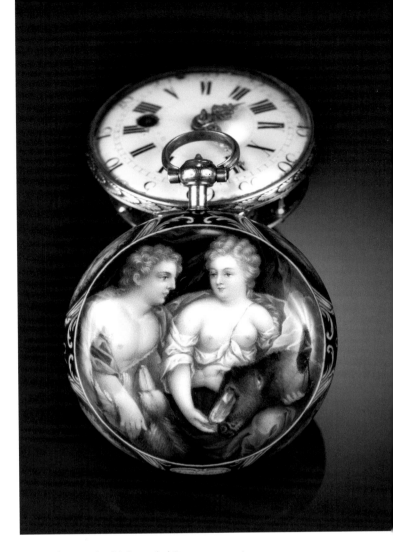

4.15 Pocket Watch with Enameled Case, movement: James Leroux, London, late 18th century, case: Jean Pierre and Ami Huaut, Geneva, after 1700, gold, enamel, brass, diameter: 4.6 cm, height: 2.6 cm, inv. no. D IV a 293

mythology (Atalanta, Meleager, and the Calydonian boar), the edge is decorated with four landscapes, and the case interior bears the coat-of-arms of a French noble family, executed in counter-enamel. A cartouche near the case edge announces that the extraordinary little images were made by "Frère Huaut," the most famous enamel artists of the time. It is not unusual to find a clockwork by James Leroux from London inside, since many clockmakers sent their cases to be enameled and painted in Geneva (ill. 4.15).

4.14 Wall clock with "Zeus Enthroned," Paris, early 19th century, brass, bronze, wood, steel, height: 102 cm, width: 67 cm, depth: 32 cm, inv. no. D IV b 180

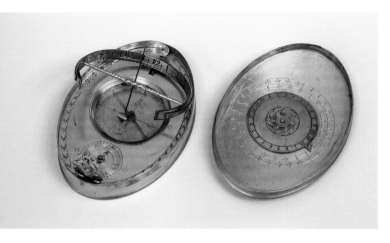

Hidden in an oval box, Salomon Krigner's (1691?–1745?) small pocket sundial is equally impressive. It consists of a chapter ring, gnomon, plumb bob, and compass. After the box is opened, the parts must be set up to perform their functions: The plumb bob is opened to bring the clock into a horizontal position. The compass takes care of the north orientation. Next, the hour ring must be set to the correct latitude, undertaken here very carefully: On a circular scale, a small hand is adjusted to the local latitude, for instance 51° for Dresden. Upon pressing the button, the hour ring moves immediately to the selected position. Now, only the gnomon must be erected – and the Sun must shine (ill. 4.16).

4.16 Equinoctial Sundial, Salomon Krigner, Warsaw or Marienburg, circa 1710, brass, glass, steel, silver, height: 1.4 cm, width: 8.0 cm, depth: 5.5 cm, height opened: 3.5 cm, inv. no. D I 80

This little sundial (ill. 4.17) by Augsburg clockmaker Johann Martin (1642–1721) functions according to another principle: Here, the chapter ring is not oriented parallel to the equator. Instead, it is located in the horizontal plane.

4.17 Horizontal Sundial and Moon Dial, Johann Martin, Augsburg, late 17th century, brass, steel, silver, case: wood and leather, base plate: width: 6.5 cm, depth: 6.9 cm, compass: diameter: 2.8 cm, height with set plumb bob: 5.0 cm, case: height: 1.6 cm, width: 7.9 cm, depth: 7.45 cm, inv. no. D I 146

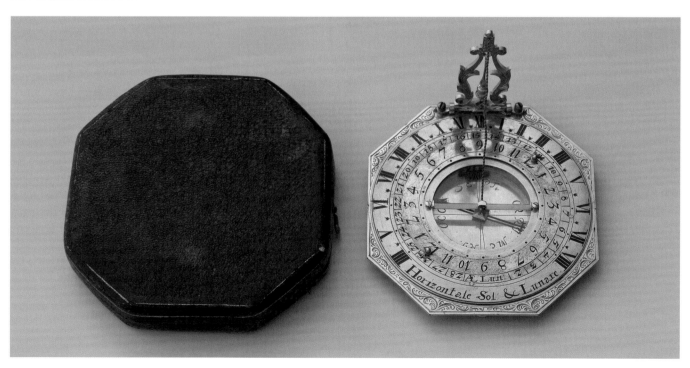

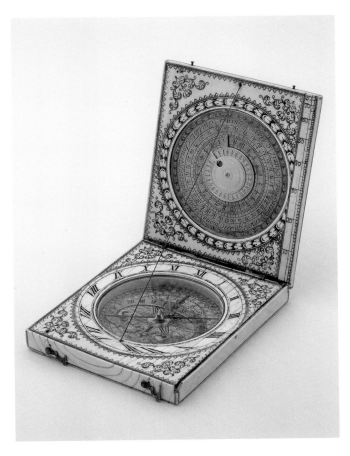

4.18 Diptych Sundial, Charles Bloud, Dieppe, after 1650, ivory, silver, glass, brass, steel, paper, height min./max.: 1.8/11.6 cm, width: 9.1 cm, depth: 10.7 cm, inv. no. D I 142

The French harbor town of Dieppe was another center for the sundial production. Charles Bloud (traceable between 1650 and 1685) became particularly famous thanks to his diptych sundials made from ivory. An equatorial sundial is embedded into the lid's top; when opening the sundial, one encounters a combination of a vertical and a horizontal sundial on the inside. Inserted into a lateral hole capped with a bronze plaque for transport, the gnomon is attached to the sundial when in use (ill. 4.18).

Of course, creative clockmakers were searching for ways to determine the time at night. The use of the Moon's shadow was already mentioned (cf. p. 92, ill. 4.17). So-called nocturnals (cf. p. 34–35, ill. 2.25, 2.26) were widespread and popular in seafaring. They took advantage of the fact that night by night the starry sky appears to revolve around the North Star: one circuit takes 23 hours and 56 minutes. The stars are thus slightly faster than the Sun, which circles

4.19 Nocturnal, Johann Michael Hager, Brunswick, after 1707, brass, silver, case: leather exterior, velvet interior, height: 0.7 cm, width: 5.5 cm, depth: 11.6 cm, inv. no. D I 144

Therefore, we refer to this as a horizontal sundial. The gnomon, the red thread, is fastened in such a manner that the angle it forms with the base plate corresponds with the local latitude. To this end, numerous drill-holes to determine different latitudes were placed along the plumb line, i.e. the part where the plumb bob is located. Finally, the pole thread must be threaded into the drill-holes.

This sundial enables the reading of the time with the aid of the shadow the full Moon casts. In order to do so, the chapter ring must be synchronized with the date. This sundial is kept in a leather-covered etui.

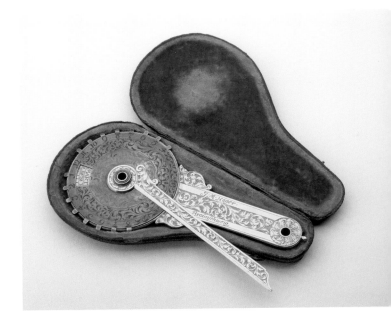

around the Earth, or so it was supposed at the time. The difference is approximately one additional celestial rotation per year; this corresponds to the ratio of 365 (sun) to 366 (stars). To take this difference into consideration, the hour digit was adjusted to the current date. Now, it was possible to aim at the North Star through the central hole and turn the hand (a.k.a. rule) until it touched the two last stars of the Big Dipper. At this moment, the time could be felt on the interface of hand and hour digit (ill. 4.19).

Priest Mechanics

One dominant question in 18th-century disputes related to the speed of scientific progress: How is it to be evaluated and how should it be dealt with? Theologians from different Christian denominations turned repeatedly to constructing astrological clocks and mechanical models to broaden their image of god's creation and its inherent laws. These churchmen are referred to as "priest mechanics." Their proximity to 16th-century instrument makers – who equally tried to reconcile divine creation with their astronomical observations – is astonishing.

Among the most famous priest mechanics are Prague-based Jesuit priest Johannes Klein (1684–1762) as well as Stuttgart court mechanic Philipp Matthäus Hahn (1739–1790) with his students Jacob Auch (1765–1842) and Johann Christoph Schuster (1759–1823).

One side of Klein's gorgeous clock shows a clock face with hour- and minute display, (ill. 4.20a) whereas the other side reveals a 24-hour clock face that also serves as equator for a terrestrial globe. The Polish crown rests on the upper attachment. A night bowl simulates where is presently day and night in the northern hemisphere (ill. 4.20b).

Additional Klein clocks with depictions of the Tychonic (named after Danish astronomer Tycho Brahe, 1546–1601) and the Copernican world views are kept in the Prague Klementinum. Klein also made clocks for the court of the Chinese emperor in Beijing.

Skeleton clocks were produced roughly contemporaneously with the French Revolution. They are clocks whose mechanism is no longer covered by a case. In order to protect the clockwork from dust, it was placed under a glass dome. Joseph Köstler (born in 1777, by 1814 master in Eisenstadt) created a captivatingly elegant clock in Eisenstadt, in the Austrian Burgenland region, with a skeletonized clock face on the outer ring that indicated hours, minutes, and months (zodiac signs). Three little clock faces are located in

4.20a Geographical Table Clock, Johannes Klein, Prague, 1738, brass, bronze, enamel, glass, wood, silver, steel, height: 87.5 cm, width: 57.5 cm, depth: 41.5 cm, inv. no. D IV d 3

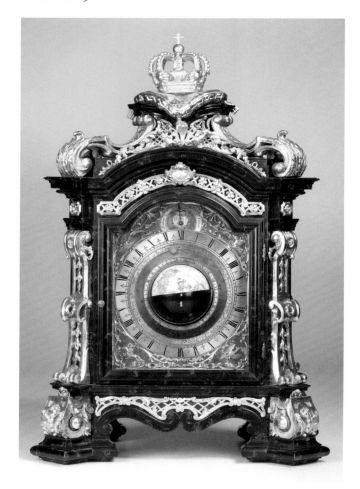

the center: the upper one indicates seconds, the one below it to the left weekdays, and the lower right one the time for 24 towns or countries (ill. 4.21).

In the early 19th century, the princely Esterházy family remodeled their Schloss in Eisenstadt according to Charles de Moreau's (1758–1840) plans. He integrated elements of monumental Classicism inspired by French revolutionary architecture. The design of Köstler's clock clearly reflects influences on this style.

4.20b Geographical Table Clock, opposite side, inv. no. D IV d 3

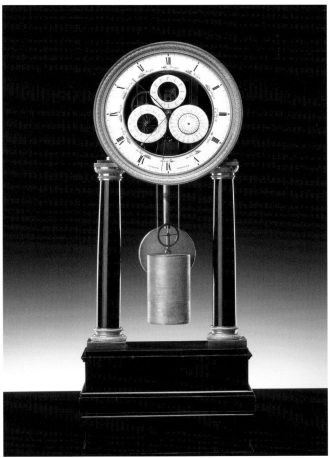

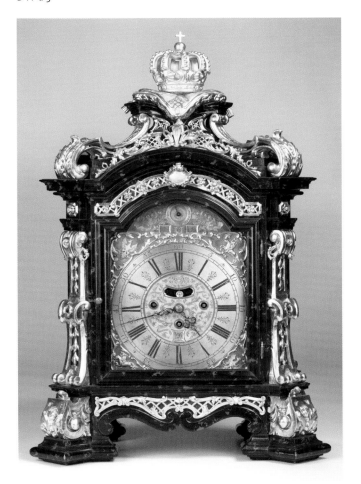

4.21 Table Clock, Joseph Köstler, Eisenstadt, Austria, circa 1815, pear wood, enamel, glass, gilded brass, steel, height: 47.5 cm, width: 22 cm, depth: 13.5 cm, inv. no. D IV b 119

Supported by Duke Carl Eugen of Württemberg (1728–1793) and working in the Swabian town of Esslingen, Philipp Matthäus Hahn caused a stir with his world machines and calculators. He employed family members and other staff in his workshop, where he also produced a complex pocket watch, probably executed by his son, Christoph Matthäus Hahn (1767–1833). The clock face shows twice twelve hours with red numerals on the left and black on the right side (each I to XII). Additionally, it has a minute division as well as Arabic numerals for quarter-hours. Four extra clock faces

mention the weekday on the top, age of the Moon and the phase of the Moon on the bottom, as well as the date on the right and the seconds on the left (ill. 4.22).

Starting in 1770 Hahn also began to build calculators, which he did not present until ten years later. They count among the first fully-functioning four-species-calculation machines, used for all four basic arithmetic operations. Jacob Auch, later the Duke of Weimar's court clockmaker and mechanic, also apprenticed in the workshop. The latter's calculator, shown here, has a capacity of eight digits with two digits for money accounting in Kreuzer currency (in accordance with the decimal system: 1 and 10) and six digits for Gulden currency (1, 10, 100, 1,000, 10,000, 100,000). An eight-digit gearing made of gearwheels and conveyors is placed between the lower and the middle of the three circuit boards. The transmission serves as the arithmetic unit. This machine also masters all four basic arithmetic operations (ill. 4.23).

4.23 Mechanical Calculator, Jacob Auch, Vaihingen an der Enz, 1790, brass, ivory, enamel, wood, leather, steel, case: height: 7.4 cm, width: 23.4 cm, depth: 6.5 cm, machine: height: 1.7 cm, width: 22.3 cm, depth: 5.1 cm, inv. no. A II 66

4.22 Pocket Watch, probably Christoph Matthäus Hahn, Stuttgart, circa 1790, enamel, brass, steel, diameter: 5.6 cm, depth: 2.5 cm, inv. no. D IV a 210

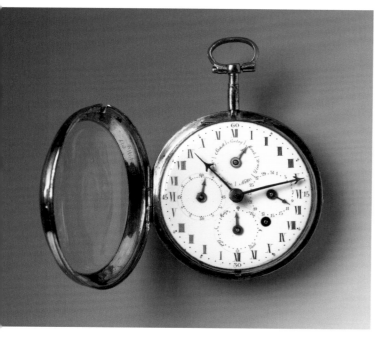

A Stage for the Time

Built in 1896, this model for the Semperoper's 5-minute-clock came to the Salon's collection in 1980. Its prototype was created in the first Semperoper, which opened as the Hoftheater in 1841. Unique for an opera house, the audience is informed about the time: Two windows are installed above the proscenium. The hours are indicated in Roman numbers at the left; the right window reveals – in Arabic numerals – the minutes in five-minute intervals. Johann Christian Friedrich Gutkaes (1785–1845), who maintained the clocks in the Mathematisch-Physikalischer Salon and was later Ferdinand Adolph Lange's (1815–1875) teacher, was commissioned to construct this clock. After creating the clock for the opera house, Gutkaes was appointed as court clockmaker. Already very old at the time, he had long since made a name for himself and was famous far beyond Dresden.

The first 5-minute-clock was destroyed in the 1869 Hoftheater fire. When the second Semperoper was finished in 1878, a clock was installed above the proscenium once more.

Modeled on its lost predecessor, however, the numbers were slightly enlarged for better legibility. This clock was conceived by Ludwig Teubner (1825–1907), who had first served as Gutkaes's assistant. Exhibited at various fairs in Dresden and Magdeburg to promote the studio, the model shown here was made in Gutkaes's workshop in 1896 (ill. 4.24).

Competitions

Jean François Poncet (1714–1804) was made court clockmaker in Dresden in 1739. A number of his clocks have survived. We know that he referred to ebauches from Augsburg, Friedberg, and England for his work. Due to their often very

4.24 Model of the "5-Minute-Clock," Ludwig Teubner, Dresden, 1896, wood, glass, gold, brass, textile, height: 31 cm, width: 40 cm, depth: 35 cm, inv. no. D IV b 148

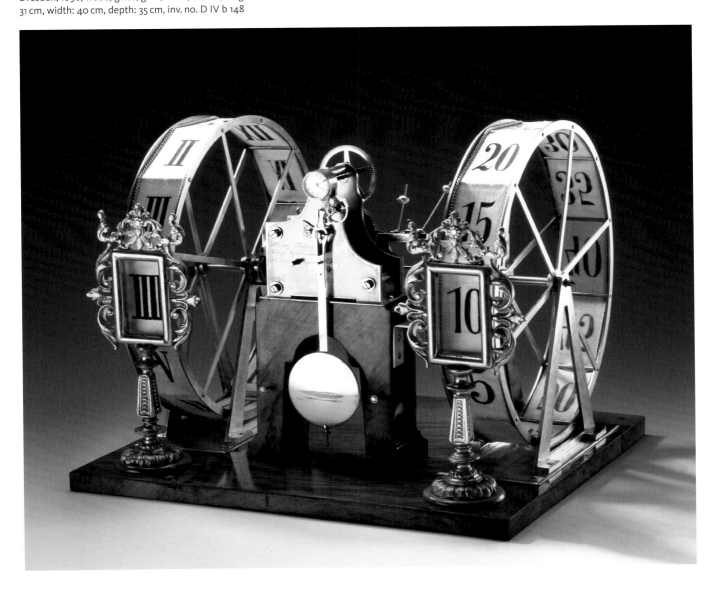

skillfully executed chased silver cases and figural scenes, his pocket watches and carriage clocks are particularly note-worthy. Equipped with a striking mechanism with repetition, the diameter of the carriage clock illustrated here is about twice that of a regular pocket watch (ill. 4.25).

For the longest time, Dresden's court clockmakers competed with the guild of organized clockmakers. Due to the guild regulations, the latter were closely tied to many restrictive rules. Intended to assure a certain minimum quality standard, this made innovations difficult. In contrast to the court clockmakers, the ones organized in the guild served the local market with longcase clocks, wall- and bracket clocks, pocket watches, and – especially popular in the 18th century – carriage clocks. Poncet's carriage clock (ill. 4.25) is a version of the latter. During the second half of

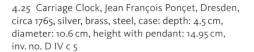

4.25 Carriage Clock, Jean François Ponçet, Dresden, circa 1765, silver, brass, steel, case: depth: 4.5 cm, diameter: 10.6 cm, height with pendant: 14.95 cm, inv. no. D IV c 5

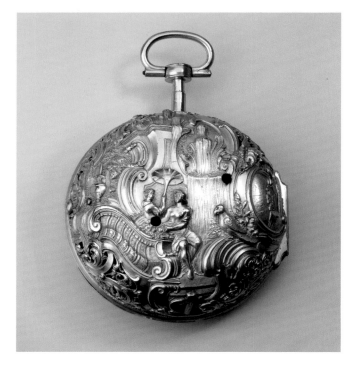

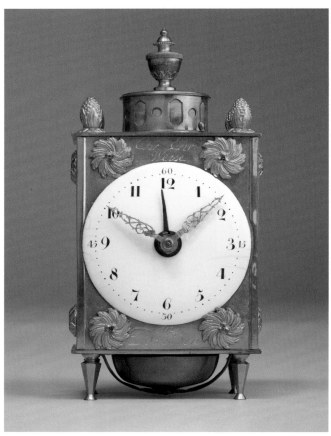

4.26 Travel Alarm Clock, Christian Ehregott Weise, Dresden, circa 1785, gilded and engraved brass, enamel, glass, height: 20.5 cm, width: 10 cm, depth: 6 cm, inv. no. D IV b 129

the 18th century, travel alarm clocks began to replace carriage clocks. An example is Christian Ehregott Weise's (1763–1811) carriage clock. Installed on the upper panel of this clock were a repeating train (R = repeat, N = not repeat) and the striking mechanism (S = strike, N = no strike); they could be switched on and off (ill. 4.26).

The repetition of Johann Gottfried Kriedel's (1702–1757) carriage clock is released by a pull, i.e. with the aid of a cord that could be pulled. Since Kriedel established himself in Cottbus in 1751, his clock must have been fabricated before that date (ill. 4.27).

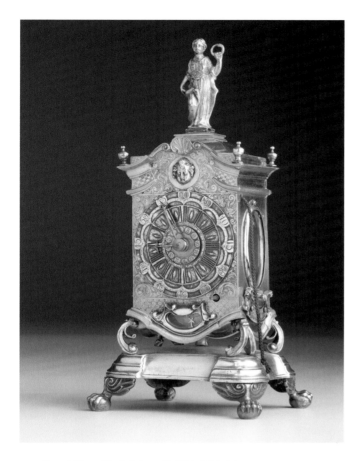

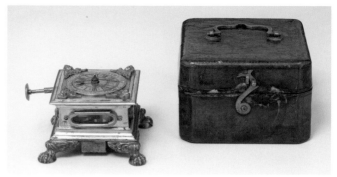

4.28 Travel Clock with Case, signed "Munier," Bautzen, 3rd quarter of the 18th century, gilded brass, bronze, steel, glass, wood, leather, height: 5.5 cm, width: 6.1 cm, depth: 6.1 cm, inv. no. D IV b 276

sible to the viewer – were also decorated and finished in minute detail: the ebauches were polished, engraved, and finished (ill. 4.29).

4.29 Horizontal Table Clock, Johann Gottlieb Graupner, Dresden, circa 1730, gilded brass, silver, steel, height: 10 cm, diameter: 11 cm, inv. no. D IV b 143

4.27 Travel Alarm Clock, Johann Gottfried Kriedel, Bautzen, circa 1749, gilded brass, silvered bronze, steel, glass, height: 25 cm, width: 12 cm, depth: 10.5 cm, inv. no. D IV b 275

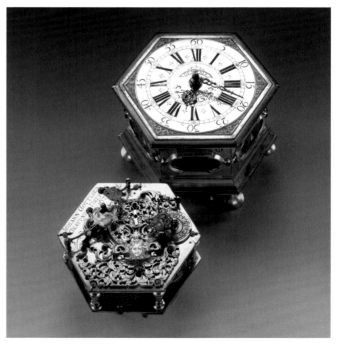

Signed "Munier," this carriage clock from Bautzen works according to a different principle: Here, the repetition, i.e. the mechanical alarm, is activated by pressing a trigger that protrudes from the case. The trigger is long enough that the repetition can be released even if the clock is inside its etui. This clock emulates the shape of horizontal table clocks that were popular in the 16th and 17th centuries (ill. 4.28).

Johann Gottlieb Graupner (um 1690–1759) was the maker of a late example of the horizontal table clocks that were popular in the 17th century. It exemplifies that in addition to the case, the other clockwork devices – normally inacces-

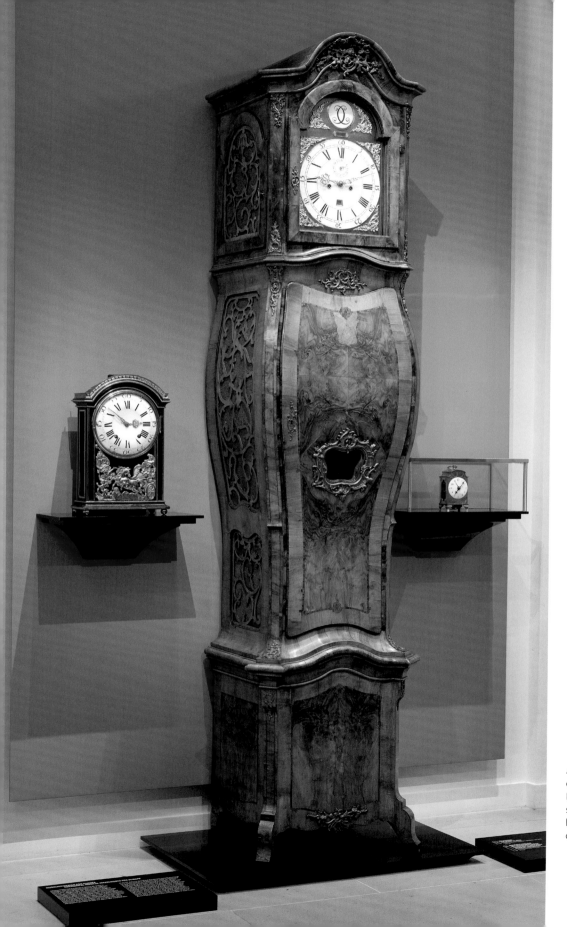

4.30a Longcase Clock with Musical Movement, Johann Gottfried Kaufmann, Dresden, 1774, walnut, steel, glass, bronze, leather, height: 277 cm, width: 67 cm, depth: 56 cm, inv. no. D IV b 141

4.30b Pinned Barrel for Longcase Clock with Musical Movement, inv. no. D IV b 141

Music Automata for Europe

Johann Gottfried Kaufmann (1752–1818) began his apprenticeship as a clockmaker in Dresden in 1770. He soon specialized in music automata. In the beginning of the 19th century he and his son Johann Friedrich (1785–1866) started constructing mechanical musical instruments that were placed in public dance halls throughout Europe. An imposing longcase clock – one of Kaufmann's earliest works –stood in the firm's Dresden premises. Erected on its back wall, a sort of pianoforte is located inside. It is equipped with 42 hammers that beat the strings and one hammer that makes a little bell ring. Thanks to laterally placed holes on the case, the sound travels freely throughout the space (ill. 4.30a). Among the surviving accessories are ten pin drums with three music pieces each (ill. 4.30b) – the last one contains music from the second half of the 19th century. It was possible to purchase barrels with current music for this clock for almost a century. The pieces include Wolfgang Amadeus Mozart's *Don Giovanni*, Giacomo Meyerbeer's *Dinorah*, Carl Maria von Weber's *Freischütz*, and the *Annenpolka* by Johann Strauss Jr.

European Clockmakers around 1800

Early-19th century clockmaking was dominated by Abraham Louis Breguet (1747–1823), who worked in Paris and who was one of the most famous clockmakers of all. Yet, the most important places for clock production were London and Western Switzerland with its center in Geneva. It was chiefly Swiss pocket watches that conquered markets in Turkey, India, and China early on. When it came to the quantity of fabricated clocks, other regions were unable to compete with London and Geneva. Yet, they managed to draw attention with bizarre clocks like those made in the Russian town of Vyatka (today Kirov), famous for its table clocks constructed almost entirely of wood.

The brilliant Breguet was an innovative designer and a clever businessman. With his "souscription" he apparently introduced the first pocket watch series. The name "sou-

4.31 Pocket Watch "Souscription No. 834," Louis Abraham Breguet, Paris, circa 1805, silver, enamel, gold, diameter: 56.2 cm, height: 1.5 cm, inv. no. D IV a 159

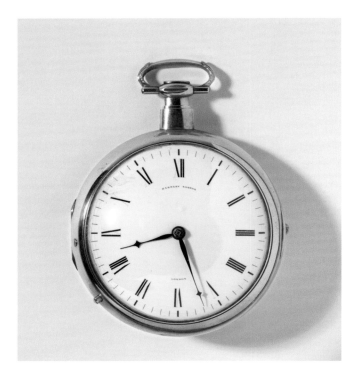

4.32a Pocket Watch with Repetition, Eardley Norton,
London, circa 1790, gold, enamel, silver, brass, diameter:
5.6 cm, height: 2.5 cm, inv. no. D IV a 138

scription" also describes his business method: Each time he
had sufficient advance orders with deposits, Breguet began
to produce them in small series. The hour rings are marked
with utmost precision, making it possible to read the time al-
most exactly to the minute, although there is but one hand.
This construction enabled Brequet to require a minimal
number of parts (ill. 4.31).

Eardley Norton's (1740–1794) golden pocket watch is much
more opulent than most other English pocket chronome-
ters: these watches were predominantly known for their
precision (ill. 4.32a). But this watch, too – furnished with a
full plate movement, fusee, chain, and verge escapement
that almost felt ancient at this time in England – conveys the
impression of high precision. This is also owed to its repe-
tition workmanship. Pressing the handle releases the hour
and quarter-hour repeater. The richly adorned clockwork is

protected by a dust capsule because the edge of the case is
decorated with an openwork freeze, making it possible for
the sound to spread more effectively (ill. 4.32b).

Norton operated a workshop in St. John Street in London,
where he manufactured bracket clocks, marine chronom-
eters, and pocket watches until his death in 1794.

Made almost entirely from wood, the pocket watches
constructed by the Bronnikov family from the Russian town
of Vyatka are true curiosities. Only the springs are made of
steel, while the shafts, pinion, and escapement cylinder are
made of bone. Three generations made these objects be-
tween 1837 and 1910; they were more expensive than golden
watches. The Bronnikov watches won numerous prizes,
medals, diplomas, and awards at national and international
fairs. The Vienna World Fair of 1873 brought them interna-
tional success. The watch in the Mathematisch-Physikalisch-
er Salon is considered one of the oldest of its kind (ill. 4.33).

The enameled clock face with Turkish numerals illus-
trates that this clock was intended for the Ottoman market:
it had gained importance during the course of the 18th cen-
tury. With regards to clock face design and case ornamenta-
tion, the makers considered taste preferences of the people
living in the Ottoman Empire (ill. 4.34a, b).

4.32b Pocket Watch with Repetition, Movement,
inv. no. D IV a 138

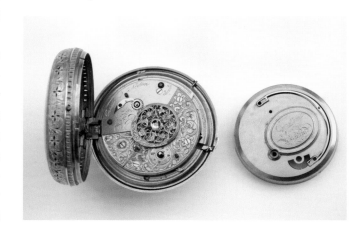

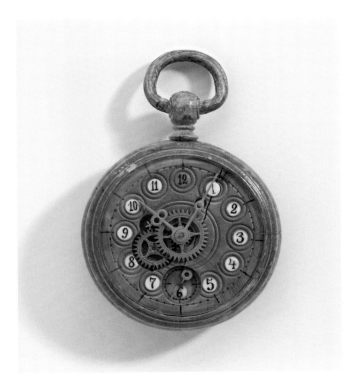

4.33 Wooden Pocket Watch, Michail Semjonowitsch Bronnikov, Vyatka, circa 1850, wood, glass, iron, bones, diameter: 5.02 cm, height: 1.84 cm, inv. no. D IV a 127

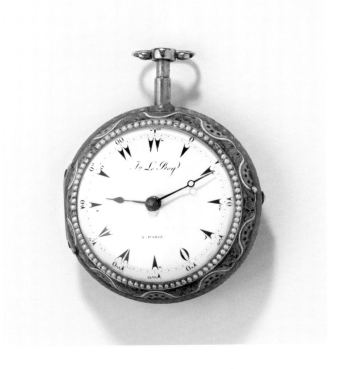

Pocket watches and marine chronometers were also made in series. However, unlike pocket watches which sold worldwide, the market for marine chronometers remained domestic for the longest time. This was primarily due to the limited availability of marine instruments.

The design of a marine chronometer enables it to compensate for the influences of temperature and humidity. To counterbalance the ship's movement, the clockwork was frequently cardan suspension (ill. 4.35). For a seafaring nation like England, the fabrication of marine chronometers was of eminent importance since it enabled precise navigation at sea.

Along with the English, the French were among the pioneers for building marine chronometers. When Dresden clockmaker Ferdinand Adolph Lange took to the road as a

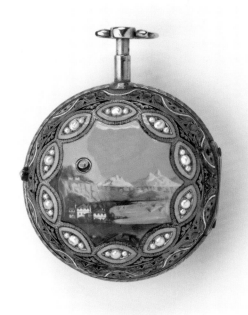

4.34a, b Pocket Watch for the Turkish Market, front an back, Julien Le Roy, Paris, circa 1780, enamel, pearls, steel, diameter: 5.2 cm, height: 2.5 cm, inv. no. D IV a 254

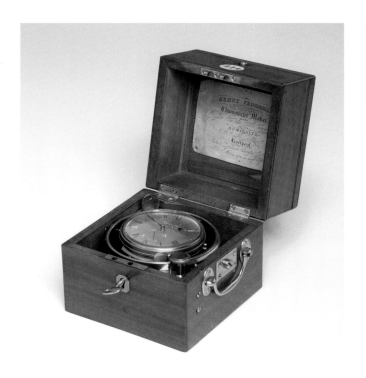

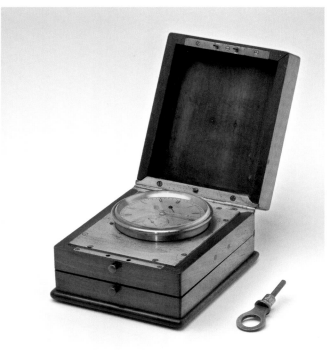

4.35 Marine Chronometer, Parkinson & Frodsham No. 414, London, circa 1840, brass, glass, mahogany, height: 13.7 cm, width: 14.5 cm, depth: 14 cm, inv. no. D IV b 41

4.36 Marine Chronometer, Victor Gannery, Paris, circa 1845, mahogany, brass, silver, steel, height: 6.6 cm, width: 10.5 cm, depth: 12.6 cm, inv. no. D IV b 126

journeyman, Joseph Thaddäus Winnerl (1799–1886) introduced him to Victor Gannery (1820–1851) in Paris. Gannery produced this little marine chronometer, either in Paris or while visiting the workshop of Lange and Gutkaes in Dresden (ill. 4.36).

It was supposedly also in Winnerl's Paris workshop where Lange was introduced to a very special escapement, the ball gear, which he subsequently installed into numerous regulators (precision pendulum clocks) in Dresden. Produced in the workshop of Gutkaes, they also bore his name. Suspended from two special lever arms, two brass balls give an impulse to the pendulum to maintain its swing; the escape wheel raises and lowers the lever arms (ill. 4.37).

After it was acquired for the Salon in 1850 and given the number "1194," it served in the Time Service Office as one of the major clocks for mean solar time. Since the Earth revolves around the Sun in an irregular manner during the course of a year, an average time needed to be determined. It was referred to as mean solar time.

Gutkaes also built a clock for brief time intervals for the Time Service, a so-called seconds counter (ill. 4.38) Unlike regulators with their seconds pendulums measuring one meter, in this case, the seconds could not be counted by the ticking of the clock, because the pendulum was too short. Therefore, a bell strike sounded the seconds, minutes were marked by a double-strike. The large hand circulating around the center of the large clock face indicates seconds; minutes are indicated on the small, mounted clock face; hours appear in the tiny section to the left beside the large clock face's center.

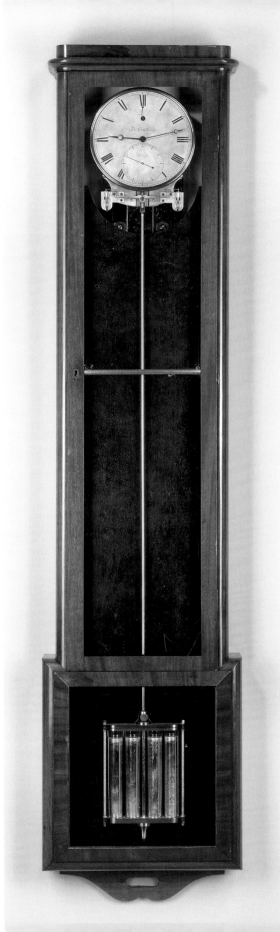

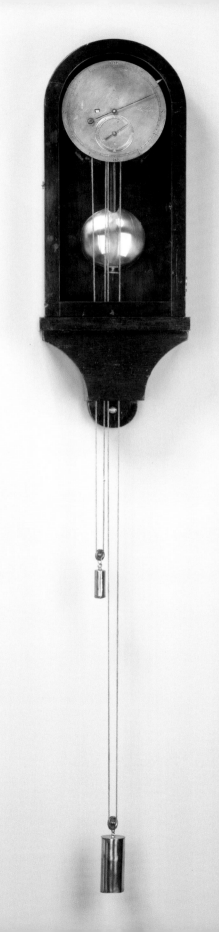

4.37 Precision Pendulum Clock, Johann Friedrich Gutkaes, Dresden, circa 1845, wood, brass, steel, height: 147 cm, width: 33.5 cm, depth: 12.5 cm, inv. no. D III 15

4.38 Seconds Counter, Johann Friedrich Gutkaes, Dresden, circa 1825, wood, iron, glass, brass, height: 65.0 cm, width: 24.5 cm, depth: 12.6 cm, inv. no. D III 10

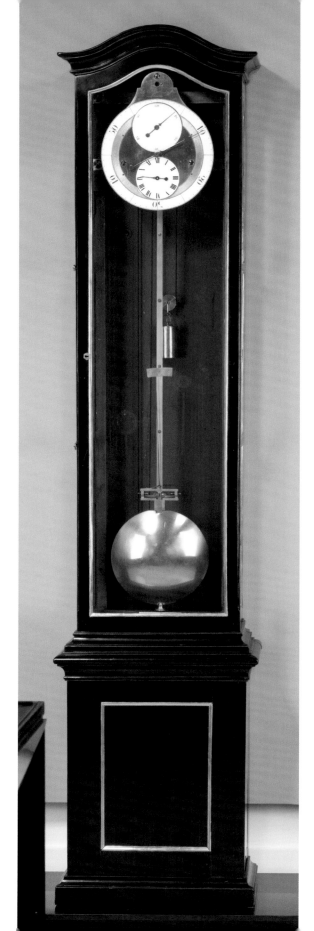

Precision from Dresden

Shortly after Johann Gottfried Köhler's (1745–1800) appointment as inspector of the Mathematisch-Physikalischer Salon in 1777, a second enthusiastic astronomer who soon made a name for himself arrived in Dresden: Johann Heinrich Seyffert (1751–1817) gained renown, especially as a clockmaker, far beyond Dresden. He succeeded Köhler in 1801. Seyffert constructed pocket chronometers, travelling clocks to determine the longitude, and longcase clocks. The clocks exhibited in the Salon all served as observation instruments for the Time Service in the Zwinger. They are among the earliest precision pendulum clocks made in Germany.

Regulators are precision pendulum clocks applied for astronomical observations. Surprisingly, Dresden does not own any English regulators, which were considered to be the most precise. It was not until 1777, when systematic celestial observations began in the Mathematisch-Physikalische Salon, that precision clocks were required. They were made locally (ill. 4.39). Court clockmakers Johann Friedrich Schumann (1758–1817) and Johann Friedrich Gutkaes began fabricating exactly these types of clocks in the early 19th century. Gutkaes's student, partner, and son-in-law, Ferdinand Adolph Lange, brought innovative ideas back to Dresden with him after his time as a journeyman – his travels had brought him to France, Switzerland, and Great Britain – and implemented them with Gutkaes.

A regulator from the Mechanische Werkstätten Strasser & Rhode in Glashütte was the last clock used for the Salon's Time Service (ill. 4.40). It replaced Köhler's longcase clocks (cf. p. 72, ill. 3.30) as central clock.

Seyffert, inspector of the Mathematisch-Physikalischer Salon since 1801, was a self-taught clockmaker. He was one of the first on the continent to use the term chronometer for

4.39 Precision Pendulum Clock, Johann Heinrich Seyffert, Dresden, 1794, wood, brass, iron, glass, steel, height: 194 cm, width: 44.5 cm, depth: 26.6 cm, inv. no. D III 11

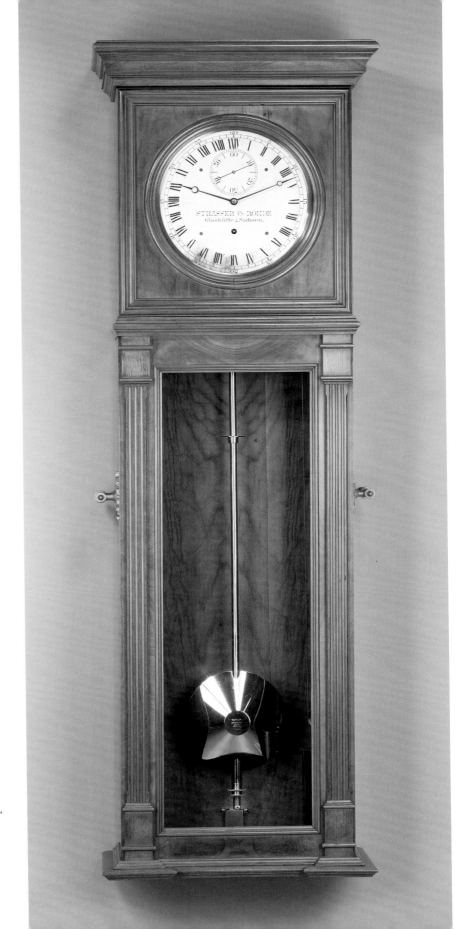

4.40 Precision Pendulum Clock, Strasser & Rhode, Glashütte, 1888, wood, brass, steel, height: 150 cm, width: 50 cm, depth: 29 cm, inv. no. D III 21

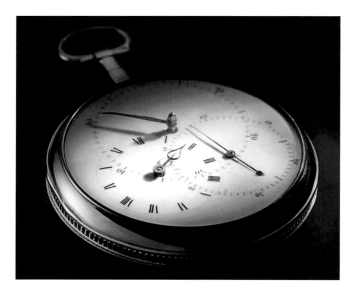

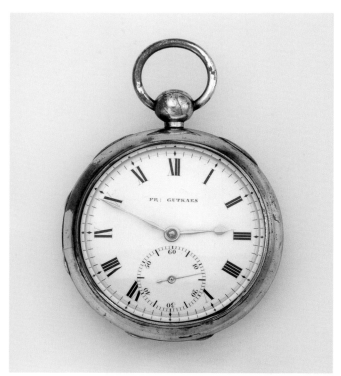

4.42a, b Chronometer No. 90, front and back with movement, Johann Friedrich Gutkaes, Dresden, circa 1835, silver, steel, enamel, diameter: 5.9 cm, height: 2.4 cm, inv. no. D IV a 346

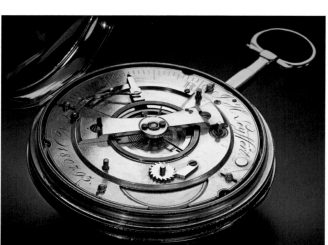

4.41a, b Pocket Watch, front and back with movement, Johann Heinrich Seyffert, Dresden, 1807, gold, steel, enamel, diameter: 5.7 cm, height: 2.5 cm, inv. no. D IV a 275

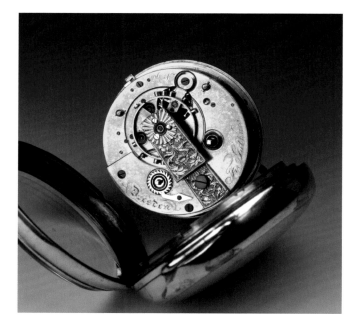

pocket watches. In order to construct the most exactly functional wearable watch, he studied the comparative pocket watches, especially those made in England (ill. 4.41a, 4.41b). Gutkaes collaborated with Seyffert in the Mathematisch-Physikalischer Salon and continued his work by constructing pocket chronometers and outstanding chronometers (ill. 4.42a, 4.42b).

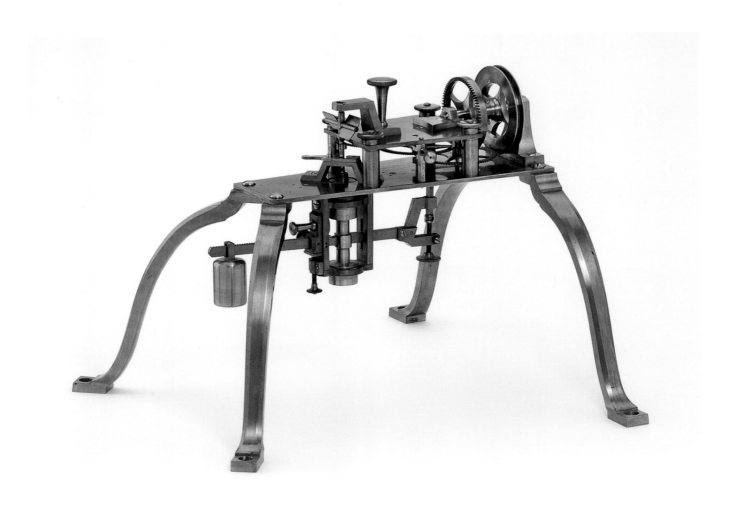

4.43 Gemstone Drill, Johann Heinrich Seyffert, Dresden, 1796, inv. no. D VIII 81

In addition to making them, clockmakers often constructed tools and machines necessary to build clocks: Johann Heinrich Seyffert constructed a gemstone drill, enabling him to drill precision holes into jewels, in this case rubies. (ill. 4.43).

The Way to Glashütte

Today, the small town of Glashütte in the Erzgebirge region stands for excellence in the art of clockmaking. More than a dozen firms produce predominantly wristwatches there, some of superior quality. The success story began in 1845 when Ferdinand Adolph Lange started training the first watchmakers there.

During his own studies at the Höhere Technische Bildungsanstalt in Dresden, Ferdinand Adolph Lange met Johann Friedrich Gutkaes in the Mathematisch-Physikalischer Salon and subsequently apprenticed with him as clockmaker. After taking to the road and visiting various European countries he became a partner in Gutkaes's firm. Starting in 1845 Lange began training watchmakers in Glashütte and built watches that soon competed with the best products from Switzerland. Although he signed his earliest watches "Lange

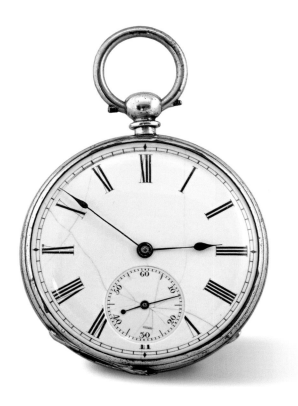

in Dresden" and "Glashütte bei Dresden," from approximately 1865 the quality seal "Glashütte in Sachsen" began to get established (ill. 4.44a, b).

Called "grande complication," complex pocket watches became the figureheads of the leading watch factories in the late 19th century. Watchmakers strove to equip their products with the utmost technical finesse ("complication") and abundant indicator-displays. The features that were united in the watchcase included: time display, perpetual calendar, phase of the Moon, age of the Moon, alarm function, striking

4.45a Grand Complication "La Grandiose," front, Louis Elisée Piguet, Le Brassus, circa 1893 (ebauche), Martin Seidel, Rudolstadt, 1942/1952, brass, silver, enamel, steel, diameter: 8.1 cm, height: 3.2 cm, inv. no. D IV a 350

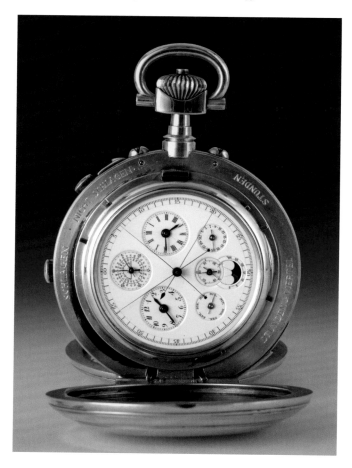

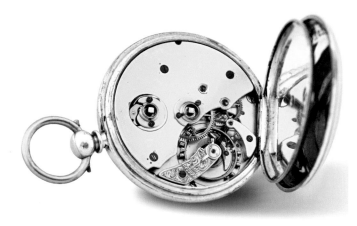

4.44a, b Pocket Watch, front and back with movement, Gutkaes & Lange, Dresden, circa 1867, silver, enamel, gold, diameter: 4.3 cm, height: 1.3 cm, inv. no. D IV a 333

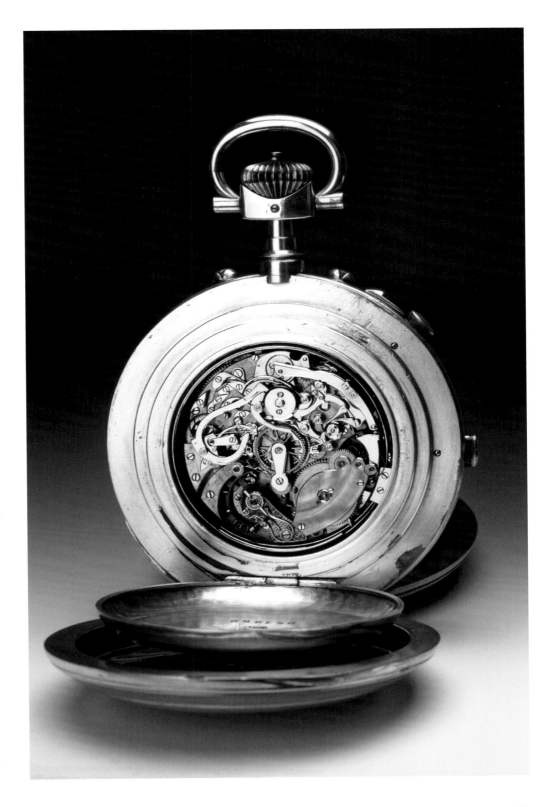

4.45b Grand Complication "La Grandiose," back with movement, inv. no. D IV a 350

mechanism, stopwatch (chronograph), and split hand (for chronographs a second hand for seconds). As a rule, pocket watches remained prestigious, individual pieces.

The "grande complication" also played a major marketing role for the factory in Glashütte. In the case of A. Lange & Söhne, it was the "42,500," for the Uhrenmanufaktur Union the "Universaluhr." The factory obtained three highly-complex works made by Louis Elisée Piguet (1836–1924) from Le Brassus in Western Switzerland in 1893. One of them was offered for sale in 1895 on the occasion of the 50th anniversary of watch production in Glashütte under the name "Universaluhr." Additionally, it was also used in brochures and advertisements. The other two ebauches remained unused for the time being.

Working in the Thuringian town of Rudolstadt, Martin Seidel (1910–1989) completed the Piguet ebauche with the

number 2 between 1942 and 1952, naming it "La Grandiose." Since he lacked the funds for a gold case, he ordered an unusually large silver case that lends the watch a singular appearance (ill. 4.45a, b). Richard Daners (1930–2018) completed the last remaining ebauche with the number 3 for the Uhrenfabrik Gübelin in Lucerne around 1983/1985. The watch began to be sold in 1988 under the name "La Fabuleuse."

"The Salon in the Salon"

"The Salon in the Salon" occupies the last third of the Bogengalerie: It is the Mathematisch-Physikalischer Salon's place of learning. Based on 18th -and 19th-century Salon traditions, this is where historical demonstrations, lectures, and courses take place. One of the oldest calculators and an

4.46 Mechanical Calculator, Blaise Pascal, France, circa 1650, brass, wood, paper mache, height: 10 cm, width: 44.5 cm, depth: 14.7 cm, inv. no. A II 11

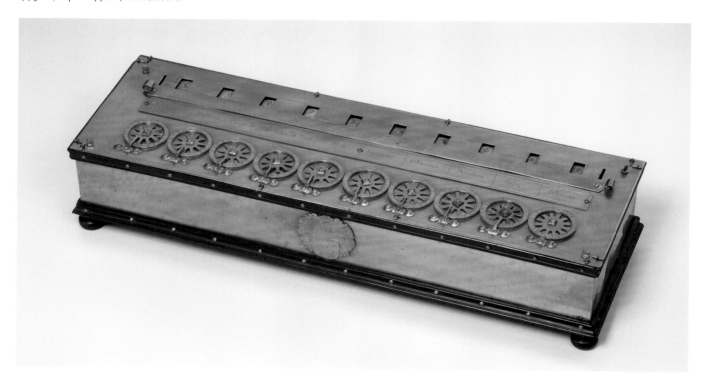

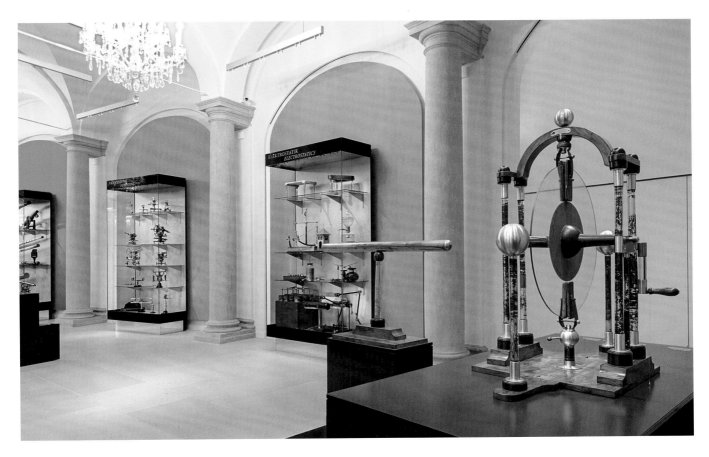

4.47 Electrostatic Generator, Fuchs, Leipzig, 1817, glass, wood, brass, textile, inv. no. B VII 8

electrostatic generator frame this section. Four wall cases display regularly rotating objects from storage.

Blaise Pascal (1623–1662) built the world's oldest calculators in France in the middle of the 17th century; therefore, they are also called "Pascaline." They allowed the mathematician-philosopher to deliver proof that additions can be done mechanically. With its ten digits, this calculator is the biggest of this type. Spoked wheels on the lid allow for adjustment. Every wheel corresponds to one specific position in the decimal system: ones, tens, hundreds, and so on. The numbers are entered with the aid of a pointed stylus. In order to add two numbers, they are simply entered successively; the sum then appears in the windows. A monitor in the exhibition gallery makes it possible to try out this calculator with its subtle lever mechanism (ill. 4.46).

One of the most popular instruments in any physical cabinet is located at the end of this exhibition space: the electrostatic generator. They were not only presented in laboratories but also in pubs and on fairgrounds, where electrifiers demonstrated them. When the crank handle is turned, pillows rub against the pane. In doing so, the upper and the lower brass balls are charged negatively, whereas the balls located on the two sides get charged positively. This charge made it possible to produce lightning, to make one's hair stand on end, or to strike sparks when kissing (ill. 4.47).

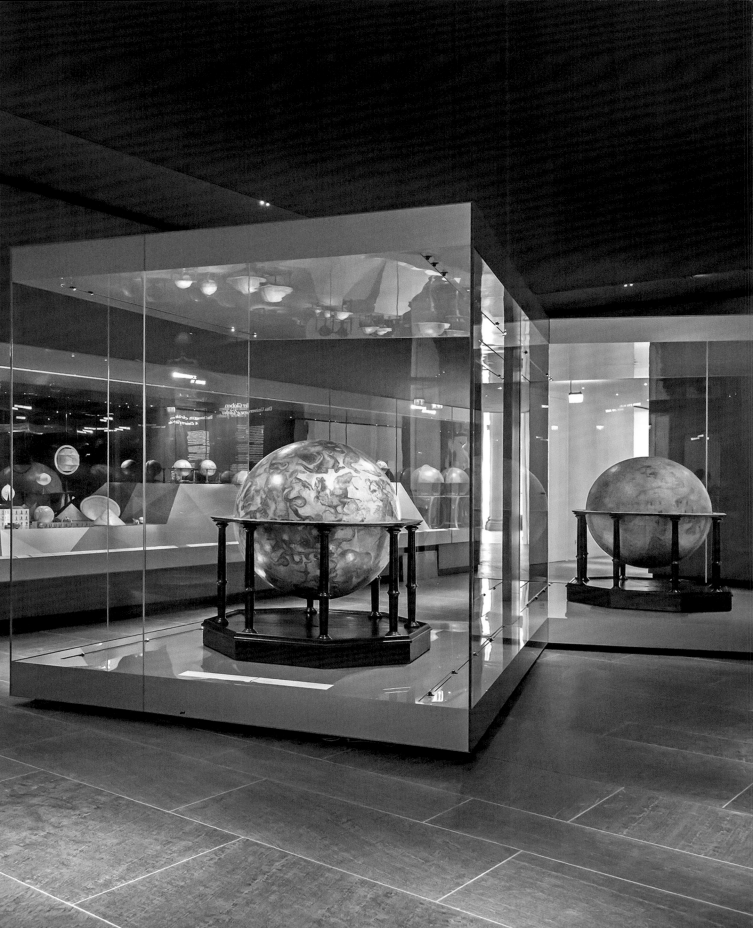

WOLFRAM DOLZ

NEUER SAAL
The Universe of the Globes

Globes are spherical models of the constellations or of other celestial bodies. Already produced in antiquity, the oldest preserved globe is kept in the Archaeological National Museum in Naples: A figure of the giant Atlas carries this 2,000 year old celestial marble globe. After its discovery in Rome the nearly two-meter tall sculpture was temporarily placed in the palace of Cardinal Farnese and subsequently referred to as the "Atlas Farnese." The oldest globe in Germany is a celestial metal globe. Created between 150 and 220 CE, it belongs to the Römisch-Germanisches Zentralmuseum in Mainz.

Although Greek scholars always surmised a spherical shape of the Earth, and their calculations brought them rather close to its actual circumference – approximately 40,000 kilometers – no ancient terrestrial globes have survived. The oldest preserved terrestrial globe was made by Martin Behaim (1459–1507). Produced in 1492, it is kept in Nuremberg's Germanisches Nationalmuseum today. It was made the same year Christopher Columbus (circa 1451–1506) discovered America. Since the latter did not return to Spain until 1493, Behaim was unable to incorporate the new continent into his depiction of the Earth. Geographer Johannes Schöner (1477–1547) began to produce printed globes in Bamberg in 1515. Among his followers was Gerhard Mercator (1512–1594), who issued his terrestrial globe in Louvain in 1541. The 17th century saw the commercial distribution of globes – in very high numbers – mostly from Amsterdam.

The advantage of a terrestrial globe vis-à-vis a world map is that the surface is displayed largely without distortion, i.e. equal area and orthomorphic. Celestial globes, on the other hand, demand a much higher level of abstraction from both viewer and maker. They reflect a notion that has existed since antiquity: The stars are attached to a shell that encompasses the Earth and moves around the globe once a day. In contrast to the terrestrial globe, for celestial globes the viewer must think his way into the hollow sphere. Since the celestial globe can only be viewed from the exterior, however, its draftsman must depict the constellations mirror-inverted.

Earth and celestial globes also make it possible to solve diverse arithmetic problems without undertaking a numerical calculation. The frame and the rings customarily mounted there serve this purpose. When appropriately setting the meridian ring to the correct latitude, the horizon ring enables easy reading of the Sun's and the stars' local daily rising- and setting times.

The Oldest Globes in the Collection

The Saxon electors began acquiring precious Earth and celestial globes in the 16th century. The Dresden Kunstkammer inventory of 1587 records nine globes. Whereas individual globes continued to be purchased in the ensuing centuries, the systematic development of the globe collection with a European dimension only began after World War II.

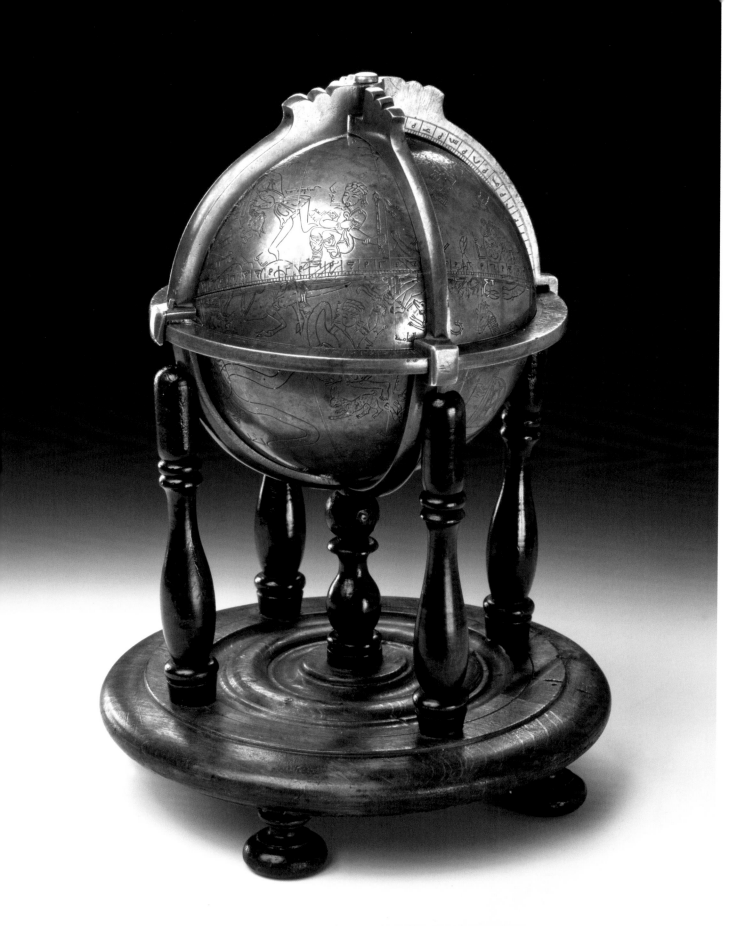

A special rarity is the "Arabic celestial globe" from the observatory of the Persian town of Marâgha. Despite its moderate dimensions, it shows almost 1,000 stars. Made around 1300, it is one of the world's oldest globes. Its maker was Muhammad ibn Muwayyad al-Urdi, whose father had already produced instruments for the Marâgha observatory.

The celestial sphere is made of brass and shows the 48 constellations astronomer Claudius Ptolemy (circa 100–circa 160 CE) described in his star catalogue. They bear Arabic names. Depending on their brightness, the stars are represented in different sizes. The hemispheres are connected on the ecliptic (i.e. the Sun's seeming orbit in front of the zodiac signs). The twelve meridians run perpendicular to the ecliptic, subdividing each sign of the zodiac into 30°. The celestial equator is also marked. While the engravings of equator, meridians, ecliptic, stars, and star names were executed in damascened silver, the names of the zodiacal sings were alternately done in gold and silver (ill. 5.1).

The Salon's oldest terrestrial globe is an elaborate brass object by Johannes Prätorius (1537–1616), fabricated in Nuremberg in 1568. Elector August (1526–1586) purchased it the same year along with a celestial globe (lost during World War II) and an astrolabe (cf. p. 50, ill. 2.47) for 200 thalers. This globe's remarkable feature is that it shows the continents of Asia and America as connected. First featured on a world map by Oronce Fine (1494–1555) in Paris in 1531, some cartographers shared this view until the second half of the 16th century. The cardinal points are represented as 12 blowing winds on the horizon ring. The stand's three lion feet rest on pomegranates. Over the feet, reliefs with attributes of science and art are found (ill. 5.2).

5.2 Terrestrial Globe, Johannes Prätorius, Nuremberg, 1568, engraved and embossed brass, diameter: 28 cm, height: 47.5 cm, inv. no. E I 4

A Golden Age

The mid-16th century marks the beginning of the "Golden Age" of cartography in the Netherlands: As a global actor, the aspiring, seafaring nation with far-reaching trade ambitions required good maps and globes. Amsterdam was the publishing center. This is where Willem Janszoon Blaeu

5.1 "Arabic Celestial Globe," Muhammad ibn Muwayyad al-Urdi, Marâgha, circa 1300, engraved brass, damascened gold and silver, diameter: 14.4 cm, height: 30.5 cm, inv. no. E II 1

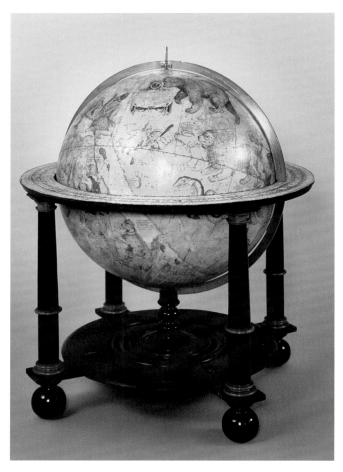

5.3 Terrestrial Globe, Willem and Joan Blaeu, Amsterdam, 1645/1648, paper mache ball, engraving, diameter: 68 cm, height: 110 cm, inv. no. E I 14

5.4 Celestial Globe, Willem and Joan Blaeu, Amsterdam, 1645/1648, paper mache ball, engraving, diameter: 68 cm, height: 110 cm, inv. no. E II 18

(1571–1638) and his sons established themselves as map publishers and soon delivered their globes throughout Europe. Janszoon, who added Blaeu to his name in 1621, spent his apprentice years with the famous Danish astronomer Tycho Brahe (1546–1601). This explains why his celestial globes were based on the most current astronomical insights of the time. Taking into account the most recent discoveries in his terrestrial globes, Blaeu was named official cartographer of the Dutch East India Company in 1633. The publisher Blaeu produced pairs of globes in six different sizes; the largest diameter measured 68 cm.

The terrestrial globe by Willem and Joan Blaeu shown in the exhibition is distinguished by its high degree of current information: In the first edition of 1617, Willem Blaeu already depicted the Netherlandish expeditions of Oliver van Noort (1558–1627), who sailed around the world from 1598 until 1601, and of Jacob le Maire (1585–1616) and Willem Cornelisz Schouten (1580–1625), who found the route around Cape Horn, the southern tip of South America, in 1616. For reasons of secrecy, the latter had to be erased and could only be published in 1618. After Willem Blaeu's death, his son Joan continued the publishing house. He updated his father's globe by adding

coastal parts of Australia, discovered in 1642/1643. Parts of the island Yezo (Hokkaido), the Kuril Islands, as well as the Russian island Sachalin were newly engraved and then glued on to the quadrangle. Undecorated marine areas were embellished with mythological creatures, ships, and marine life (ill. 5.3).

Tycho Brahe's star catalogue – his portrait crowns the publisher's imprint – formed the basis for depicting the stars on Willem Blaeu's celestial globe. Thanks to his exact observations, Brahe contributed to some substantial changes in astronomy around 1600. Blaeu calculated the positions of the stars on the globe for the year 1640. On August 18, 1600, Willem Blaeu even observed a supernova himself in the constellation swan, which he rendered on the globe and described. The most important achievement of this globe, however, is the inclusion of more than 300 new stars on the southern sky, which the Dutchmen Pieter Dirkszoon Keyser (1540–1596) and Frederick de Houtman (1571–1627) mapped while travelling to East India (ill. 5.4).

Worthy of a King

Italian theologian and cartographer Vincenzo Coronelli (1650–1718) produced a huge pair of globes – each with a diameter of 3.90 m – for King Louis XIV of France (1638–1715) in 1683. Intended for the chateau in Versailles, the globes were representational objects to pay homage to the Sun King. Inspired by these splendid objects, Coronelli published them beginning in 1688 – albeit in reduced size. With a diameter of 1.10 m they were the largest printed globes in the world at the time. Numerous European princes showed keen interest in purchasing them, although the transport was cumbersome. Consequently, most often only the printed globe segments (gores) were purchased and mailed and glued to the spheres on the spot. Adolph Drechsler (1815–1888), director of the Mathematisch-Physikalischer Salon, only had the spheres for the Dresden gores produced in 1872 and 1877. Since the Royal Schatzkammer assumed the costs, the terrestrial

5.5 Cartouche with the Portrait of Vincenzo Coronelli, Terrestrial Globe, cartography: engraving by Vincenzo Coronelli, Venice, 1688, globe: Adolph Drechsler, Dresden, 1872, paper mache ball: diameter: 110 cm, height: 138 cm, inv. no. E I 2

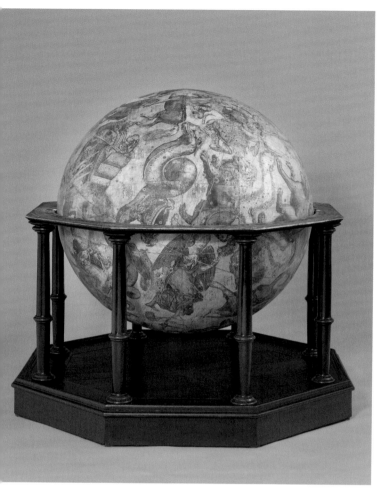

5.6 Celestial Globe, cartography: engravings by Vincenzo Coronelli, Venice, 1693, globe: Adolph Drechsler, Dresden, 1877, paper mache ball: diameter: 110 cm, height: 138 cm, inv. no. E II 9

depiction of the Great Lakes in North America. Founded in 1684, the "Accademia degli Argonauti" – the world's first geographical society – also delivered crucial information to him for his maps and globes. The large cartouche on the southern hemisphere shows Coronelli's portrait (ill. 5.5).

In addition to Ptolemy's 48 constellations, Coronelli's celestial globe also shows the southern constellations – mapped by Keyser and Houtman – that Blaeu had already included in his celestial globe. The latter were supplemented by 341 stars Edmond Halley had observed from the island of Sankt Helena, starting in 1677. All the star positions were calculated for the year 1700. Little arrows near the stars point out the precession, the time related changes constant shift of the stars in the sky, resulting from the slight change in direction of the Earth axis (ill. 5.6).

Earth and Sky

The creation of the geocentric worldview originated from the apparent movements of Sun and stars people perceived in the firmament. It describes well what we can see from the Earth with the naked eye. According to this world model, the Earth stands firmly in the center and seven celestial bodies revolve around it. The sphere of the fixed stars is found outwardly; it seems to turn around the Earth once a day. In front of this "shell," the seven "planets" – Mercury, Venus, Mars, Jupiter, Saturn, as well as Sun and Moon – perform their own movements. This theory, most delicately worked out by the late-antique scholar Ptolemy, prevailed for almost 1,500 years. Placing the Sun in the center, the helio-centric worldview developed by Nikolaus Copernicus (1473–1543) found gradual acceptance beginning in the mid-16th century. So-called armillary spheres were used as demonstration models to illustrate the celestial mechanics. The name is derived from the Latin words *armillaris* = ring and *sphaera* = sphere.

Charles François Delamarche (1740–1817) built his geocentric armillary sphere in Paris around 1800: Attached to

globe was dedicated to King Johann of Saxony (1801–1873). Still, the funds made available were insufficient to realize the customary meridian rings.

Vincenzo Coronelli's printed terrestrial globe is based on the most current maps of the time and on travel accounts from France, Holland, England, and Portugal. In his role as father general of the Minorite Order in Venice, he had access to missionary reports from North-, Central-, and South America. This is for instance reflected by the detailed

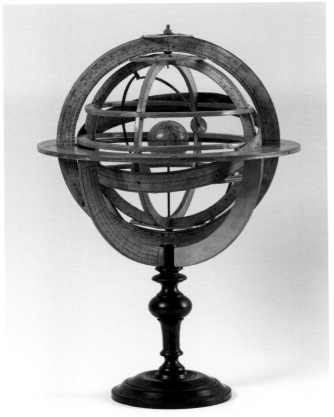

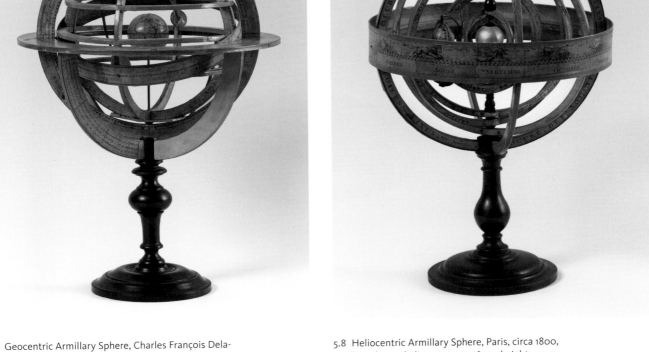

5.7 Geocentric Armillary Sphere, Charles François Dela-marche, Paris, circa 1800, cardboard, paper, diameter: 30 cm, height: 45 cm, inv. no. E II 42

5.8 Heliocentric Armillary Sphere, Paris, circa 1800, cardboard, wood, diameter: ca. 26 cm, height: 45 cm, inv. no. E II 41

curved quarter circles made of metal, Sun- and Moon disks orbit around the stationary Earth. The firm, moveable cardboard armillary sphere represents equator and ecliptic, as well as the tropics and the polar circles. The entire armillary sphere can be tuned to the specific location's latitude with the aid of the externally attached meridian ring. The latter, in turn, is inserted into the horizontal ring. In order to demonstrate the annual course of the Sun, the Sun disk can be moved along the ecliptic in front of the twelve zodiac signs. It is similarly possible to demonstrate the phases of the Moon as well as lunar and solar eclipses (ill. 5.7).

According to Nikolaus Copernicus's theory, the heliocentric or Copernican armillary sphere places the Sun as a golden sphere in the center of the armillary sphere. The Earth with the Moon and the other planets can be moved around the Sun. As major celestial circles only the meridian, the colures (i.e. the largest circles running through the celestial poles), and the ecliptic with the zodiac and a calendar are attached. The remaining six circles represent – from inside to outside – the planets Mercury, Venus, Earth, Mars, Jupiter, and Saturn. The circle for the Earth is disrupted: Built into the gap are the Earth as a sphere and the Moon. Upon turn-

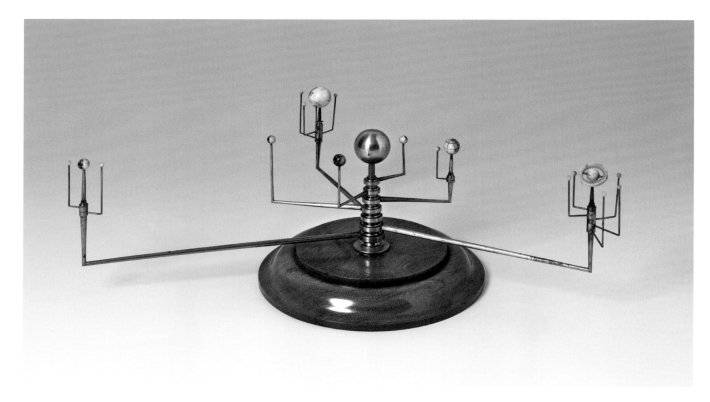

5.9 Planetarium, William and Samuel Jones, London,
circa 1800, brass, ivory, wood, paper, diameter: 30 cm,
height: 11.2 cm, inv. no. E II 43

ing the Earth ring, the Moon begins to move – operated by
a belt drive (ill. 5.8).

Originating from the family of the famous astronomer
Wilhelm Friedrich Herschel (1738–1822), this helio-centric
planetarium was marketed by William (1763–1831) and Samuel
Jones (1770–1859) from London around 1800. Uranus, discov-
ered by Herschel in 1781, is already included, as are the clas-
sical planets Mercury, Venus, Earth, Mars, Jupiter, and Saturn.
Although certain moons are allocated to planets, only what
could be seen with telescopes available at the time is record-
ed. Moveable arms make it possible to adjust the planetary
constellation to any calendar date desired (ill. 5.9).

A tellurium (from Latin *tellus* = Earth) showing the move-
ment of the Moon around the Earth and its orbit around
the Sun is the planetarium's counterpart. Installed above a

5.10 Tellurium, William and Samuel Jones, London, circa
1800, brass, steel, ivory, wood, paper, diameter: 30 cm,
height: 11.5 cm, inv. no. E II 44

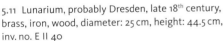

5.11 Lunarium, probably Dresden, late 18th century, brass, iron, wood, diameter: 25 cm, height: 44.5 cm, inv. no. E II 40

5.12 Heraldic Celestial Globe, Erhard Weigel, Jena, circa 1690, copper ball, brass, diameter: 27.5 cm, height: 59 cm, inv. no. E II 36

calendar disk, a transmission mechanism facilitates demonstrating the emergence of the four seasons, phases of the Moon, and lunar eclipses (ill. 5.10).

A so-called lunarium (from Latin *luna* = Moon) is capable of demonstrating the Moon's movement around the Earth as well as the Sun's (alleged) movements. In contrast to the tellurium, in this case, it is not the Sun but the Earth that stands in the model's center. When setting the transmission in motion with the help of a crank handle, it is possible to follow the 24-hour rotation of the Earth around its own axis, the monthly rotation of the Moon around the Earth, and the alleged annual rotation of the Sun around the Earth. Hours, days, and weeks can be read on a small face on the lunarium's front. The position of Dresden was engraved into the terrestrial globe.

In this exceptional model, the Sun was installed on the outer rim of the case. In order to delineate the alleged rotation of the Sun in front of the twelve zodiacal signs, the tilted ecliptic ring was placed in such a way that it could be moved in front of the Sun (ill. 5.11).

Broadly speaking, Erhard Weigel's (1625–1699) celestial globe, produced in Jena around 1690, can be called a precursor of the projection planetarium. Weigel had the idea to allow a glimpse into the celestial globe with the aid of large openings on the southern hemisphere. Since he marked the positions of the stars with small holes in the sphere, the viewer can view the constellations as groups of luminous, correctly positioned dots. In addition, Weigel replaced the traditional constellations with coats-of-arms of European princes, important towns, and estates. The new constellations – chased in the copper sphere as raised reliefs – are rendered in color. Because of the heraldic references, this globe is also called "heraldic celestial globe" (ill. 5.12).

Moon and Mars

Only two years after the telescope was invented in Holland, the Italian scholar Galileo Galilei published a – still rather inaccurate – map of the Moon in 1610. More precise maps were presented by Johannes Hevelius (1611–1687) in Danzig in 1647 and by Tobias Mayer (1723–1762) in Göttingen in 1750. Shortly thereafter, Inspector Johann Gottfried Köhler (1745–1800) began his intense exploration of the Moon's surface in the Mathematisch-Physikalischer Salon, continued by his successor, Wilhelm Gotthelf Lohrmann (1796–1840).

Ernst Fischer's (died 1886) lunar relief globe stands in the same tradition. Made in Dresden between 1865 and 1875 (ill. 5.13), Fischer modeled the terrestrial satellite as full Moon, thereby taking into consideration the libration – the Moon disk's slight "variation"– which has the effect that more than half (59%) of the Moon's surface is visible. This phenomenon is based on the fact that the Moon's circulation velocity around the Earth varies; it is also based on the incline of the Moon's equator against the orbit level. Since the rotation of the Moon occurs at the same time as the circulation of the Moon around the Earth, only its front could be mapped until the flight of Soviet space craft Lunik 3 around the Moon in 1959. While constructing his globe,

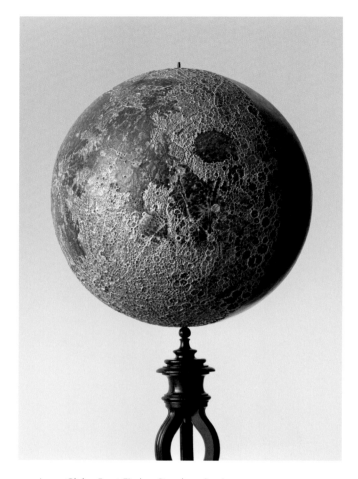

5.13 Lunar Globe, Ernst Fischer, Dresden, 1875, tempera on plaster and wood, diameter: 55 cm, height: 152.5 cm, inv. no. E II 15

Ernst Fischer also executed six wall maps of the Moon as pen-ink drawings.

Wilhelm Beer (1797–1850) and Johann Heinrich Mädler (1794–1874) were the first to create a map of the surface of Mars in 1830. Giovanni Schiaparelli (1835–1910) published a map with broad Mars "canals" in 1882. It served as template for Dresden's Mars globe. Corresponding with the observation undertaken with an astronomical telescope, the South Pole is located at the top. The globe presents the "red planet" at the end of summer, with extensive northern expanses of snow, during the Mars opposition of 1881/1882. During such

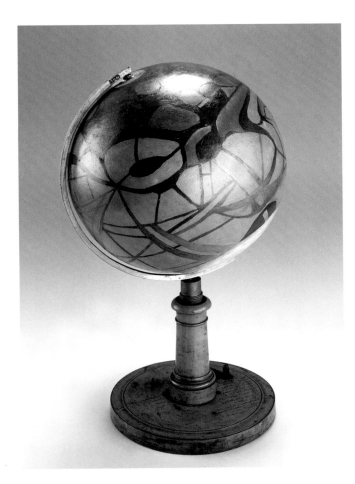

insight formed the basis for creating a method for barometric height measurement. Originating from sea level, with an increase in height of 10 m, the air pressure decreases by 1 mm. At a height of 3,500 m, a 1-mm-change in air pressure corresponds to a difference in height of 15 m. The Swiss scholars Johann Jakob Scheuchzer (1672–1733) and Horace-Bénédict de Saussure (1740–1799) were the first to undertake barometric height calculations in the Alps in the first half of the 18th century. Since it is impossible to climb all mountains, their height was determined trigonometrically, i.e. with the aid of triangular measurements. Based on the same principle,

5.15 Terrestrial Globe, Karl Wilhelm Kummer, Berlin, 1836, paper mache ball, painted, wood, diameter: 56.5 cm, height: 107 cm, inv. no. E I 10

5.14 Globe of Mars, unknown manufacturer, late 19th century, tempera on plaster, diameter: 30.5 cm, height: 53.5 cm, inv. no. E II 13

a constellation, Mars stands in one line with Earth and Sun; hence it can be observed particularly well from the Earth. The albedo stretches are colored in matte orange and hues of dark- to grey-blue. "Albedo" is the measure for the retroreflective properties of non-self-illuminating surfaces (ill. 5.14).

Height Measurements

During the early period of vacuum experiments, around 1650, it was noted that the height of a mercury column in a glass tube depends on the local elevation on Earth. This

Franz Ludwig Pfyffer (1716–1802) manufactured a huge relief of central Switzerland (Lucerne, Gletschergarten) in 1786.

Levels were already used in ancient times to identify height differences. This led to the development of levelling instruments with telescope and level (little tubes filled with air or water). A leveling instrument serves the geometric height determination. Some European countries applied this method to survey their entire terrain at the end of the 19th century. In this process, sea level represents point zero. For Germany, the references were the water gauges of Amsterdam (North Sea) and Kronstadt (Baltic Sea).

The content of the relief globe produced by Karl Wilhelm Kummer (1785–1855) in Berlin in 1836 is based on the geographic work of Carl Ritter (1779–1859). Made of paper mache, the relief portrays the mountains with a strong emphasis on individual peaks. Alexander von Humboldt was the first to embark on systematic barometric height calculations in South America and Mexico from 1801 until 1804. His results, as well as Joseph B. Pentland's (1797–1873) findings – he ascertained trigonometrically a height of 12,500 ft (3,810 m) for Lake Titicaca in Peru and Bolivia in 1828 – were absorbed when modeling the Andes (ill. 5.15). The prototype for Kummer's relief globes were the tactile terrestrial globes of Johann August Zeune (1778–1853), a Berlin teacher for the blind.

The Problem with Longitudes

To ensure adequate orientation on the globe, a system of coordinates began to be developed in late antiquity. It consisted of latitudes that ran parallel to the equator and meridians that ran perpendicular to it. Whereas determining one's own latitude is relatively easy (see next paragraph), establishing the geographical longitude was a difficult challenge for a long time, especially on high seas. Due to inadequate measuring methods, many maritime accidents occurred, resulting in severe economic losses. As a consequence, the English parliament passed the "longitude act" in 1714, offer-

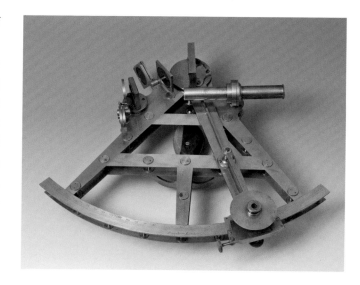

5.16 Mirror Sextant, Edward Troughton, London, circa 1790, brass, glass, length: 31 cm, width: 35.5 cm, inv. no. C VI 7

ing a reward of up to BPS 20,000 to solve the problem. Two methods helped achieve the goal: exact measurement of the Moon's position with a sextant and construction of a seaworthy clock, capable of comparing the time at the port of departure with the local time at the present location.

Sextants began being used, mostly at sea, since the 18th century. They are special protractors for precisely measuring the elevation angles of stars, making it possible to calculate the latitude. The sextant's distinct construction allows it to simultaneously look into two different directions. Sun and horizon are aimed at using two mirrors, and the angles between them are measured. It is relatively easy to deduce the latitude with the help of an appropriate chart, using the height of the Sun at noon.

Defining the longitude with the help of the lunar distance method is very complex and requires laborious calculations. Here, too, the mirror sextant is used for measuring angles, in this case the angles between Moon and fixed stars (ill. 5.16).

Ultimately, the customary method for identifying longitudes was a time comparison between location and port of departure with the assistance of a marine chronometer.

Beside John Harrison (1693–1776), considered its inventor, the English clockmaker Thomas Mudge (1715–1794) also submitted two identical marine chronometers for evaluation to London's longitude commission in 1777. Based on the original color of their cases, they are referred to as the "blue" and "green" marine chronometers (ill. 5.17a, 5.17b).

5.17a, b "Blue Marine Chronometer," side view an dial, Thomas Mudge, Plymouth, 1777, gilded brass, glass, enamel, silver, diameter: 12.2 cm, height: 10 cm, inv. no. D IV b 11 (acquired in 1925)

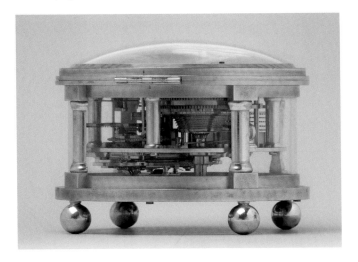

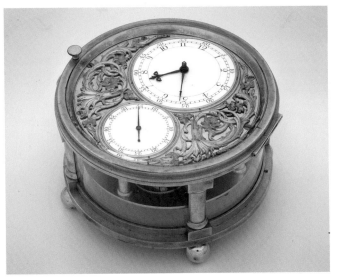

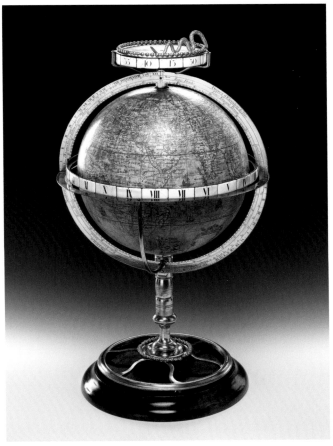

5.18 Mechanical Terrestrial Globe, Louis Charles Desnos, Paris, 1782, engraving, paper mache ball, brass, steel, wood, diameter: 26 cm, height: 58 cm, inv. no. E I 5

The mechanical terrestrial globe of French geographer Louis Charles Desnos (1725–1805) from 1782 illustrates the connection between the difference in efficiency factor and longitude. A clockwork turns this globe around its own axis once every 24 hours. If subdividing the circumference in 360 longitudes, the distance of 15 longitudinal degrees equals a one-hour difference. A clockwork moves Desnos's globe with its enameled 24-hour ring past a fixed sun sphere which is part of the model. When standing in front of the globe, one can read the current time. Additionally, midday (12 o'clock noon) is indicated for all places on the globe located below

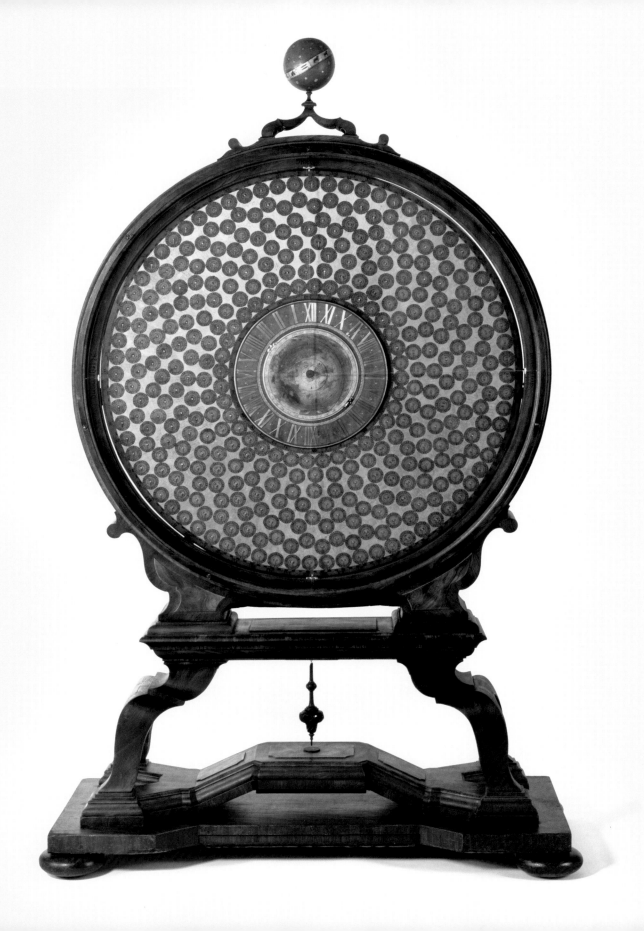

the Sun sphere and on the same longitude at this point in time (ill. 5.18).

Longitudes also play a major role in Andreas Gärtner's world clock, produced around 1690. On its gilded main disk, small clock faces were applied for each of the 360 longitudes, with each showing the name of a town or an island on the respective longitude. Mounted in the midst of the small clock faces is a downward-pointing hour hand. When the main disk turns, the small clock faces move under the fixed vertical hands, so that the local time of the places mentioned is legible for every longitude. Dresden's local time, for example, is displayed on a small as well as on the central clock face (ill. 5.19).

Johann Georg Klinger's (1764–1806) terrestrial globe from 1792 depicts the three long journeys James Cook (1728–1779) undertook between 1768 and 1779. Cook primarily explored Australia's east coast and New Zealand. Significant features of this globe are the updated and corrected shorelines that are based on exact measurements of the longitudes with the help of a marine chronometer (ill. 5.20). On his second world voyage, from 1772 until 1775, James Cook used a chronometer by Larcum Kendall (1719–1790) to determine longitudes. It was a copy of John Harrison's chronometer "H4." While in use, the chronometer revealed its high accuracy and precision.

Variety of Forms

There are certain globes, where continents or star constellations are painted or drawn directly onto the sphere with the help of a grid. In the case of printed globes, on the other hand, paper is glued onto the prepared spheres. Since printing takes place on a flat surface, special drawing and math-

5.20 Terrestrial Globe, Johann Georg Klinger, Nuremberg, 1792, engraving, paper mache ball, diameter: 32 cm, height: 56 cm, inv. no. E I 18

5.19 World Time Clock, Andreas Gärtner, Dresden, circa 1690, wood, steel, brass, paper, diameter: 135 cm, height: 238 cm, width: 149 cm, inv. no. D IV d 2

ematical processes are required to divide the sphere's curved surface into flat segments. This is comparable to peeling an orange. Normally, twelve tapered gores of paper that run from the equator to both poles are needed. These sections were produced using a special printing process.

Strasbourg publisher Marin et Schmidt obtained a ten-year patent in Paris for Aloyse Weinling's (1785–1850) design of an inflatable terrestrial globe. The world map was printed on leather. The inside of the sphere contains an inflatable bladder that appears to have originally been made of natural rubber. The globe introduces fifteen discovery routes. (ill. 5.21).

5.22 Portable Terrestrial Globe, John Betts, London, late 19th century, textile, iron wire, length: 38 cm, inv. no. E I 44

5.21 Inflatable Terrestrial Globe, Ambroise Tradieu, Aloyse Weinling, Strasbourg (Marin et Schmidt), 1833, leather, natural rubber (?), wood, diameter: 47.5, height: 115 cm, inv. no. E I 22

Earth and celestial realm can also be depicted on cones, cylinders, or cubes. Since is it challenging to transport large globes, many ideas were developed how to downsize them most practically and quickly. Thus, inflatable and collapsible globes came into being; globe makers patented some of them.

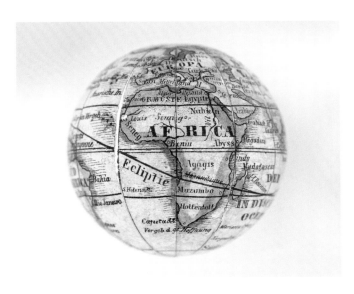

John Betts (1844–1875) made an expandable terrestrial globe in London at the end of the 19th century that functioned like an umbrella, creating a safely transportable globe. He received a patent from Great Britain's Royal Patent Office for his invention. Listing the latest discoveries, the map was printed on cloth (ill. 5.22).

Affordable for a larger public, pocket- and collapsible globes were particularly popular in the context of playful learning. These small globes were customarily accompanied by brochures showing images of typical representatives of the peoples of the world, as evidenced in the little globe monogrammed "M. P. S." (ill. 5.23a, 5.23b) or in Carl Johann Sigmund Bauer's (1780–1857) collapsible globe. The latter

5.23a Pocket Globe and Brochure, signed "M. P. S.," probably Nuremberg, circa 1830, engraving, wood, diameter: 4.4 cm, inv. no. E I 46

5.23b Pocket Globe, unfolded Brochure, inv. no. E I 46

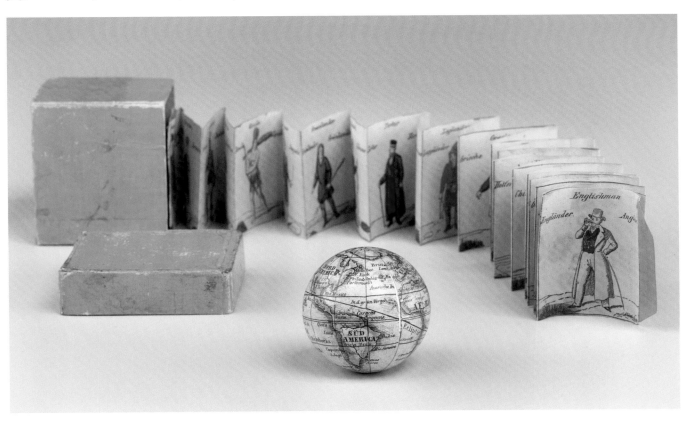

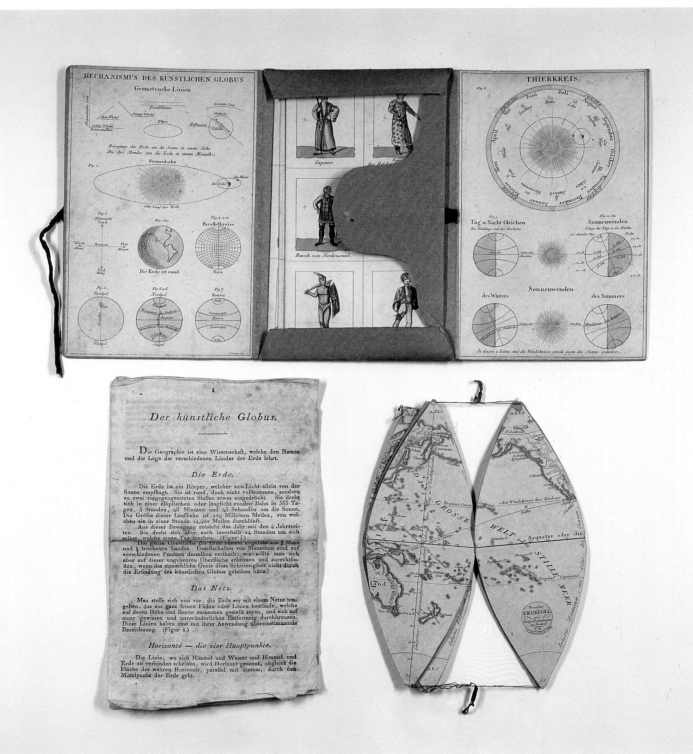

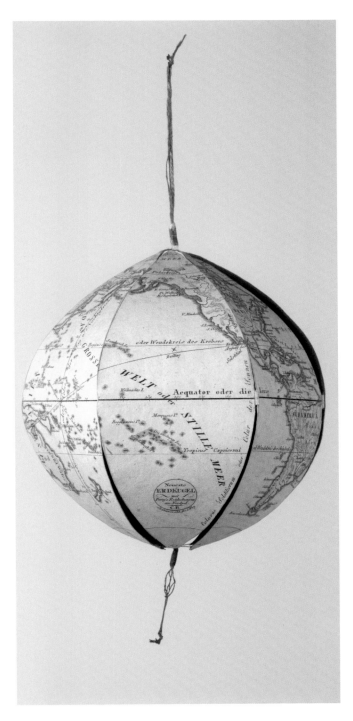

5.24a Folding Globe with Slipcase, Carl Johann Sigmund
Bauer, Nuremberg, circa 1825, height: 17.3 cm, inv. no. E I 48

5.24b Folding Globe, put together, inv. no. E I 48

consists of six gores connected by threads; sleeves make it possible to compress them in such a way that a terrestrial globe emerges (ill. 5.24b). The accompanying slipcase contains explanations pertaining to the seasons and the Earth's climate zones (ill. 5.24a).

Johann Baptist Homann's (1664–1724) pocket or bag globe is also small and handy. Made in Nuremberg around 1715, it incorporates three astronomical models: Glued to the inside of the outer case is a concave celestial globe that shows the constellations "correctly," i.e. it offers the view one has from the Earth. Inside the celestial globe, which can be opened along the equator, is a terrestrial globe inside of which the armillary sphere is placed (cf. p. 121, ill. 5.7, 5.8). It shows the geocentric worldview with the stationary Earth in its center (ill. 5.25).

The terrestrial body by Christlieb Benedict Funk (1736–1786) displays the major map projections employed in cartography. It consists of a cylinder, two truncated cones, and two planes. The tropics are shown on the cylinder, the temperate zones on the truncated cones, and the poles are depicted directly on the planes (ill. 5.26). This was the perfect model to explain the projections to students. Additionally, such a terrestrial body was easier to make than a globe. Funk attached great value to depicting and labelling islands accurately. The accentuation of borders in Europe by colored border markers is noteworthy. Also listed are the routes of world voyages undertaken by Ferdinand Magellan (1519–1522) and George Anson (1740–1744), as well as James Cook's last journey (1776–1779).

With his terrestrial and celestial double cones Funk intended to offer an inexpensive alternative to already-finished globes. The complete cones consist of three different elements: Mounted on top of the support cone that serves as base, the terrestrial cone is rotatable. Equally rotatable, the celestial cone is stored inside the latter. Buyers could also purchase the maps as flat prints, cut them out themselves to the shape of cones, and glue them together (ill. 5.27).

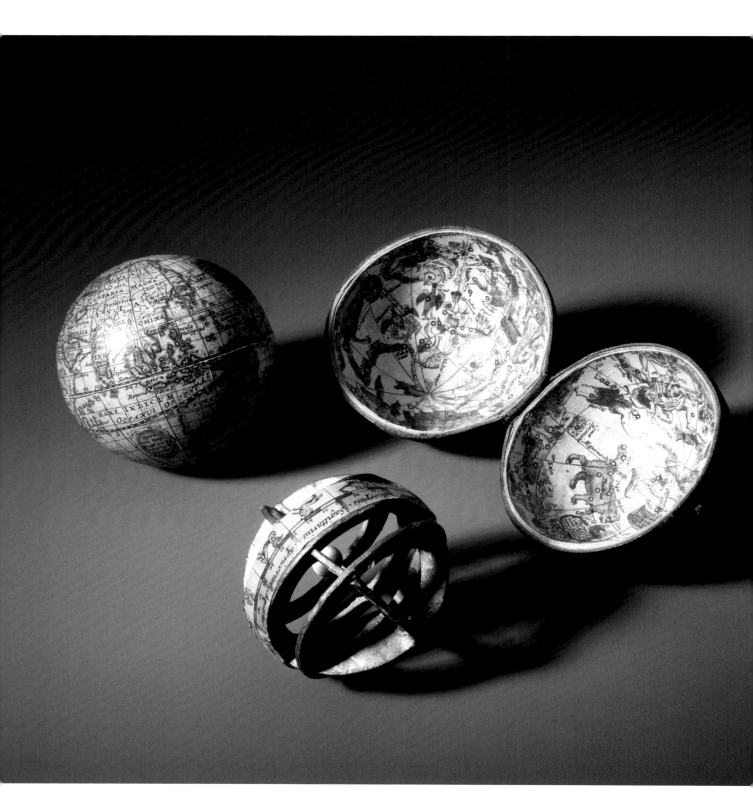

5.26 Terrestrial Globe, Christlieb Benedict Funk, Leipzig, 1785, engraving, paper mache, diameter: 23.5 cm, inv. no. E I 21

5.27 Terrestrial and Celestial Cone, Christlieb Benedict Funk, Leipzig, circa 1780, engraving, paper mache, diameter: 36 cm, height: 17 cm, inv. no. E I 30

Globes as Serial Prints

Mass distribution of documents and graphic arts has been possible ever since printing with moveable type was invented in around 1440. The first globe assembled from printed segments was made by Martin Waldseemüller (1470–1520) in 1507. The globe gores were still executed as woodcuts at the time. Introduced a few decades later, copperplate engraving turned out to be better suited for printing maps because it was possible to depict thinner lines and larger editions could be printed. Johann Gabriel Doppelmayr (1677–1750) from

5.25 Pocket Globe ("Bag Globe"), Johann Baptist Homann, Nuremberg, circa 1715, engraving, paper mache, diameter celestial globe: 7.3 cm, diameter terrestrial globe: 6.7 cm, diameter armillary sphere: 5.8 cm, inv. no. E II 27

Nuremberg created his globes with the copperplate engraving technique, thereby producing the largest editions in 18th-century Germany. Doppelmayr also worked for Germany's largest map publisher, founded by Johann Baptist Homann in Nuremberg in 1702, who published almost 1,000 different maps. Established in 1707, the Augsburg-based publishing house of his student Matthäus Seutter (1678–1757) became Homann's fiercest competitor.

Johann Gabriel Doppelmayr's double globes appeared in three sizes with sphere-diameters of 10 cm, 20 cm, and 32 cm. Johann Georg Puschner (1680–1749) engraved the map segments. The first edition of the terrestrial globe was issued in 1728. In his new edition of 1792, Wolfgang Paul Jenig (1743–1805) took the results of James Cook's three world voyages into account, especially with regards to displaying the Society Islands, New Zealand, the Great Barrier Reef, and the Torres Strait Islands (ill. 5.28).

5.28 Terrestrial Globe, Johann Gabriel Doppelmayr, Wolf Paul Jenig, Nuremberg, 1792, engraving, paper mache ball, diameter: 32 cm, inv. no. E I 16

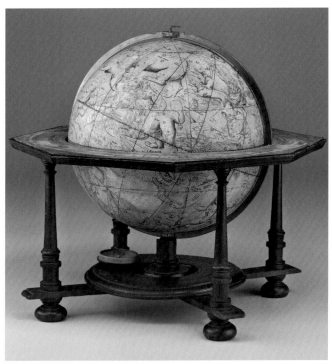

5.29 Celestial Globe, Johann Gabriel Doppelmayr, Nuremberg, 1728, engraving, paper mache ball, diameter: 32 cm, inv. no. E II 12

Doppelmayr was unable to take into consideration the most current findings of Vitus Bering (1681–1741) – who went on his research expedition to Asia's eastern coastline in 1728 and discovered the Chukchi Peninsula and Kamchatka – in his big terrestrial globe of the same year 1728. These places were included on the middle terrestrial globe (20 cm diameter) which Doppelmayr brought on the market in 1730. Of equal note on the latter were such past expeditions as English adventurer William Dampier's (1651–1715) to East Asia and Australia in 1699. The smallest pair of globes finally came out in 1736.

In his celestial globes Johann Gabriel Doppelmayr showed the customary 48 constellations of Ptolemy, supplementing them with 11 new constellations, introduced by Danzig astronomer Johannes Hevelius (1611–1687). Whereas Albrecht Dürer (1471–1528) depicted the Cetus constellation as a peaceful whale in his woodcut of 1515, on the globe it is shown as a monster based on the atlas *Uranographia* of Hevelius – (ill. 5.29).

Augsburg publisher Matthäus Seutter only printed one pair of globes. His terrestrial globe first appeared in 1710 and could also be acquired in the form of individual gores for do-it-yourself assembly. What is striking vis-à-vis California in the map picture is its rendering as an island. Connected to the north with New Guinea, Australia's east coast is still mapped in rather fragmentary fashion, and the Van-Diemens-Land (Tasmania) is pushed far off to the east.

5.30 Terrestrial globe, Matthäus Seutter, Augsburg, circa 1710, engraving, paper mache ball, diameter: 21 cm, height: 35 cm, inv. no. E I 50

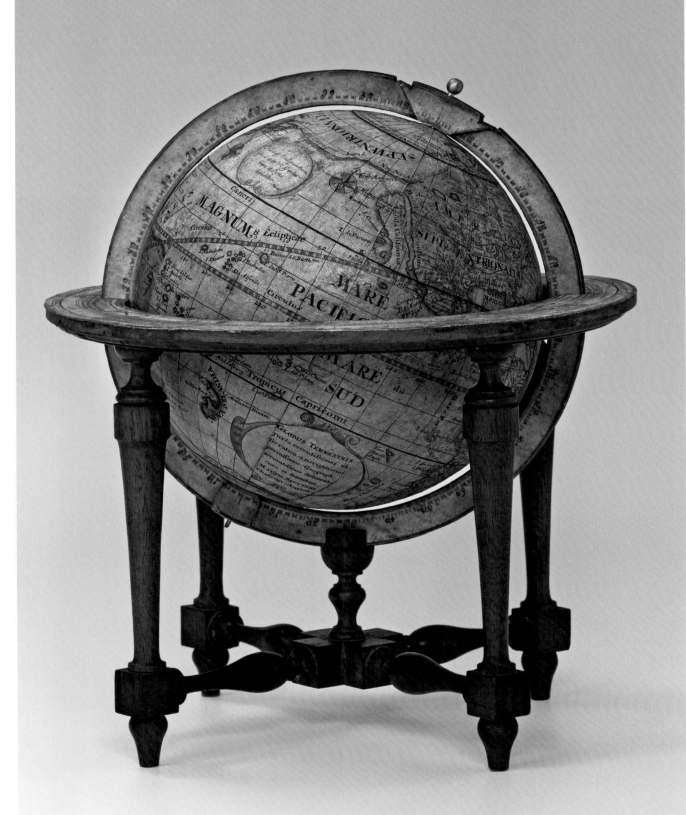

At the South Pole, Seutter still depicted the "Terra Australis Incognita" (ill. 5.30).

Seutter's celestial globe is characterized by its sumptuous coloration. The twelve segments show a total of 68 constellations. Their rendering follows the constellations astrono-

mer Johannes Hevelius compiled and for the southern sky the compilation of Pieter Keyser and Frederick de Houtman. The figures are portrayed rather naively. On all globes, the star sizes were subdivided into six categories, according to their luminosity (ill. 5.31).

5.31 Celestial Globe, Matthäus Seutter, Augsburg, 1710, colored engraving segments, paper mache ball, diameter: 21 cm, height: 35 cm, inv. no. E II 21

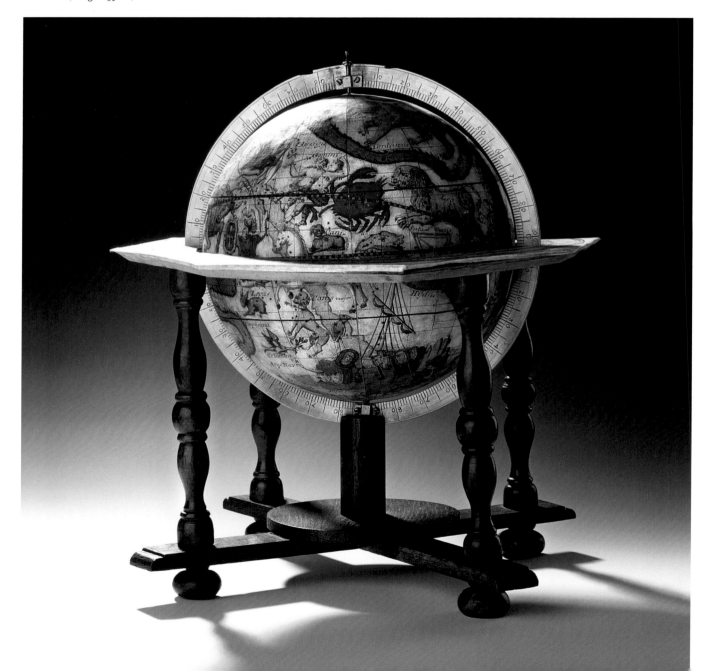

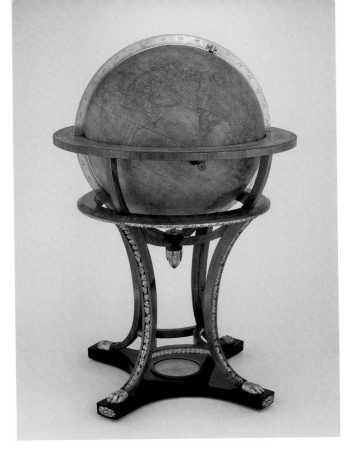

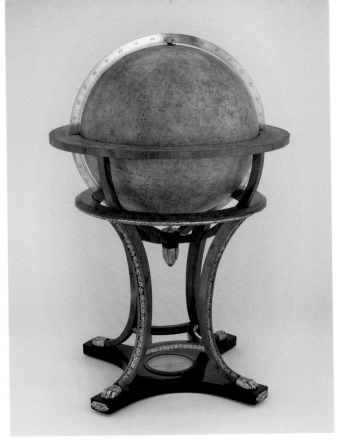

5.32 Terrestrial Globe, Schreibers Erben, Christian Gottlieb Riedig, engraved by Heinrich Leutemann, Leipzig, 1820, engraving, paper mache ball, diameter: 49 cm, height: 103.5 cm, inv. no. E I 6

5.33 Celestial Globe, Schreibers Erben, Christian Gottlieb Riedig, Leipzig, 1820, engraving, paper mache ball, diameter: 49cm, height: 103.5 cm, inv. no. E II 10

Contemporary Taste

The design of globe stands followed current furniture styles of the respective periods. At the beginning of serial production in the Netherlands during the Renaissance, simple, four-legged oak globe stands were typical. During the Baroque period, globes served increasingly representational functions. Therefore, their mounts were often embellished with colorful carvings. The pair of globes from Leipzig shown in the exhibition rests on an Empire-style stand with mahogany veneer and gilded stucco ornaments. Purchased for his library in 1822, King August I of Saxony (1750–1827) later exhibited it in the Mathematisch-Physikalischer Salon.

The terrestrial globe Leipzig publisher Schreibers Erben published was drawn by Christian Gottlieb Riedig (1768–1853)

in accordance with the "newest discoveries and astronomical positionings" of the time, as is written on the globe. It also factored in Adam Johann von Krusenstern's (1770–1846) Russian circumnavigation of 1806 and the discoveries John Ross (1777–1856) made upon his search for the Northwest-Passage in 1818 (ill. 5.32).

For charting the star positions of the celestial globe, the atlas *Uranographia* of the renowned Berlin astronomer Johann Elert Bode (1747–1826), first published in 1801, served as Riedig's guide. Truly remarkable are the newly recorded constellations that depict scientific-technical instruments and apparatuses developed during the Age of Enlightenment. Among the objects placed in the sky are the air pump, the electrostatic generator, and Wilhelm Herschel's telescope (ill. 5.33).

Selected Literature

Johann Gottlieb Michaelis · Catalogus Instrumentorum Staticorum Musæi Regii Mathematicii (manuscript), Mathematisch-Physikalischer Salon, Dresden 1732 (This is one of the eleven volumes of the first inventory of the Salon, written by Michaelis in 1730–32)

Karl Wilhelm Dassdorf · Beschreibung der vorzüglichsten Merkwürdigkeiten der Churfürstlichen Residenzstadt Dresden und einiger umliegender Gegenden, Dresden 1782

August Ferdinand Möbius · Beobachtungen auf der Königlichen Universitäts-Sternwarte zu Leipzig. Leipzig 1823

Adolph Drechsler · Katalog des Sammlungen des Königl. mathematisch-physikalischen Salons zu Dresden. Dresden 1874

Curt Reinhardt, Tschirnhaus oder Böttger? · Eine urkundliche Geschichte der Erfindung des Meissner Porzellans. Oberlausitzische Gesellschaft der Wissenschaften, Görlitz 1912

Herbert Wunderlich · Das Dresdner »Quadratum geometricum« aus dem Jahre 1569 von Christoph Schißler d. Ä., Augsburg, mit einem Anhang: Schißlers Oxforder und Florentiner »Quadratum geometricum« von 1579/1599. Berlin 1960 (Veröffentlichungen des Mathematisch-Physikalischen Salons, volume 1)

Helmut Grötzsch · Die ersten Forschungsergebnisse der Globeninventarisierung in der Deutschen Demokratischen Republik. Ein Beitrag zur internationalen Weltinventarisierung durch d. Unesco. Berlin 1963 (Veröffentlichungen des Staatlichen Mathematisch-Physikalischen Salons, volume 2)

Herbert Wunderlich · Kursächsische Feldmeßkunst, artilleristische Richtverfahren und Ballistik im 16. und 17. Jahrhundert. Berlin 1977 (Veröffentlichungen des Staatlichen Mathematisch-Physikalischen Salons Dresden, volume 7)

Helmut Grötzsch · Dresden, Mathematisch-Physikalischer Salon. Leipzig 1978

Helmut Schramm · Astronomische Instrumente, Katalog, Mathematisch-Physikalischer Salon, Dresden no date (1987)

Joachim Schardin · Kunst- und Automatenuhren. Katalog der Großuhrensammmlung. Staatlicher Mathematisch-Physikalischer Salon. Dresden no date (1989)

Klaus Schillinger · Zeicheninstrumente. Katalog, Staatlicher Mathematisch-Physikalischer Salon, Dresden 1990

Klaus Schillinger · Solare Brenngeräte. Katalog, Staatlicher Mathematisch-Physikalischer Salon. Dresden 1992

Uhren - Globen, wissenschaftliche Instrumente · Exhibition guide, Dresden 1993

Klaus Schillinger (Ed.) · Kostbare Instrumente und Uhren aus dem Mathematisch-Physikalischen Salon. Leipzig 1994

Wolfram Dolz · Erd- und Himmelsgloben. Sammlungskatalog, Staatlicher Mathematisch-Physikalischer Salon. Dresden no date (1994)

Joachim Schardin · Taschenuhren und Seechronometer deutscher, österreichischer und englischer Meister. Sammlungskatalog Mathematisch Physikalischer Salon, Dresden 1997

Klaus Schillinger · Rechengeräte aus der Sammlung des Mathematisch-Physikalischen Salons. Bestandskatalog. Dresden 2000

Klaus Schillinger · Zur Geschichte der Zeitbestimmung und Zeitabgabe am Mathematisch-Physikalischen Salon, in: Dresdner Geschichtsbuch 7, 2001, p. 210–232

Peter Plaßmeyer · »Churfürst August zu Sachßen etc. seligen selbsten gemacht.« Weltmodelle und wissenschaftliche Instrumente in der Kunstkammer der sächsischen Kurfürsten August und Christian I., in: Barbara Marx (Ed.), Kunst und Repräsentation am Dresdner Hof. München/Berlin 2005, p. 156–169

Michael Korey · Die Geometrie der Macht. Die Macht der Geometrie. Mathematische Instrumente und fürstliche Mechanik um 1600 aus dem Mathematisch-Physikalischen Salon. München/Berlin 2007

Peter Plaßmeyer (Ed) · Die Luftpumpe am Himmel. Wissenschaft in Sachsen zur Zeit Augusts des Starken und Augusts III. Dresden 2007

Emmanuel Poulle, Helmut Sändig, Joachim Schardin und Lothar Hasselmeyer · Die Planetenlaufuhr. Ein Meisterwerk der Astronomie und Technik der Renaissance, geschaffen von Eberhard Baldewein 1563–1568, Deutsche Gesellschaft für Chronometrie Volume 47, Jahresschrift 2008

Weltenglanz. Der Mathematisch-Physikalische Salon Dresden zu Gast im Maximilianmuseum Augsburg · Exhibition catalog, München/Berlin 2009

Wolfram Dolz, Yvonne Fritz (Ed.) · Genau Messen = Herrschaft verorten. Das Reißgemach von Kurfürst August, ein Zentrum der Geodäsie und Kartographie. Dresden 2010

Peter Plaßmeyer, Sibylle Gluch (Ed.) · Einfach – Vollkommen. Sachsens Weg in die Internationale Uhrenwelt. Ferdinand Adolph Lange zum 200. Geburtstag. Dresden 2015

Michael Korey, Samuel Gessner, Claudia Bergmann (illustration) · The Wonderous Course of the Planets: A Heavenly Machine for Elector August of Saxony - An Introduction to Eberhard Baldewein's Planetary Clock in Dresden. Dresden 2020

Credits

Staatliche Kunstsammlungen Dresden/Mathematisch-Physikalischer Salon

Archive: 1.1, 1.2, 1.3, 1.4, 1.5, 2.4, 2.6, 2.9c, 2.10, 2.14, 2.25, 2.30, 2.32, 3.1, 3.12, 3.28, 3.37

David Brandt: 1.7, 1.8, 1.9

Elke Estel/Hans-Peter Klut: 2.27, 2.28, 2.33, 2.38, 2.39, 2.44, 2.45, 3.6, 3.7, 3.13, 3.19, 3.21, 3.22, 3.27, 3. 29, 3.30, 3.35, 4.1, 4.10, 4.12, 4.16, 4.20a, 4.20b, 4.26, 4.27, 4.28, 4.31, 4.32a, 4.32b, 4.33, 4.34a, 4.34b, 4.35, 4.37, 4.38, 4.39, 4.40, 5.21, 5.22, 5.23b, 5.24b, 5.29

Jürgen Karpinski: 1.10, 1.11, 2.2, 2.3, 2.5, 2.8, 2.13, 2.17, 2.18, 2.19, 2.20, 2.31, 2.37, 2.46, 2.48, 3.11, 3.14, 3.17, 3.25, 3.26, 3.34, 3.36, 4.3a, 4.3b, 4.4, 4.11a, 4.11b, 4.13, 4.15, 4.21, 4.22, 4.23, 4.24, 4.29, 4.42b, 4.45a, 4.45b, 4.46, 5.1, 5.2, 5.12, 5.15, 5.18, 5.20, 5.25, 5.31

Hans Christian Kraas: 1.15, 2.0, 4.0, 4.47, 5.0

Michael Lange: 2.7, 2.9a, 2.9b, 2.12, 2.15, 2.16, 2.21, 2.22, 2.23, 2.34, 2.35, 2.36, 2.41, 2.42, 2.47, 3.3, 3.5, 3.8, 3.9, 3.10, 3.15, 3.16, 3.20, 3.31, 3.32, 4.5, 6.6a, 6.6b, 4.8, 4.17, 5.3, 5.4, 5.6, 5.7, 5.8, 5.9, 5.10, 5.11, 5.13, 5.16, 5.19, 5.30

Jürgen Lösel: 1.0, 3.0

Peter Müller: 2.1, 2.11, 2.24, 2.26, 2.29, 2.40, 2.43, 3.2, 3.4, 3.18, 3.23, 3.24, 3.33, 4.2, 4.7, 4.9a, 4.9b, 4.14, 4.18, 4.19, 4.25, 4.30a, 4.30b, 4.36, 4.42a, 4.43, 5.5, 5.14, 5.17a, 5.17b, 5.23a, 5.24a, 5.26, 5.27, 5.28, 5.32, 5.33

SLUB Dresden/Deutsche Fotothek/unknown photographer:
1.6, 2.4

Glashütte, Lange Uhren GmbH: 4.41a, 4.41b, 4.44a, 4.44b

Captions of the introductory images:

p. 6, ill. 1.0: Grottensaal
Foyer of the Mathematisch-Physikalischer Salon.

p. 18, ill. 2.0: Langgalerie
The Cosmos of the Prince

p. 52, ill. 3.0: Festsaal
Instruments of Enlightenment

p. 72, ill. 4.0: Bogengalerie
The Course of Time

p. 114, ill. 5.0: Neuer Saal
Universe of Globes

Imprint

**Published by the Staatliche Kunstsammlungen Dresden,
Mathematisch-Physikalischer Salon, Peter Plaßmeyer**

Editing: Peter Plaßmeyer
Texts: Wolfram Dolz, Michael Korey, Peter Plaßmeyer
Project Management Publishing house: Imke Wartenberg
Translation: Daniel Kletke, Berlin
Proofreading: Jeremy Gaines, Frankfurt am Main
Image editing: Peter Müller, Peter Plaßmeyer
Layout, typesetting, image processing: Angelika Bardou, Berlin
Printing and binding: Beltz Grafische Betriebe GmbH, Bad Langensalza

Publishing:

Deutscher Kunstverlag GmbH Berlin München
Lützowstraße 33
10785 Berlin
www.deutscherkunstverlag.de
Part of Walter de Gruyter GmbH Berlin Boston
www.degruyter.com

The Deutsche Nationalbibliothek lists this publication in the Deutsche
Nationalbibliografie; detailed bibliographic data are available on the
Internet at http://dnb.dnb.de.

© 2020 Deutscher Kunstverlag GmbH Berlin München

ISBN 978-3-422-97987-1